JERUSALEM
STONE AND SPIRIT

3000 YEARS
OF HISTORY AND ART

Dan Bahat Shalom Sabar

Design: Joseph Jibri, Nadia Gorenstein

Jerusalem – Stone and Spirit
3000 Years of History and Art

Editor: David Arnon

Graphic editing and design: Joseph Jibri, Nadia Gorenstein

Assistant editor: Rachel Ohana

Text editor: Richard Flantz

Printing production: Ronny Rausnitz

Color separations and plates: Shapiro Repro Ltd.

Printing: Kal Press Ltd.

Gold embossing: Hi-Tec Print Ltd.

Binding: Bookbindery Weiss

ISBN 965-222-748-X

© 1997. All rights reserved, Matan Arts Publishers Ltd.

Tel: 972-3-6048090, Fax: 972-3-6045689

Pages 2-3:
Map of Jerusalem
Matthaus Merian (1593-1650), 1647.
Kaplan collection, Jerusalem

Contents:

JERUSALEM
STONE AND SPIRIT

3000 YEARS OF HISTORY AND ART

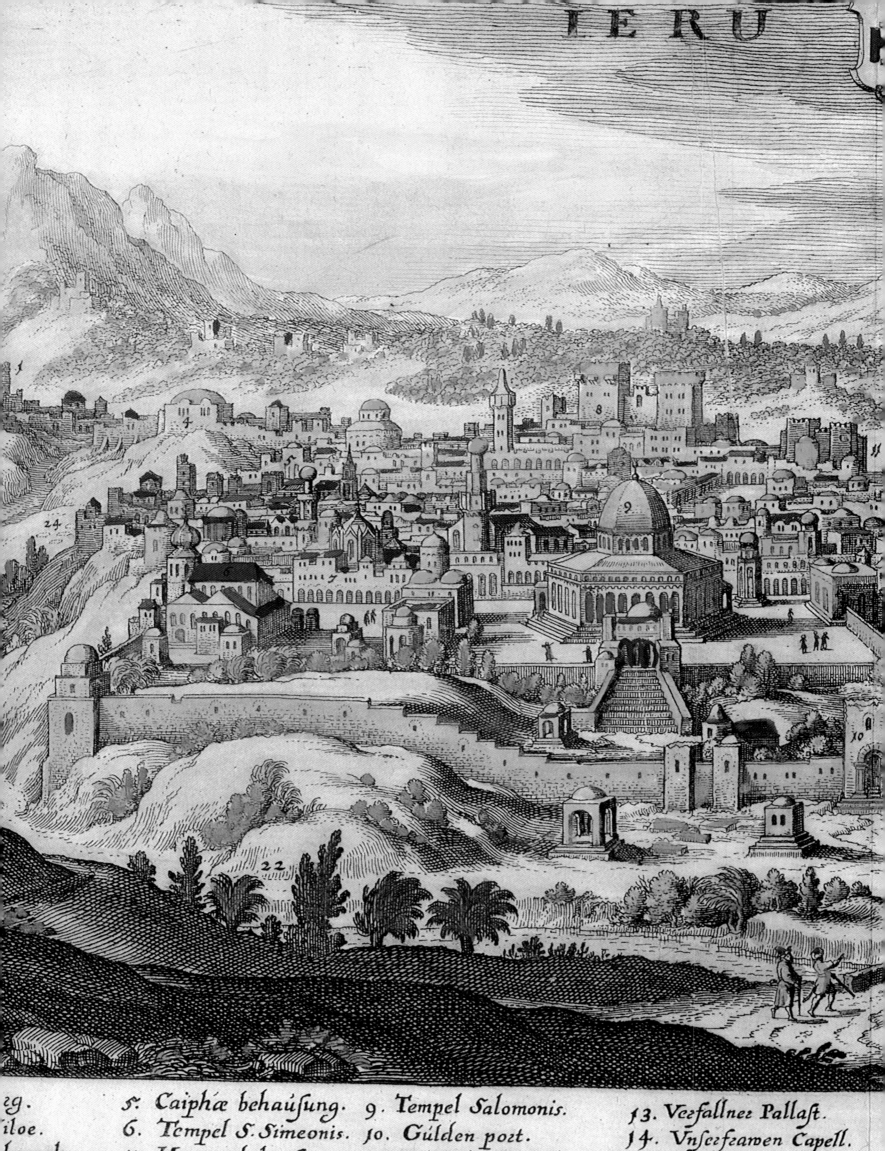

eg.	5. Caiphæ behaufung.	9. Tempel Salomonis.	13. Verfallner Pallaft.
iloe.	6. Tempel S. Simeonis.	10. Gülden port.	14. Unferfrawen Capell.
begrebn:	7. Hannas behaufung	11. Der Bilger Spital.	15. S. Anna behaufung.
on.	8. Davids Pallaft.	12. Tempel des H. Grabs.	

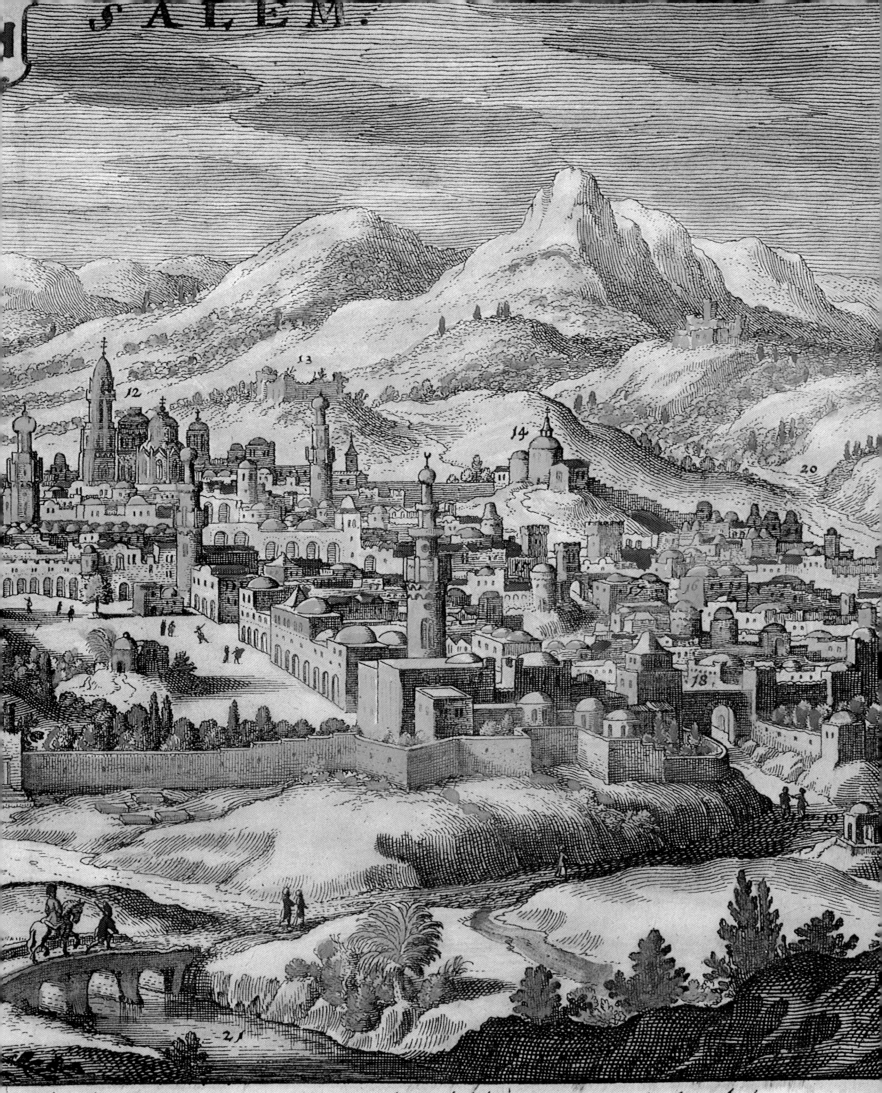

SALEM.

Pilati behausung. 20. Strass nach Behtlehem. 23. Helisei begebnus.
S. Steffans thor. 21. Der Bach Cedron. 24. Der Bilgern begebnuß.
Ohrt da Steffanus 22. Valle Iosaphat.
gesteiniot worden.

FOREWORD

*J*erusalem, the capital of Israel, has always been a lodestone and a source of inspiration to people of different religions and to people from many cultures throughout the world.

Many have longed to reach it – pilgrims, curious travelers, commanders of armies, and artists who have been enchanted by the city. They have visited it, have been captivated by its charms, have imprinted their impression upon it, and have created a marvelous and unique blend of influences.

Since the times of King David, Jerusalem has written a central page in the history of mankind. The annals of this marvelous city are also fascinating chapters in the history of the world's nations, and exploring these also opens a window upon diverse art works of spectacular beauty.

Jerusalem has not infrequently found itself at the center of regional and global disputes. I hope the day is not distant when Jerusalem, the 3,000-year-old city, will be a model for the solution of conflicts and a symbol of tolerance and co-existence.

This magnificent book contains a comprehensive description of Jerusalem's history, and items of art which have been created and collected in the entire world. It is a fascinating and eye-captivating combination of history and art, which reflects the city and binds together spirit and matter, the sacred and the profane.

I am certain that this book will raise the spirit of everyone for whom the history and the art connected with the Land of Israel and with Jerusalem are close to his or her heart.

Ezer Weizmann
President of the State of Israel

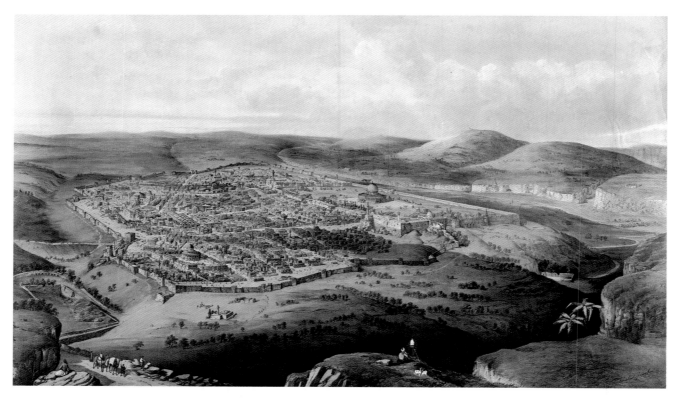

Realistic Picture-Map of Jerusalem
The anonymous artist stood on the southern ridge of Ketef Hinnom, shown artificially raised for stronger effect; early 19th century.
Teddy Kollek Collection, Jerusalem

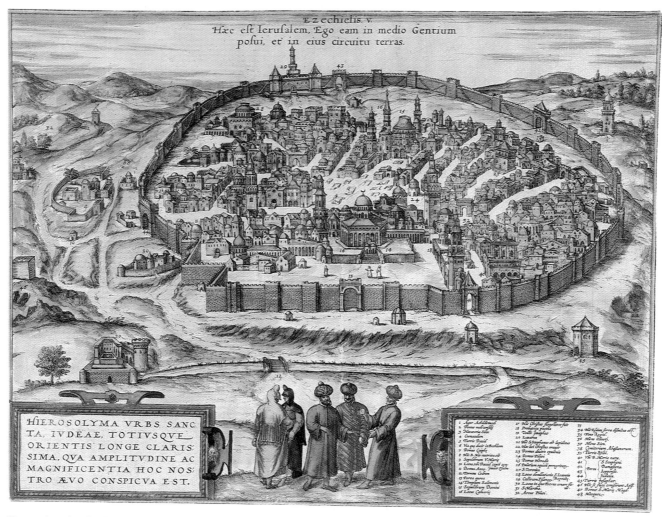

"Jerusalem in the Midst of Nations"
Copper-engraved map from the atlas Theatrum Orbis Terrarum, by the theologian George Braun and the engraver Franz Hogenberg, Cologne, Germany, 1584. The Jewish Museum, New York

PREFACE

The books that have been written about Jerusalem could easily fill several average-size book-cases. Why do we need yet another book on this subject? This question has guided the authors of the book from the very first stages of work on it. The goal was to create a different kind of book, one which would present the extraordinary history of the Holy City from a unique point of view: a blend of historical description and eye-captivating visual images in which the imaginary is often more frequent than the realistic.

The sanctified sites of the city, the fascinating personages who have been active in it throughout history, and its breathtaking landscapes, have captivated the imaginations of artists of the three monotheistic religions in the chronicles of which Jerusalem is so central. The images that have been produced over the centuries bear witness more to the spiritual-religious outlook of their authors than to the actual course of events in the city. The incorporation of these images into chapters that deal with historical aspects, beside important contemporary monuments unearthed by archaeologists, contributes to an original perception of the special place of Jerusalem in the cultural oeuvre of both the West and the East.

In choosing the illustrations for the book we have tried to arrive at a large and partially unknown selection of sources from different countries and periods. Our thanks to all the museums and libraries which have assisted us (the full list appears on p. 148). The designers, for their part, have made considerable efforts to preserve the original quality of the exhibits, and the excellent results of their work are evident on every single page. Special thanks to the producer and editor of the book, David Arnon, who has spared no effort or expense to give the finished product a handsome appearance, which faithfully serves Jerusalem in all its earthly and spiritual grandeur.

Dan Bahat *Shalom Sabar*

JERUSALEM IN ART THROUGHOUT THE AGES:

REALITY AND IMAGINATION

Holy cities and sites throughout the world enjoy a special status in the visual arts of many nations. Since the beginnings of human history, artists and artisans have been called upon to portray sites that are sacred in their nation's history, and with stylus, brush or chisel, to depict symbols and events connected with these sites, whether or not they were actually part of the nation's historical or spiritual-religious reality. The symbols and events portrayed both by known, professional artists and by folk artists whose names have long been forgotten, have often become an integral part of the image of the site itself, establishing its material and spiritual image for future generations.

No city has been the subject of such various, ideologically disparate descriptions as Jerusalem. The city's long history, the different cultures which have ruled in it, and its central importance for the three major monotheistic religions, have accorded it an exceptional place in the history of art. This wide variety of beliefs and ideas has influenced artists to depict the city in ways that reflect more the people of the time and their views than how the city actually looked. To be sure, throughout history artists have chosen to depict various physical aspects of the city, but even then their choice has attested to the importance of the site or of a symbolic event connected with it. Beside these physical depictions we find stereotyped symbolic representations of the sacred sites which could be fully understood only by members of the specific community for whom the symbols were created. In the course of this history there has never been a dearth of fascinating, imaginative and eye-catching depictions, such as those images which did not purport to reproduce the actual landscape, but rather to portray an ideal spiritual city – a city that never existed, yet served as the focus of yearning for those who believed in prophetic visions of the End of Days.

The earliest known artworks relating to Jerusalem or its holy places date to some one thousand years after King David transformed the little mountain town into the capital of his kingdom. These include minor Jewish artworks and mosaic synagogue floors made in Palestine and the Diaspora during the Talmudic era, which display many symbols of Jerusalem and the Temple. The principal symbol was undoubtedly the seven-branched candelabrum, the Menorah, which was used to represent the magnificent Temple even prior to its destruction (pp. 63, 69). After 70 A.D., it became the quintessential symbol of the destroyed Temple and of the yearnings for its reconstruction. The Romans, too, evidently knew its significance for the Jewish people, for on the Arch of Titus it is the central object in the triumphal procession of spoils brought from the provinces of Judea (p. 71). Along with the Menorah, its flames usually depicted as turning miraculously towards the center to symbolize the Divine Presence, a ram's horn (shofar), a censer, the Ark of the Covenant and the Four Species also appear on these artworks (pp. 77, 78, 87). These symbols served to remind the people of the Temple at its most glorious; the Four Species relate to the Feast of Tabernacles, the central religious and national event at the Temple in ancient times.

The form of the Temple, too, expressed national aspirations for Jewish independence and the rebuilding of Jerusalem. The first to visually perpetuate the image of the Temple was the leader of the second rebellion against the Romans, Bar-Kochba. On the coins he minted, the façade of the Temple appeared in the form of a structure with four columns supporting an architrave (pp. 80, 87). This was not an accurate depiction of the façade of the Temple that had been destroyed two generations earlier, but rather that of a pagan-Hellenistic temple – an accepted visual formula in ancient times for portraying a sacred site. The symbol was imbued with Jewish meaning through the image located between the two central columns. While in Hellenistic temples this spot was reserved for the statue of the god in whose honor the temple had been built, on Bar-Kochba's coin it is occupied by the Ark of the Covenant which had stood in the Holy of Holies of the Temple. Also created during this period was the "Jerusalem of Gold", a piece of jewelry that Rabbi Akiva made for his wife, Rachel, probably in the shape of the city's wall; this piece of jewelry has not survived.

The Temple
Illustration from the book "Rishon le-Tziyyon", by the Moroccan rabbi Hayyim Ben Attar (1696-1743), printed in Istanbul, 1750

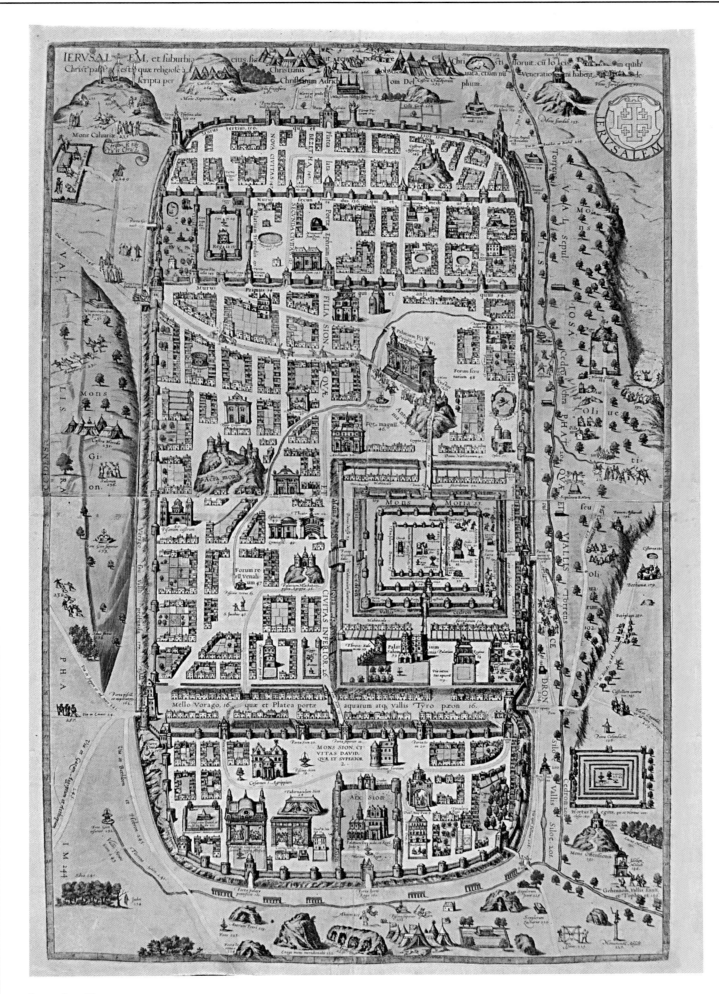

Jerusalem Map

The map is primarily based on the Bible and the writings of Josephus Flavius; by Christian van Adrichom, 1584.

Laor Collection, Jewish National and University Library, Jerusalem

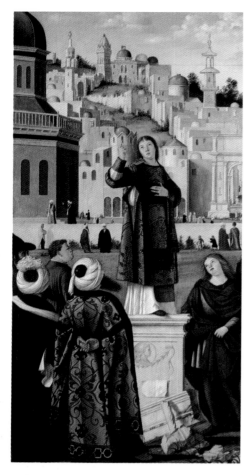

The Sermon of Saint Stephen outside the walls of Jerusalem
Vittore Carpaccio, ca. 1514. The Louvre, Paris (detail)

The Holy Sites on the Temple Mount
Detail from a popular printed page of the holy places in the Holy Land, Jerusalem, ca. mid-19th century

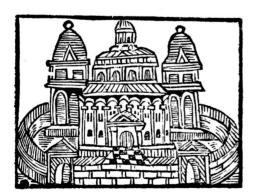

Imaginary picture of the Temple
From Hebrew book of Grace after Meals, printed in Prague, 1750

For the Christians, the Temple was not a significant site, for they saw its destruction as a fulfillment of Jesus' angry prophecies, as when he proclaimed in the Temple: "There shall not be left here one stone upon another, that shall not be thrown down" (Matthew, 24:2). From their point of view, the central site of the city was the Sepulcher of Jesus, which was perpetuated by the magnificent church built in the fourth century by Queen Helena, mother of Constantine, the first Christian emperor. In the Christian art of that period, the Church of the Holy Sepulcher, easily recognized by its round dome, appears as the central Christian holy place in Jerusalem (p. 98). In the footsteps of Helena, many Christian pilgrims came to Jerusalem, and churches were built in those places where Jesus had lived and taught, to commemorate his miracles and his works. The famous Madaba map provides something of a guide to the sites established by the sixth century, and shows historical sites in the Land of Israel referred to in the Scriptures. Jerusalem is deliberately positioned in the center of the map, almost ten times larger in scale than all the other sites; at its center is the Church of the Holy Sepulcher (pp. 92, 98, 99). Yet despite the overt ideology expressed in the mosaic map's design, the depiction of the streets and houses of Jerusalem is more or less accurate, and archaeologists have found it helpful, for example, in discovering the remains of "The Cardo", the main street of Byzantine Jerusalem.

The image of Jerusalem as a heavenly city was widespread in Christianity already in ancient times. The Jerusalem of the future was described in Revelation (ch. 21) as a city with a symmetrical structure, with twelve gates inlaid with pearls and precious gemstones and streets paved with gold (p. 123). On wall mosaics in churches of the fifth and sixth centuries, it was customary to portray the colorful city wall on the triumphal arch at the entrance to the church apse. Opposite Jerusalem stood Bethlehem, the two central cities in Jesus' mission. Underneath each city stood six sheep, together representing the twelve apostles and all the followers of Jesus (pp. 91, 94-95, 97).

With the rise of Islam in the seventh century and the conquest of the Holy Land and Jerusalem by the Caliph Umar, a third religion joined in to make its contribution to the city's architectonic development and the creation of new visual symbols for it. Although Jerusalem is not explicitly mentioned in the Koran, later traditions attributed various events to the city. Already in 691 A.D., the Umayyad Caliph 'Abd al-Malik built the "Dome of the Rock" over the Stone of Foundation, which was the site of the Holy of Holies in Solomon's Temple. In the later traditions, this site is identified with the rock upon which Muhammad rested his foot when he ascended to heaven ("al-Miraj"). This event, sometimes together with Muhammad's night voyage from Mecca to Jerusalem, is depicted in many Muslim miniatures (pp. 110-111, 113). In these manuscripts, the houses of Jerusalem and the Temple have the appearance of Muslim mosques of the period and place where the miniatures were produced (pp. 103, 105).

Islam later attributed another event to the Stone of Foundation: the binding of the son of Abraham the "Hanif", the first monotheist. As the Koran does not explicitly mention the name Isaac, commentators on the Koran have identified the son bound by Abraham as Ishmael. This event was conceived of as a parallel to Muhammad's ascension, since according to Islamic tradition both occurred at the same spot. Indeed, several manuscripts were found to contain miniatures portraying the two events in a compositional schema that emphasizes the parallel between them: Abraham and Ishmael, or, alternately, Muhammad riding his horse, standing in the center of a circle of angels who carry bowls of fire and incense. In both scenes, one of the angels carries the ram for the sacrifice.

Islam's contribution to the appearance and representations of the holy places extended beyond the Muslim world itself, influencing both Christian and Jewish art. When the Crusaders captured Muslim Jerusalem in 1099, they found the city in all its glory; events and places mentioned in the Hebrew Bible and the New Testament seemed to come alive before their very eyes. They saw themselves as Joshua conquering Canaan or as the Maccabees liberating the Temple from the hands of infidels (p. 55). In the fine Crusader maps which have survived, sites in the city which had been built during different periods received anachronistic names that identify them with the distant heroic past of the people of Israel. Thus, for example, the Herodian Hippicus Tower is called "David's Tower" (Turis David) (pp. 115-116, 119), and the adjacent gate is called "David's Gate" (Porta David). However, the edifice which has had the longest lasting influence on the image of Jerusalem in Western art is the octagonal structure of the Dome of the Rock, which the Crusaders called "The Temple of the Lord" (Templum Domini). Following this mistaken identification, the Muslim structure became the most widespread stereotyped symbol of the Temple in both Christian and Jewish art (pp. 32, 36, 87, 101, 103, 108, 110, etc.).

The Middle Ages and the Renaissance witnessed an increasing interest in the visual depiction of events from the annals of Jerusalem. The writings of Josephus, including his detailed descriptions of the city and its history, provided a fertile source for artists such as Jean Fouquet, who tastefully illuminated the manuscripts of the Jewish

historian (pp. 35, 38, 41, 53, 59, 68, 75). These miniatures contain new topics related to the history of the Second Temple in Jerusalem, such as "Pompey Enters the Holy of Holies in the Temple" (p. 57). In representations of the city from this period, we can see that the artists gave the Holy City the appearance of medieval or Renaissance towns (or even of their own home cities) (e.g., pp. 41, 48-49, 59). During the Renaissance in particular, depictions of Jerusalem tended to include classical structures, such as Roman triumphal arches and other ancient architectonic elements, for at that time Jerusalem was thought of as a city from the remote past which they were trying to restore to life (pp. 23, 67, 72-73, 84). The notion of Jerusalem as an ideal city also underwent an abrupt change. Thus, for example, in Raphael's painting "The Marriage of Mary and Joseph", the scene is set in an idyllic landscape in the center of which stands a perfectly harmonious structure, the Temple, inspired by the Dome of the Rock, but transformed through Renaissance concepts of the ideal architectonic structure (p. 79).

Along with new concepts, visual conventions dating from the Middle Ages or even earlier were used during the Renaissance and Baroque periods. One distinctive example is the development of cartography, which undoubtedly influenced maps of Jerusalem and accurate descriptions of the city as it really was (pp. 10, 129). Nonetheless, in the year 1581, a map of the world was printed in Germany with Jerusalem at its center (p. 17). Another common belief, which remained firmly entrenched in the sixteenth and seventeenth centuries, attributed the spiral columns in the basilica of St. Peter in the Vatican to Solomon's Temple. The people of the time genuinely believed in their healing properties (p. 57). Raphael used these columns in depicting one of St. Peter's miracles which occurred at the gate of the Temple.

It is interesting to note that the variety of ways in which Jerusalem was viewed during the Renaissance also penetrated into the art of the Jews in Italy, and from there reached other Jewish communities in Europe, and even the Orient. Thus, for example, in a Haggadah printed in Venice in 1609, Jerusalem – with the Messiah approaching – is depicted as an ideal city of the High Renaissance (cf. pp. 62, 108), and on the title pages of Hebrew books printed in Italy there appears a pair of spiral columns, symbolizing the pillars Yachin and Boaz that stood at the façade of Solomon's temple. In the seventeenth and eighteenth centuries these images circulated and appeared on Jewish ritual objects, tombstones, in synagogues and in Hebrew books, from the small towns of Eastern Europe all the way to Syria and India.

Jewish folk art, by nature conservative and not very receptive to innovations, preserved visual conventions known from the Middle Ages until modern times. People of the Old Yishuv (Jewish Settlement) in Palestine developed an image of Jerusalem which became a distinguishing mark on articles produced in the country during the last century, up to the beginning of the twentieth century. This stereotyped image is based on the Crusader tradition, and shows the Temple in the form of the Dome of the Rock and "Solomon's House of Study", which is none other than the Al-Aqsa Mosque. These two edifices rise above a brick wall representing the last vestige of the Temple Mount, the Western Wall, with a row of cypress trees between them, symbolizing the cedars of Lebanon used to build the Temple (pp. 138, 141, 142). This image was widespread throughout the Jewish world of that period, and was imprinted on hundreds of sacred objects in every community. In the nineteenth century, there was an awakening of renewed artistic interest in Palestine in general and in Jerusalem in particular. This phenomenon was connected to Muslim Orientalism, which acquired a place of honor in Western thought and culture during this period. Artists from colonialist Europe came to Muslim countries and were captivated by the charms of the Oriental imagination and the exotic sights. These artists' Orientalist enthusiasm for the city of David and Jesus inspired many art works which romantically conveyed the light and the colors of the East to Western Europe (pp. 82-83, 109, 128, 130-132, 139, 141).

The romantic approach was also the basis of the works produced by artists of the Bezalel school, which was founded in 1906 in Jerusalem by Boris Schatz (pp. 137, 145). Ideas of a national renaissance in Zion, together with the local landscape and population as revealed to the eyes of such artists as Ephraim Moses Lilien, Reuben Rubin and Nahum Gutman, clothed Jerusalem in naive, romantic and idyllic garb. Likewise, during the period preceding the establishment of the State of Israel, many artists (such as Anna Ticho, Ludwig Blum and others) made Jerusalem their subject and illuminated its magical landscapes in new ways. In the present generation much thought is devoted to Jerusalem, especially by Israeli artists who confront the city directly and incline towards subjects which demolish myths of its sanctity in the art of the three major religions.

In this brief review we have endeavored to point to Jerusalem's centrality in art throughout the ages and to note the extent to which each picture reflects the spirit of the time and place of its creation. Jerusalem's special place in religion and thought throughout the ages finds impressive visual expression in the vast number of works created over the last two thousand years or so. We hope that the illustrations included in this book will make perceptible this extraordinary and fascinating aspect of the history of Jerusalem and its heroes in the cultures of East and West.

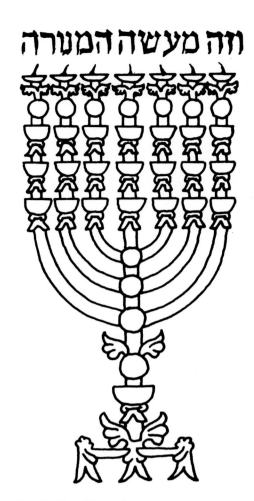

The Golden Menorah
From a manuscript Hebrew Bible illuminated in Perpignan, 1299 (detail). Bibliothèque Nationale, Paris

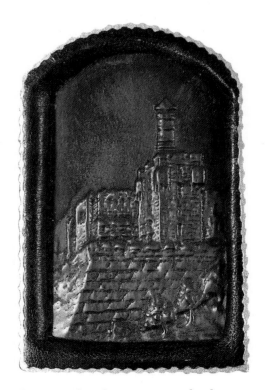

Copper embossing on a prayer book cover, showing David's Citadel
The picture is embossed on a thin layer of copper, "Bezalel" work, Jerusalem, early 20th century. Private collection, Herzliya (detail)

JERUSALEM'S BEGINNINGS: THE CITY IN ANTIQUITY

Research on Jerusalem had already begun during the Second Temple period, if not earlier. The books of the 1st-century historian Josephus Flavius already describe deeds of building and destruction in Jerusalem, with information on the city's past drawn from various sources. Josephus was not always accurate, due to the lack of remains in the area from earlier periods, but in the final analysis his description of what the city was like before his time has been largely confirmed by modern archaeological finds. Josephus' writings have survived and his work, available to this day, was well known in ancient times. Thus, for example, the famous traveler Benjamin of Tudela (1167) based his description of the walls of Jerusalem on Josephus' description of its three walls. Other pilgrims who visited and described the city also often explained that in the past the city had been built differently – that its bounds and holy places had been different. (Generally these descriptions referred to the sites at the time of Jesus, i.e. the Second Temple period.)

These descriptions may be seen as the beginnings of research on Jerusalem, and as an aid to help us begin to understand the changes which occurred there in the course of time. The truly scientific study of the city began in 1838, with the visit to Jerusalem of an American clergyman, Edward Robinson. Imbued with a desire to know the true facts, Robinson began to study vestiges of earlier periods which he found in Jerusalem. Many of these still remained in full view at the time of his visit. Unlike other visitors to the city, he had come without preconceptions, nor was he biased by legends or religious traditions lacking scientific foundation. With the publication of his books containing descriptions of Jerusalem and scientific discussions of the city's problems in various periods, he in effect opened the age of scientific study of the city.

The French scholar Felicien de Saulcy conducted the first archaeological excavation in Jerusalem – of a burial cave known as "The Tombs of the Kings". De Saulcy discovered fascinating finds which indicate that these were the tombs of the royal family of Adiabene, a small kingdom located in what is today northern Iraq.

In the 1860s, the British conducted a major survey of the Holy Land, which described the country with all its sites, as well as its flora and fauna. This survey placed special emphasis on Jerusalem. In 1864, Charles Wilson conducted a preliminary survey, following which the first accurate map of Jerusalem was drawn. The discovery of many remains on the surface led to the great archaeological excavation conducted by a team headed by Sir Charles Warren. His excavations, mainly around the walls of the Temple Mount, as well as his examinations of the depth of the bedrock in different parts of the city, serve to this day as the sole guide to study of the natural rock upon which Jerusalem was built. His work beside the Temple Mount is unparalleled, and to this day, all research on the Temple Mount is based on Warren's observations.

The 19th century was notable for its studies of the various urban structures, such as markets, city squares and even ancient churches (mainly from Crusader times), which were discovered among the town houses. By the 1880s the location of the City of David, the city's historical core, had already been discovered. This was a long, narrow hill between the Kedron valley in the east and the Tyropoeon in the west. The hill rose northward in the direction of the Temple Mount, than which it was considerably lower; thus, the city's northern side was its weak point. The first scientific excavation on the hill, in 1913-1914, was conducted by the French archaeologist Raymond Weill, who headed an expedition financed by Baron Rothschild. The excavation was halted with the outbreak of the First World War and was renewed in 1923-1924. In this excavation, significant remains of the City of David, such as the various water works, were discovered (Warren's Shaft had already been discovered in 1867 by Charles Warren, whose activities in Jerusalem were briefly mentioned above).

With the establishment of the British Mandate, a new phase of archaeological exploration in Jerusalem began. In the City of David, diggings were conducted in 1925 and again in 1927, but the British also made excavations at the Citadel (Johns) and the Damascus Gate (Hamilton). Then came the excavation which revolutionized our knowledge of the city's size during the Second Temple period – the excavation conducted by E.L. Sukenik

Sargon II
King of Assyria (722-705 B.C.)

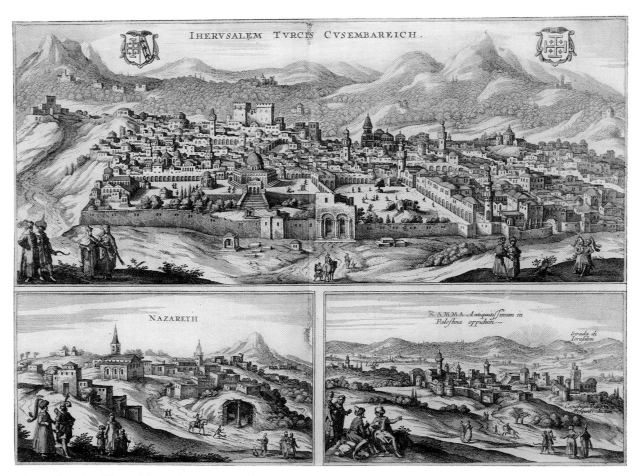

Jan Janssonius Map of Jerusalem

At bottom are views of Nazareth and Ramma (Ramleh); copperplate engraving, Amsterdam, 1657.
Laor Collection, Jewish National and University Library, Jerusalem

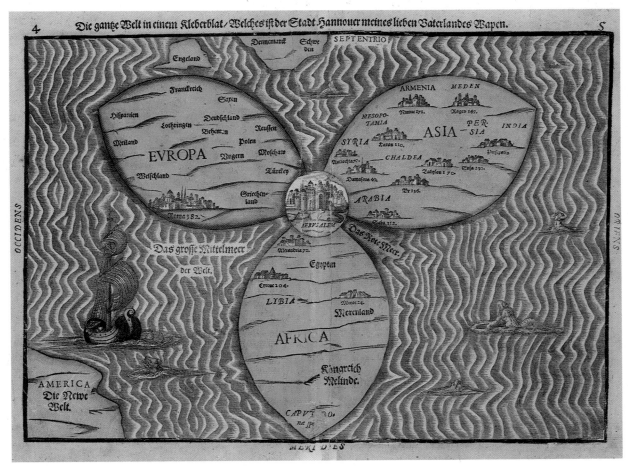

Bunting Map of Jerusalem in the Center of the World

The world is shown as a clover leaf with Jerusalem at its center; woodcut, Germany, 1581. Laor Collection, Jewish National and University Library, Jerusalem

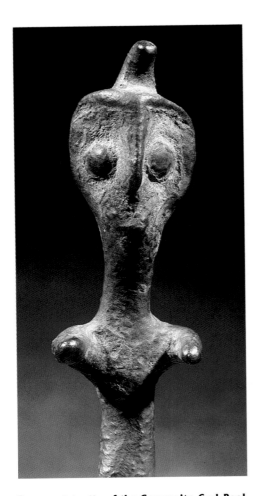

Bronze statuette of the Canaanite God Baal
Height 5.8 cm., found in Jerusalem,
13th century B.C. Reuben and Edith Hecht Museum,
University of Haifa

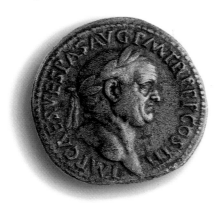

"Judaea Capta" coin with head of Roman Emperor Vespasian
Struck in 71 A.D., following the crushing of the Great Revolt against the Romans and the destruction of the Temple. The Israel Museum, Jerusalem

and L.A. Mayer along the Third Wall. This excavation helped to solve one of the most important questions about the city: to what extent the city had expanded prior to its destruction by the Romans in 70 A.D.

A new chapter in the archaeological study of Jerusalem began in 1961 when the renowned British archaeologist, Kathleen M. Kenyon, began her excavations in various sections of the city. She focussed mainly on the City of David, but also examined other sites in the city, such as the Muristan (the ancient market place), Mount Zion, the Armenian Garden, and the Damascus Gate. Her excavations, which at the time of writing are still being published, have vastly increased our knowledge of the city in later periods, i.e., from the period after the destruction of the Second Temple until the present day. Because the sections she excavated were small, many of her conclusions about the extent of the city's expansion at various periods were proved incorrect, and only the Israeli excavations in the city after the 1967 Six Day War rectified some of her errors, with her agreement.

The accelerated development of Jerusalem after the Six-Day War led to many rescue excavations, including those of N. Avigad in the Jewish Quarter, the diggings in the Armenian Garden, in Tancred's Tower, and in hundreds of burial caves from the Second Temple period, which were discovered during the construction of neighborhoods such as French Hill, Ramot and Ramat Eshkol. Israel also initiated large-scale excavations at the southwestern corner of the Temple Mount, at the Citadel and in other places. Over the years, the picture of the city has changed completely and our knowledge of Jerusalem has greatly increased.

The topographical archaeological study of the city is not based on archaeology alone. The vast number of historical sources available to us – the extensive literature written by pilgrims whose descriptions of Jerusalem have provided a rich source of information on the city, the maps drawn over the years, the religious literature from Jewish, Christian and Muslim sources – all combine to create the historical- archaeological picture of the city. Jerusalem – its name means "the city founded by the god Shalem", the god of the night in Ugaritic mythology – was originally founded on a long, low, and narrow hill known today as the hill of the City of David.

This hill was selected because of the spring flowing at its foot, the Gihon Spring. Its fortification was made possible because of the steep slopes of the hill, which was protected on all sides except from the north. The manner in which it was fortified in earlier periods is still not adequately clear to this day.

The city was probably founded during the Chalcolithic Era – the fourth millennium B.C. – as attested to by the archaeological excavations conducted there in the 1980s. The nature of this ancient settlement has not become clear to us, mainly because of the narrowness of the area reached by the archaeologists at the level of this period.

Already at the beginning of the third millennium B.C. (in about 3000 B.C.), the first signs of settlement in this place appeared. A number of houses characteristic of the period were found on the eastern slope of the hill, and they were undoubtedly part of the city complex at that time. The houses of that period are characterized by lateral structures with benches along their inner walls and bases of columns that supported their ceilings. This type of house has been found in many places in Israel. In Jerusalem, in addition to the houses, a collection of beautiful artifacts from that period was discovered near the Gihon Spring, apparently originating from the tombs of that era discovered during an adventurous excavation by an English archaeologist in 1911. These tombs, known as "The Ophel Tombs", were the first of this type to be discovered in the Holy Land, and at the time their discovery aroused great interest.

The first fortification of Jerusalem was built in the 18th century B.C. Long sections of the city wall from this period remained intact half-way down the eastern slope of the hill. It had survived in this way because it had continued to serve as a fortification for hundreds of years until the destruction of the First Temple (586 B.C.), and also because the city's residents reinforced it from time to time. It appears that the first water works to serve the residents of the city also derives from this period. Since the Gihon Spring does not flow constantly but rather in brief spurts followed by dry spells, it was impossible to harness it to provide constant irrigation for the fields around the city. Its waters were therefore conveyed via an aqueduct to the Siloam [Shiloach] Pool, located in the course of the valley that bordered the hill of the City of David to the west. This was the Tyropoeon valley, which passed between Jerusalem's eastern and western ridges. The pool was named "Shiloach" [sending] because it was meant to send water to the surrounding fields where irrigated crops [Hebrew: "shlachin"] were grown (and cf. John 9:7), as opposed to nonirrigated crops watered "by the grace of Baal" [Hebrew: "Baal" crops].

Sections of the Siloam channel were discovered on the eastern slope of the hill of the City of David, the slope which descends towards the Kedron valley. In the 18th century B.C., this was a city which not only ruled its immediate surroundings but was also known far and wide already in the 20th and 19th centuries B.C. it is mentioned in Egyptian sources known as the Execration Texts (Letters of Damnation). These letters were considered to have magical meaning, and consisted of lists of cities ruled by the Egyp-

tians. Whenever one of these cities attempted to rebel, the priests in the Egyptian temples broke artifacts (bowls or figurines), inscribed with the name of the rebellious city. In this way they hoped to break the power of that city. The reference to Jerusalem in these writings points to its considerable importance in the network of cities in the Land of Israel during these centuries. We may therefore conclude that the construction of the city wall during the 18th century B.C. was the outcome of centuries of existence as a city of importance to the entire area.

Our knowledge about the following centuries derives solely from archaeology, since we have no historical sources referring to Jerusalem during that period. Even the archaeological data we do have is quite limited since Israelite reconstruction in the City of David damaged vestiges from earlier periods.

In the 14th century B.C., data concerning the city surfaces again. At that time the entire land was under Egyptian rule and was involved in a religious conflict. King Amenhotep IV, known by his name Ikhnaton, led a revolution in Egypt when he decreed that instead of the many gods of Egypt, Aton, the Sun God, was the one and only god. Because of the fear of the priests of the god Amon, the chief among the Egyptian gods, the king moved the Egyptian capital to a city he founded, Akhtaton, known by its Arabic name of Tell el-Amarna, the name of the Bedouin tribe which lived in that area.

Terracotta bird's head
Height 6.2 cm., found in Jerusalem, 13th century B.C.
Reuben and Edith Hecht Museum, Haifa

This Pharaoh was clearly unconcerned with events transpiring throughout his kingdom, and thus the whole area was in turmoil. The cities in the mountain region of the Land of Israel were fighting each other to increase the areas under their control. Jerusalem also played a part in this power struggle, and apparently did not fare well in it. It appears that even the Egyptian garrison in Jerusalem rebelled and wounded the king of Jerusalem, Abdihepa, who requested assistance from the Pharaoh. In a series of letters, six of which survived and were discovered at Tell el-Amarna, he asked for a small number of soldiers and archers to be sent to him. The letters remained unanswered, for the Pharaoh was otherwise occupied, and it is difficult to know how things turned out. From the letters, it appears that Jerusalem at this time had an important status in the mountain region, and did not sit idly by in these power struggles for control of the area.

Archaeology, too, also has some data to contribute to this episode. In the uppermost part of the settlement in the City of David, a large structure was discovered, of which only the foundations remain. Here, in the 14th century, the king of Jerusalem, perhaps the same Abdihepa or one of his heirs, attempted to build himself a grand palace on a massive foundation made of supporting beams filled with earth. Although its upper sections did not survive, the base was preserved because David made this the site for his own palace and overlaid the foundations with enormous stone works – the terrace structure which can be seen in the City of David. Recently, a later date for this structure was suggested.

From the rich tombs which have been exposed in Jerusalem's environs, we learn of the city's relative wealth and of its commercial links with countries bordering on the sea. North of the city, diggings have also unearthed the remains of an Egyptian temple, which in all probability served the Egyptian garrison that ruled the city.

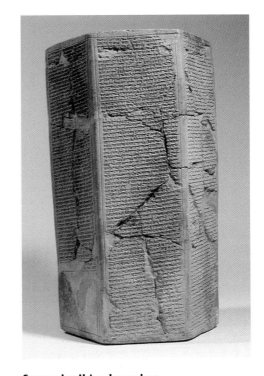

Sennacherib's clay prism
Recording in cuneiform writing his unsuccessful attack on Jerusalem in 701 B.C., Nineveh, Assyria, 691 B.C. The Israel Museum, Jerusalem

The decline of Egypt made possible the ascent of other elements in the country – the tribes of Israel probably also appeared at this stage, and the annals of Jerusalem took another sharp turn.

The arrival of the Israelites in the mountain region changed the course of Jerusalem's history. Jerusalem's king, Adoni-Zedek, made an alliance with the kings of the cities in the mountain region and in the plain, and together they went to war against Joshua son of Nun. The biblical description of the battle – the battle of Gibeon and the Valley of Ajalon (Joshua 10:1-37), ends with the cities participating in the alliance being captured and burned. Nothing is said about Jerusalem, whose king Adoni-Zedek was killed by Joshua.

There is, however, a biblical description which says that the descendants of Judah captured Jerusalem (Judges 1:8). Yet it seems that if such a conquest indeed took place it was very short-lived, for the descendants of Benjamin did not "dispossess the Jebusite inhabitants" of Jerusalem, which remained a foreign enclave in the heartland of this tribe (Judges 1:21).

It appears that during this period of weakness, Jerusalem was captured by the Jebusites, who had recently arrived in the land. Although the sources do not specify the origins of the Jebusites, scholars accept the view that they are an offshoot of the Hittites who escaped from their land following the destruction of the Hittite empire. This view is based on the presence of Hittites among the population of Jerusalem (Uriah the Hittite, and Arauna the Jebusite, whose name attests to his being a Hittite since the name Arauna means "lord" in this language). The Hittite element was known in Jerusalem already at the time of Ezekiel (Ezekiel 16:3). This was the same element that ruled the city when King David captured Jerusalem.

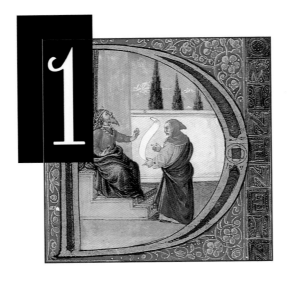

THE CITY
OF KING DAVID

1000-961

B.C. B.C.

"…But I have chosen Jerusalem, that my name might be there:
and have chosen David to be over my people Israel."
(II Chronicles 6:6)

Coronation of David
From a Byzantine manuscript, "The Paris Psalter", Constantinople, 10th century, Bibliothèque Nationale, Paris

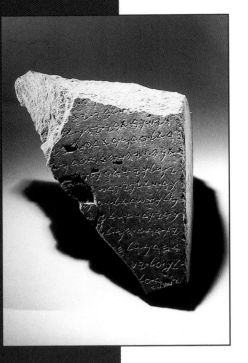

Until the time of David, Jerusalem was a small Canaanite-Jebusite city, like all the other cities in the country. However, after it was captured by David, Jerusalem became the most important city in the land. The Bible explicitly states that all of Israel participated in the conquest of the city. That is to say, the conquest of the city by David created a bond between the city and the whole nation. The Bible also states that all the people went to bring the Ark of the Lord "that dwelleth between the cherubims" (I Chronicles 13:6) from Kiryat Ye'arim to Jerusalem. Through his deeds David established the historical connection between the city and the nation, and between the dynasty of the House of David and God. This connection gave Jerusalem the uniqueness which it retains to this day.

About two hundred years before the time of David, a new ethnic group, the Jebusites, appeared in Jerusalem, and the city, which was the only one they inhabited, was then named Jebus. The Jebusites were living in the city when David captured it in approximately 1000 B.C.

Jerusalem was given a special place among the Tribes of Israel. When the Bible describes the border between Benjamin and Judah (Joshua 18:11-19), it is drawn from Jericho in the east to Kiryat Yearim in the west. Jerusalem was actually south of this line, and therefore seemed to belong to Judah; but the author of this border made certain to create a deep enclave southward, thus removing Jerusalem from the domain of Judah and transferring it to that of the tribe of Benjamin. This stratagem made Jerusalem acceptable to all the tribes. Had the city remained within the domain of Judah, it is doubtful whether it would have been accepted as the capital by the northern tribes, especially Ephraim and Manasseh, who certainly would not have

accepted the domination of Judah. The author of the Book of Joshua emphasizes the "neutrality" of Jerusalem.

David became king in Hebron and reigned there for seven years and six months. Hebron's location at the southern edge of the mountain region made it a somewhat closed city. When the representatives of all the tribes approached David asking him to be their king with the consent of God, he was crowned in Hebron as king of the entire nation (II Samuel 5:1-3).

David realized that in order to rule over all the people, he had to leave Hebron and go to Jerusalem. After capturing the city he "reigned [there] thirty and three years over all of Israel and Judah" (II Samuel 5:5). The capture of Jerusalem by David is related twice in the Bible – in II Samuel 5, and in I Chronicles 11:4-8. The two narratives are not identical. The Book of Chronicles describes David's arrival in Jerusalem ("that is, Jebus"). As he stood before the walls of the city, he proclaimed that the first to enter the city "shall be chief and captain"; and Joab ben Zeruiah, David's nephew, was the one to do so. The Book of Samuel tells a more complex tale. Araunah the Jebusite, King of Jerusalem, assembled the blind and the lame on the wall, proclaim-

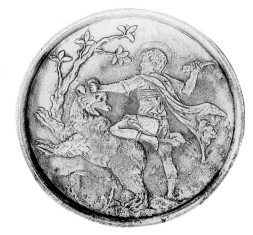

The young David killing a bear
Byzantine silver plate, Constantinople, 610-629. Museum of Antiquities, Nicosia, Cyprus

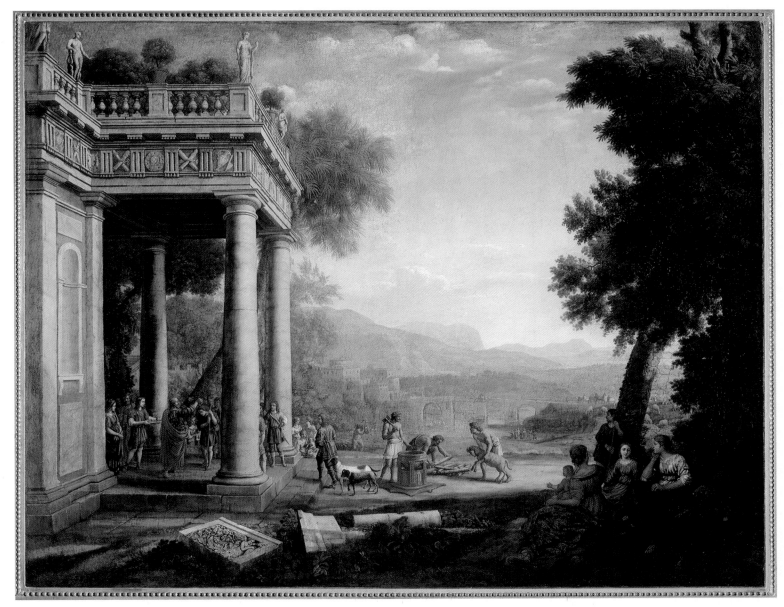

ing: "David shall not enter here"; however David "getteth up to the gutter" and so the city was captured. There has been much debate as to the meaning and manner of the capture. For example, for many years it was customary to view the word *tsinor* ["gutter"] as referring to the water channel known today as Warren's Shaft, which was meant to allow water to be drawn via an underground passage from the Gihon Spring in the event of a siege, when leaving the city to obtain water would be impossible. Scholars thought that David succeeded in penetrating the city

Landscape with David anointed by Samuel
Claude Lorrain (1600-1682), 1643. The Louvre, Paris

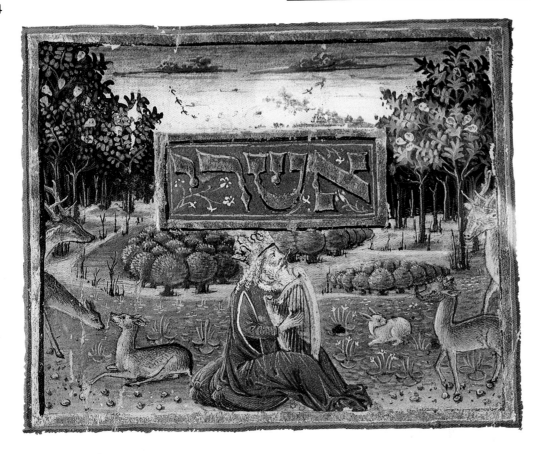

King David playing the harp
Initial panel to the Book of Psalms,
"The Rothschild Miscellany",
Hebrew manuscript from North Italy (Ferrara?),
ca. 1470. The Israel Museum, Jerusalem

Tombs of the Kings of the House of David
From Hottinger, Cippi Hebraici – a Latin translation
of a Hebrew work listing the graves of the righteous,
Heidelberg, Germany, 1659

Lower left:
King David, the Psalmist, kneeling in prayer
From The Copenhagen Haggadah, Altona-Hamburg,
1739. Royal Danish Library, Copenhagen

Lower right:
David carrying Goliath's head
From a manuscript of "Miroir de l'Humaine
Salvation", Flanders, 15th century.
Musée Condé, Chantilly (France)

via this "shaft", climbing up it and thus entering the city. Recent archaeological research has shown that this installation was built at a period later than the time of David; hence this assumption that the city was captured via the water channel has been discarded, and other possibilities have been suggested. For example, according to one interpretation "tsinor" refers to a magic implement in the shape of a large fork, like some seen on Egyptian reliefs – a device to be used in the event of a siege of a city. Another possibility is that Jerusalem was captured by means of some musical instrument which was called a "tsinor". As in the capture of Jericho, the use of this instrument wrought panic among the city's residents, who then resorted to opposing magic, and stationed the blind and lame on the wall as a deterrent: should the attackers attempt to capture the city, their fate would be the same that of the disabled on its walls.

In any case, immediately after the capture of Jerusalem, David turned his attention to construction projects in the city. He strengthened the fortifications of the city and settled in its citadel, even calling it the "Citadel of Zion (which is the City of David)".

Archaeological excavation on the hill of the City of David has exposed a building which David erected in Jerusalem. This building, of which only the lower part remains, exemplifies the use David made of his predecessor's palace, improving it and also laying down a huge foundation stone that reached a height of more than 18 meters. This is actually the most important vestige from the time of David ever discovered in Jerusalem.

David's palace was apparently a most magnificent structure. The Bible (II Samuel, 5:11-12) relates that it was Hiram, King of Tyre, who sent cedars, carpenters and masons to Jerusalem to build a palace for David. The new wives and concubines that David took from among the women of Jerusalem, in addition to those he had brought with him from Hebron, were also housed in this palace.

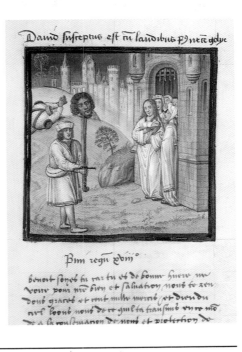

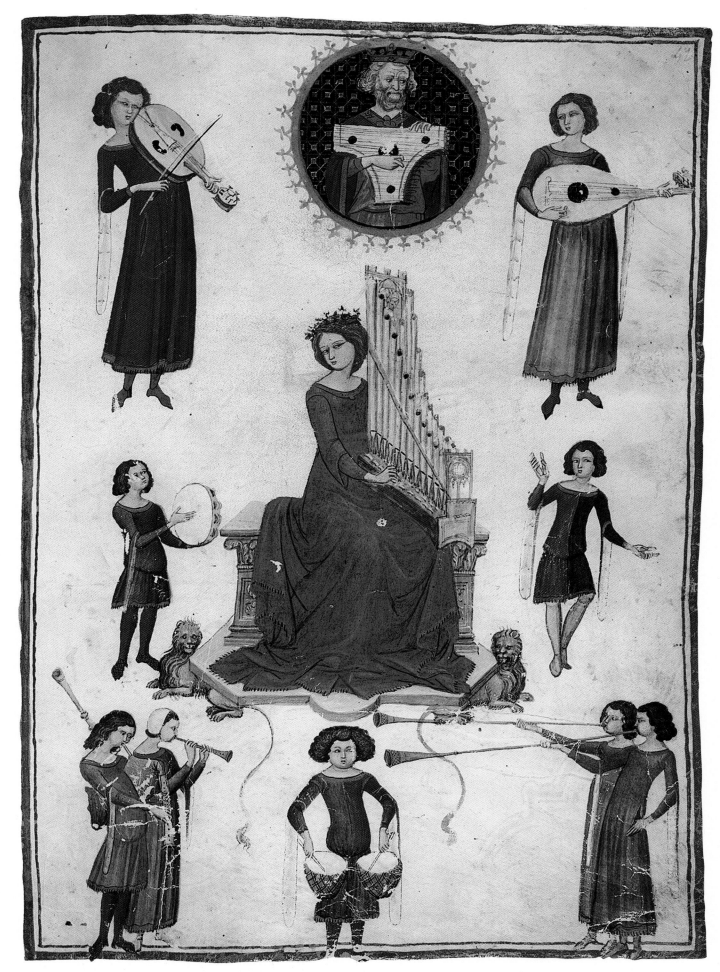

David the Musician, accompanied by musicians playing various instruments, with the Allegory to Music in the center
From a manuscript of Severinus Boetius, "De Musica", Naples, mid-14th century. Biblioteca Laurenziana, Florence

28

Right:
**David calling on the Lord in his distress
(Psalms 118:5)**
*From "The Rothschild Miscellany",
Hebrew manuscript from North Italy (Ferrara?),
ca. 1470. The Israel Museum, Jerusalem*

**King David playing the harp before his
musicians and imperial guards**
*"First Bible of Charles the Bald", Tours, France, 846.
From the Bibliothèque Nationale, Paris*

King David sings the Psalms
*From a Latin manuscript, Italy, 15th century.
Biblioteca Laurenziana, Florence*

Previous pages:
**Scenes from the life of David and the
battle with the Philistines**
*Title-page in a manuscript of the Book of Psalms,
Italy, 15th century. Biblioteca Laurenziana, Florence*

Fortified by the knowledge that his kingdom was established, and that he was still successfully striking at his enemies, principally the Philistines, David decided to bring the Ark of the Covenant to Jerusalem. The Ark was then located at the house of Avinadav on the hill of Kiryat Yearim, and it was brought with great ceremony to the home of Oved the Edomite. The reason for this was that David felt apprehensive that having the Ark of the Covenant in his own dwelling might bring disaster. However, when he saw that the house where the Ark had been placed was prospering, he moved it to his own palace, where it remained until Solomon moved it to the Temple.

David now turned his attention to the greatest enterprise of his life – building the Temple in Jerusalem, but he was not allowed to do this because he was a man of bloodshed, having waged many wars. Nonetheless, the Bible – especially the Book of Chronicles – does not detract from the significance of David's contribution to the building of the Temple. It was David who selected the site where the Temple was to be built. He did this by building an altar to God on the threshing floor of Araunah the Jebusite, the site of Mount Moriah (I Chronicles 21:18). David even took pains to prepare the architectural and building plans for the Temple (I Chronicles 28:11-12). He also brought many laborers and stonemasons to build the Temple. Prior to this (I Chronicles 18:7-11), he had collected spoils of war from Aram and Transjordan, transported them to Jerusalem and consecrated them for use in the Temple.

David also made a treaty with Hiram, King of Tyre, which enabled him to bring building supplies and masons to Jerusalem to build the Temple. The Bible also explains that David prepared everything necessary to build the Temple, although he was unable to carry out the building, because "Solomon, my son, is young and tender, and he must grow up to build the House of the Lord..." (I Chronicles 22:5). It seems that in this way the Bible demonstrates David's participation in the act of building the Temple, otherwise so completely identified with Solomon, showing that David was the initiator, the planner and the supplier of construction materials for the Temple. This activity occupied David almost until his death.

Despite all the data from the archaeological finds, it is still not possible to know what took place on the Temple Mount in the time of David. Herod's huge construction enterprise on the Temple Mount precludes an archaeological investigation of the site. However, regarding the city itself, one can learn that it only extended over the hill of the City of David, and that its expansion to the north, to the Temple Mount, occurred only in Solomon's time.

The greatness of David's enterprise in Jerusalem is recognizable to this day. He succeeded in unifying the city and linking it to his dynasty and to the Temple; that is, in linking the city with God.

King David playing the lute
Initial B in a manuscript of the Book of Psalms illuminated by Girolami dei Libri, Verona, ca. 1550. Victoria and Albert Museum, London

KING SOLOMON BUILDS THE TEMPLE

961-922
B.C. B.C.

*"And the King made silver in Jerusalem as stones,
and cedar trees made he as the sycamore trees that are in the plains in abundance."*
(II Chronicles 9:27)

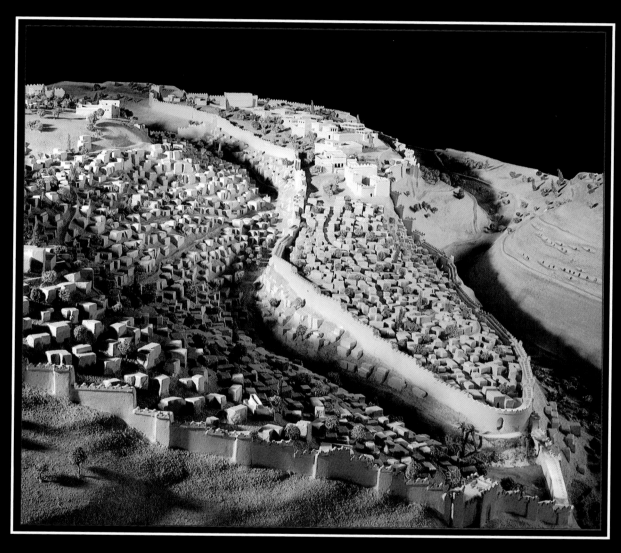

Jerusalem at the time of the First Temple
Model (scale 1:500), Bible Lands Museum, Jerusalem

The construction of the Temple during the reign of King Solomon was an important step in establishing Jerusalem's status. Through this project Solomon connected God with the city. He brought to Jerusalem a priestly family whose function was to serve in the Temple and also to arrange the division of the entire land into districts. Solomon's reign was one of the most magnificently flourishing periods in the annals of Jerusalem, as may be seen in the descriptions of the Queen of Sheba's visit and of the King's great wealth (II Chronicles 9:22).

King Solomon
Detail from "The Judgement of Solomon", Nicolas Poussin (1594-1665), 1649, The Louvre, Paris (page 36-37)

Right:
"Ariel, Ariel" – The Temple as the Dome of the Rock
Mark of the Hebrew printer Hayyim ben Jacob ha-Cohen, Prague, 1604-1612

Solomon began his reign while his father David was still alive. David stood by his side from the outset. "Solomon my son, whom alone God hath chosen, is yet young and tender, and the work is great; for the palace [the Temple] is not for man, but for the Lord God" (I Chronicles 29:1). Solomon was crowned king, and his first act was to go to the great "high place" at Gibeon, which was the main place of worship in the land at that time, since the Tabernacle and the brazen altar made by Bezalel ben Uri stood there (II Chronicles 1:3-5).

King Solomon's major construction project in Jerusalem was the building of the Temple. Solomon approached Hiram, King of Tyre, and asked him to send him cedars as he had done for David, his father, and Hiram also sent him advisors and masons. Solomon was able to build the Temple mainly because David had provided him with the means, the building materials (I Chronicles 29:2-5), and funds which he had raised among the rich (*ibid.*, 9:6-8). Construction of the Temple on Mount Moriah,

on the threshing-floor of Araunah the Jebusite, began after completion of all the preparations.

The above description is taken mainly from the Books of Chronicles, in which there is a strong tendency to attribute many projects to King David. However, there is no doubt that David did indeed prepare the ground for the construction of the Temple and that he groomed Solomon for his role as its builder. When the construction of the Temple was completed, Solomon brought the Ark of the Covenant from "the City of David – which is Zion" (II Chronicles 5:2), and the Temple began to play its role as the House of God (II Chronicles 7:12, 16). The divine blessing did not depart from the dynasty of the House of David, which has been linked with the building of the Temple throughout the generations. Solomon's subsequent enterprises are described in the Book of Chronicles as enlarging the kingdom, strengthening it economically, preparing a fleet in Eilat, and other projects of this kind.

A similar description of the erection of the Temple appears in I Kings, with one difference: David's significant role as a participant in its construction is missing. In I Kings 6:1 we read that construction of the Temple began in the 480th year after the Exodus from Egypt, suggesting that this was the most important event since the Exodus, which was undoubtedly the most significant episode in the history of the Jewish people.

Archaeology cannot offer us any additional data on the Temple. The Mount Moriah area has been built upon several times in the course of history, especially during the time of Herod, when the whole mountain was surrounded by huge supporting walls, the westernmost of which is known to us today as the "Western Wall". With the inclusion of Mount Moriah and its immediate surroundings within the area of the Temple Mount, all vestiges of building prior to Herod's time disappeared. Today, we can only surmise the outlines of the wall around the Temple Mount according to the natural topography of Mount Moriah. It should be recalled that when Herod enlarged the Temple Mount, he deviated beyond the bounds of

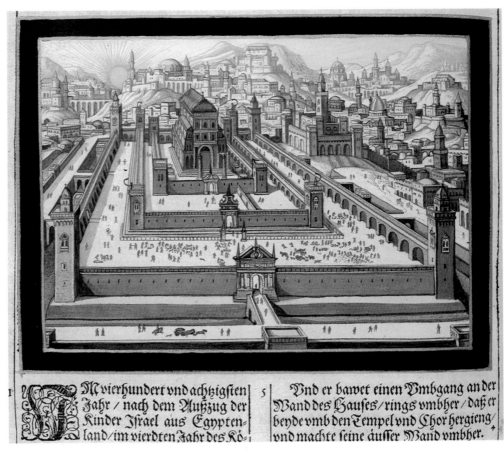

King Solomon's Temple at the height of its splendor
From a printed Bible with colored copper engravings by Matthaus Merian (1593-1650), Strasbourg edition, 1630. Countess of Sponeck Collection, Frankfurt

King Solomon's prayer at the dedication of the Temple
From the Merian Bible, Strasbourg, 1630. Countess of Sponeck Collection, Frankfurt

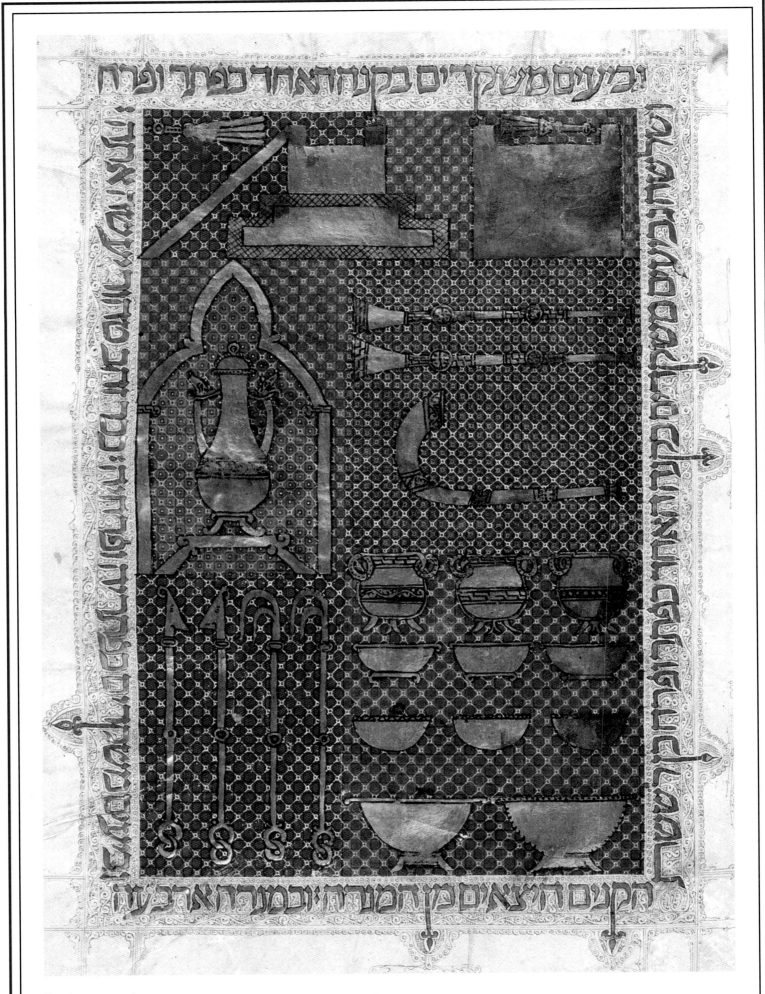

Sanctuary vessels

From a Hebrew manuscript of the Bible, Spain, early 14th century. Biblioteca Estense, Modena

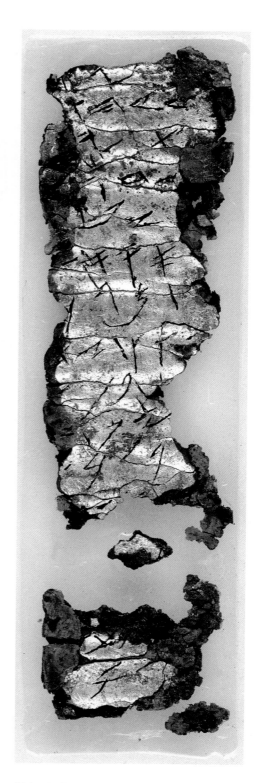

"Priestly Benediction" (Numbers 6:24-26)
*Earliest biblical quotation found. Silver plaque,
Ketef Hinnom, Jerusalem, mid-7th century B.C.
The Israel Museum, Jerusalem*

Mount Moriah, and thus the lowest part of St. Anne's valley, part of the Tyropoeon stream and the slopes of Mount Moriah were filled in. Likewise, the southern part of the Hill of Antonia was quarried and removed, and thus we can only surmise what the boundaries of Solomon's Temple Mount were. The outlines of the wall which surrounded the mountain certainly traversed a uniform line of height. "The Temple Mount" [literally, "the mountain of the House"] is referred to in the Bible by this name only a few times: "The mountain of the Lord's house shall be established in the top of the mountains" (Isaiah 2:2; Micah 4:1). The actual phrase "the mountain of the House" appears in Jeremiah 26:18 and Micah 3:12: "... Zion shall be plowed like a field, and Jerusalem shall become heaps, and the mountain of the house as the high places of a forest". To this day no remnants of this wall have been found.

With the joining of the Temple Mount to the City of David, a large intermediate area remained between these two parts of the city, known as the Ophel. This name, Ophel, can be translated as a height, and in fact this area, which is to the south of the Temple Mount, slopes sharply down to the City of David. During the 1960s, archaeologists working at the northeasternmost edge of the City of David, on the site where David's Citadel had stood, discovered a section of a wall constructed in a manner similar to other sites dating from Solomon's time – a wall comprised of casements. A city wall made in this fashion is actually constructed of two parallel walls which are crossed by intersecting walls that create a series of enclosures or cells. One section of this wall is in fact the most significant remnant from the time of Solomon to be discovered in Jerusalem so far. It may be assumed that this wall completely encompassed the Temple Mount, and included the Ophel within it. Since, as mentioned above, the name Ophel means a height, it seems possible it may have been the first "city", i.e., the area in which the

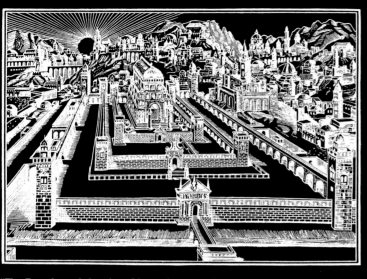

"The Temple and the city of Jerusalem, may it be built soon in our days"
Detail from the Amsterdam Haggadah, 1695

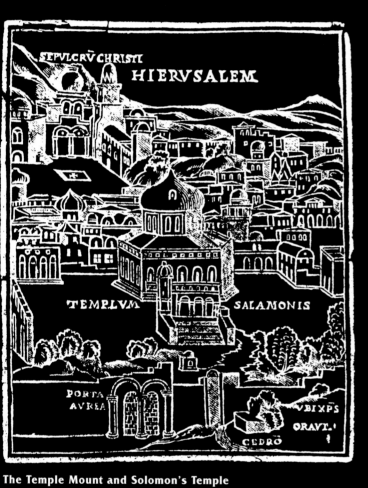

The Temple Mount and Solomon's Temple
From a printed book by the Italian traveller Pietro Antonio, 16th century

The Holy Sites on the Temple Mount and Mount of Olives
Detail from a panoramic view of the Holy Land, by Rabbi Chayyim Solomon Pinia of Safed, 1874-75

Right:
The Judgement of Solomon
Nicolas Poussin (1594-1665), 1649. The Louvre, Paris

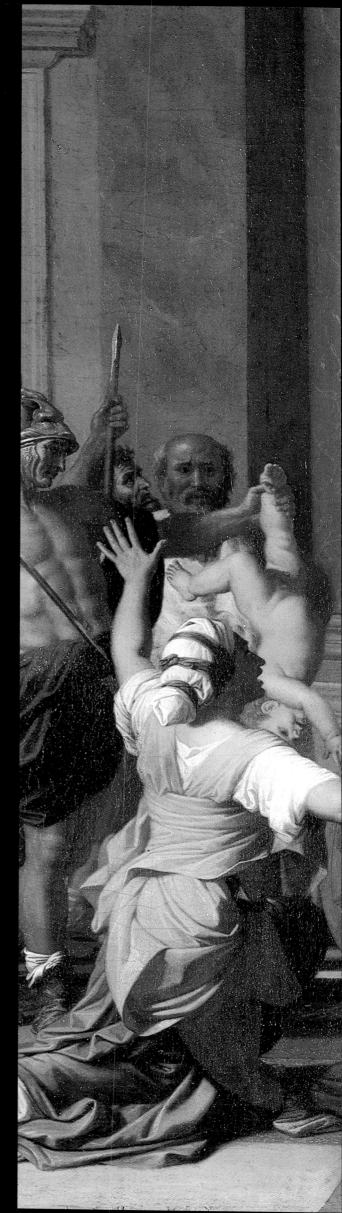

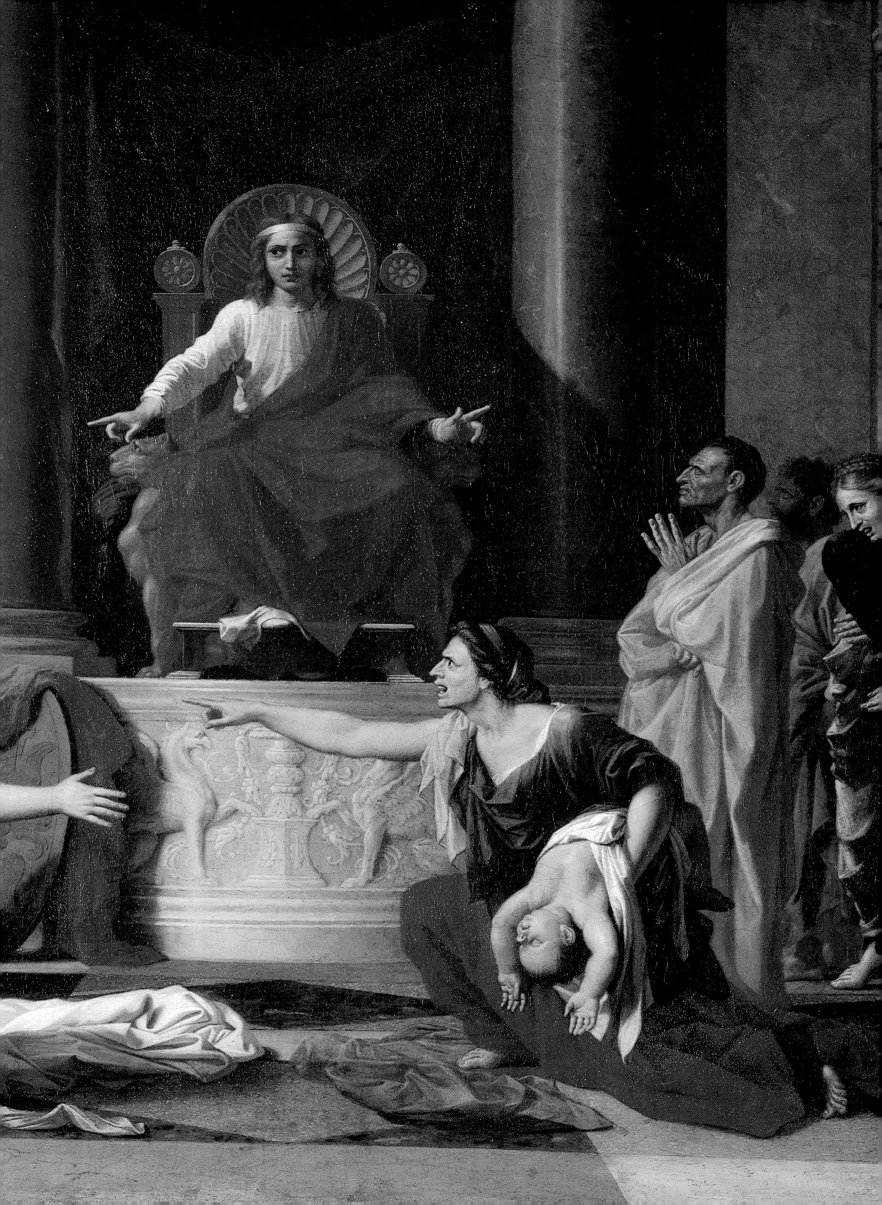

King Solomon reading the Torah
From "The London Miscellany", Hebrew biblical and liturgical manuscript, North France, ca. 1280. British Library, London

"Jerusalem"
Ancient Hebrew inscription on a wall of a rock-cut burial cave near Lachish, Israel, early 6th century B.C.

government buildings were concentrated, as well as the markets dealing mainly in foreign trade, which, according to the Bible, was a very important matter in Solomon's time.

Apart from the Temple, David's palace too stood on the Temple Mount. While we have some data about the Temple, from the detailed biblical description and from knowledge about other temples from the period discovered in Syria, for example, we know very little about the palace. Although we can make some assumptions as to the form of its structure, on the basis of a palace from the time of Solomon discovered at the excavations at Megiddo, we know that the palace in Jerusalem was much more complex than the one at Megiddo. For instance, we know nothing about the "House of the Lebanon Forest", which was one of the most beautiful parts of the palace; and all we can say today is that this part of the palace was very large and that its roof was supported by a row of columns made of cedarwood – hence its name.

A later chapter, in connection with another event in the time of Jehoash, mentions the "courtyard of the horses". We may assume that this courtyard was close to the palace, its form that of stables around a central courtyard, similar to one discovered at Megiddo (from a time slightly later than Solomon's). Furthermore, the home of Pharaoh's daughter, one of the most important of Solomon's wives, was also near the palaces, although because of "the impurity of Egypt", Solomon distanced her quarters from the Temple, which stood north of the palace. Hence we can may assume that her home was situated south of the palace.

The water works known as Warren's Shaft may possibly also be attributed to the time of Solomon. This view is based on the possibility that a similar concept was also executed at Megiddo; and although it is not completely clear in what period it was built, the time of Solomon is undoubtedly a reasonable possibility. A less similar water works, discovered at Hatzor, is dated to a later period than the time of Solomon. Also, since Jerusalem was a renowned capital, it is inconceivable that no solution was found for the problem of water for the city in the eventuality of a siege. The purpose of the water works was to ensure accessibility to a water source, albeit for a limited number of people, even under siege conditions.

Solomon's construction projects added a further dimension to Jerusalem subsequent to David's achievements. The status of God was now finally established in Jerusalem, which was given the name "the place of His Throne" or "the place of the soles of My feet" (Ezekiel 43:7). The dynasty of the House of David was now firmly supported, for it had established the place of God's Temple in Jerusalem. Jerusalem was now established as the capital of the kingdom by the grace of God.

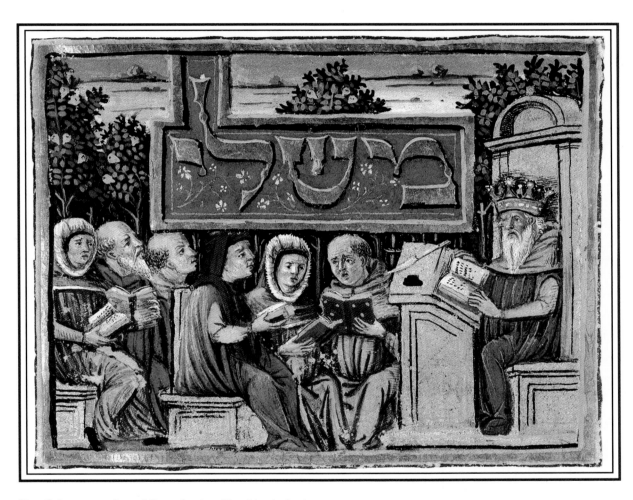

King Solomon, author of *Proverbs*, teaching his students
"The Rothschild Miscellany", initial panel, Book of Proverbs, Hebrew manuscript from North Italy (Ferrara?), ca. 1470. Israel Museum, Jerusalem

3

THE CAPITAL OF THE KINGDOM OF JUDAH

922-332
B.C. B.C.

"Look upon Zion, the city of our solemnities:
thine eyes shall see Jerusalem a quiet habitation."
(Isaiah 33:20)

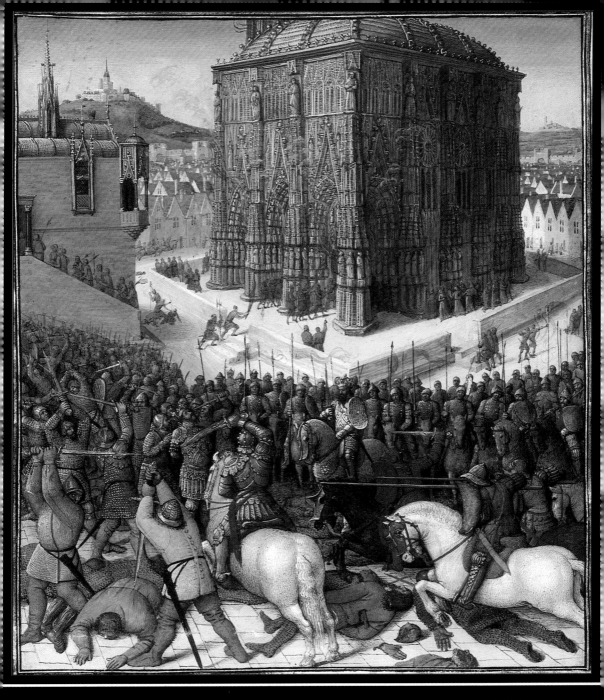

Conquest of Jerusalem by Nebuzaradan, commander of Nebuchadnezzar's guard (II Kings 25:9 ff.)

From a manuscript of Josephus Flavius, Antiquities of the Jews, illuminated by Jean Fouquet, France, ca. 1460, Bibliothèque Nationale, Paris

After the division of David's and Solomon's kingdom into two states, Jerusalem remained a center for only the southern tribes. Only after the destruction of the Kingdom of Israel (722 B.C.) did it become apparent that the inhabitants of that kingdom too continued to see Jerusalem as their political and spiritual capital, and many of them migrated to Jerusalem and reinforced it to a great extent. During the period between the division of the kingdom and the destruction of the First Temple – a span of some 350 years – Jerusalem became established as the capital of the Jewish people, a status it has retained to this day.

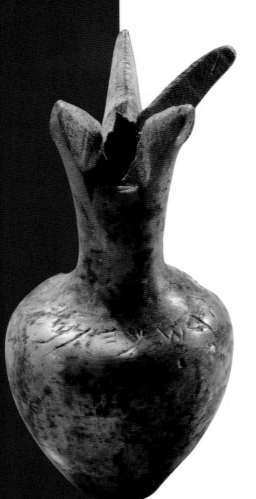

Ivory pomegranate from the top of a priest's staff
Possibly from Solomon's Temple, Jerusalem, ca. mid-8th century B.C. The Israel Museum, Jerusalem

Right:
Reconstruction of pavement in a palatial Jerusalem mansion
The colored stone tiles were discovered in the excavations of the Jewish Quarter in the old city of Jerusalem. Late second Temple period.

Shortly after Solomon's death two events occurred in Jerusalem which seriously affected the city's status. The first was the campaign of Shishak I, King of Egypt (c. 925 B.C.), which injured Jerusalem and the Temple; the second was the division of the kingdom into two states, Israel and Judah.

Archaeological research along topographical lines has invested a great deal of effort in trying to understand the development of Jerusalem in the period between the reign of Rehoboam and the destruction of the Temple. Until relatively recently, two main hypotheses were prevalent among researchers: one approach claimed that Jerusalem had remained a small city until the destruction, extending only over the hill of the City of David and the Temple Mount; the other held that Jerusalem had spread out towards the western hill as well, that is, to that part of Jerusalem where the Jewish Quarter, the Armenian Quarter and Mount Zion are found today. For many years archaeological

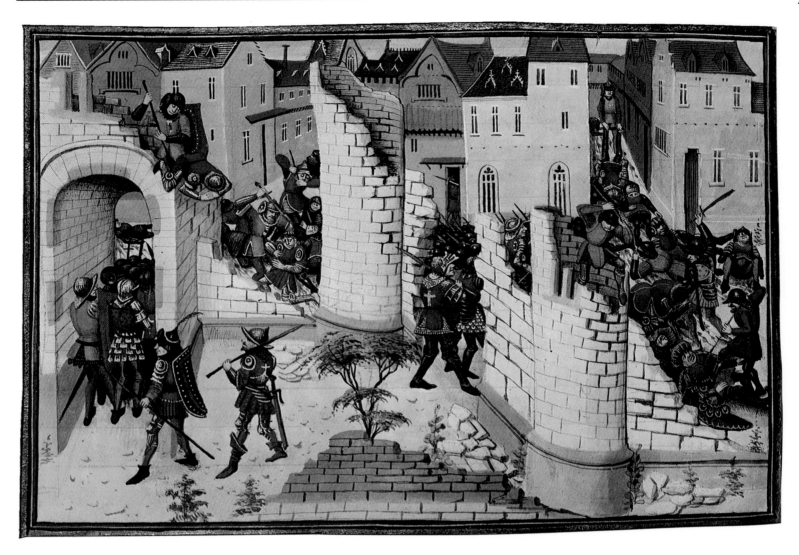

Conquest of Jerusalem
From an illuminated manuscript of Story of the Emperors, France, 15th century.
Bibliothèque de l'Arsenal, Paris

research could reach no resolution of this question. After the Six-Day War, when archaeological excavations began in the Jewish Quarter, the city wall, probably built by Hezekiah, was exposed; it was the broadest wall ever to be discovered in Judah until that time, and it also included the western hill within the city's bounds. This discovery, together with several less impressive ones of sites from this period in the area of the Citadel and possibly also in the area of Mt. Zion, confirmed the view that towards the end of the First Temple period Jerusalem extended beyond the bounds of the City of David and the Temple Mount. The city's growth, which began in the reign of Hezekiah, stemmed from the conquest of Samaria (722 B.C.) by Tiglath Pileser III, king of Assyria. Many of the inhabitants of the Kingdom of Israel were exiled, and of those who remained, many chose to move to the Kingdom of Judah, which retained its independence. Since the memory of Jerusalem as the capital of the entire Jewish nation probably remained strong among the tribes of Israel, for many Israelites moving to Jerusalem seemed a natural thing to do. Furthermore, with the increasing Assyrian pressure on Judah, the coastal cities of Philistia, thriving under Assyrian rule, grew stronger and began to push back the Judean coastal residents, who also inclined to move to Jerusalem. The city, with its narrow bounds, could no longer contain such a large population, and it "spilled over" beyond the city's western wall to the Tyropoeon Valley, and from there up the eastern rise of the western hill. In this manner, a new quarter was created in Jerusalem (the Mishneh, or "secondary quarter", Zephaniah 1:10), which was geographically more convenient to settle than the hill of the City of David.

The main problem with this expansion was that of water resources to supply the city's needs. Indeed, the main advantage of settlement on the hill of the City of David, which was lower than most of its surroundings, stemmed from its proximity to the Gihon Spring and to other water sources. It appears that the city's residents found the solution in a new water source. North of the Temple Mount runs the Beth Zeita valley, (or Bethesda, as the Christians refer to it), which today is known mainly for

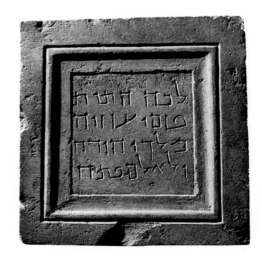

Stone tablet indicating the burial site of Uzziah, King of Judah
Probably found on the Mount of Olives, Jerusalem, 70 B.C. – 70 A.D. The Israel Museum, Jerusalem

Ezekiel's Vision of the Dry Bones
*Detail of a wall-painting in the ancient synagogue
of Dura-Europos, Syria, 244-45 A.D.*

Right:
Nebuchadnezzar's siege of Jerusalem
*"Historic" map by Augustin A. Calmet,
early 18th century*

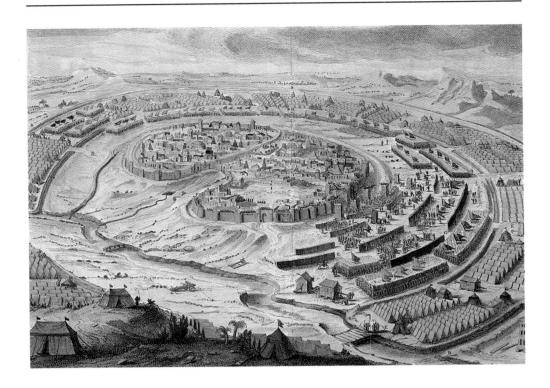

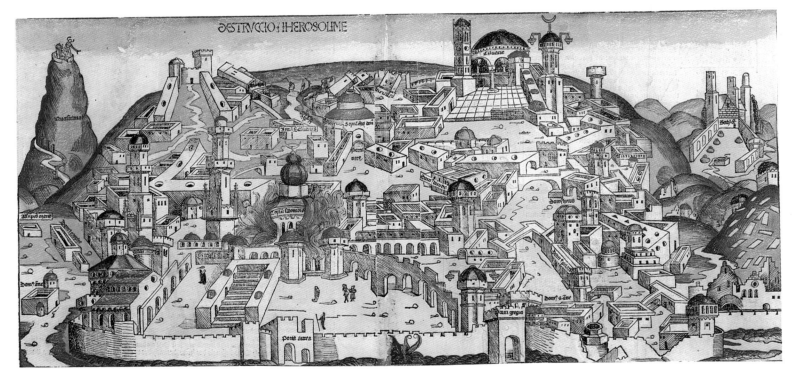

Destruction of Jerusalem
*From Hartmann Schedel's Liber Chronicorum,
printed in Nuremberg, 1493. The Israel Museum,
Jerusalem*

its two pools where livestock were washed before being taken to the Temple. Actually these are one pool, with a large dam separating them into two pools, one slightly higher than the other. Monks of the Order of the White Fathers which owns the site carried out archaeological excavations there during the 1950s, and the important conclusion their work yielded was that the dam separating the two pools was built during the First Temple period, and that from beneath it there also emerged a channel carved in the rock which descended southward. The British archaeologist Sir Charles Warren discovered the continuation of this channel in the Ophel area. It is probable that maintaining the level of this same channel could bring water to the eastern slope of the western hill. This is possibly the channel of the upper pool mentioned in 2 Kings 18:17.

Settlement on the western hill involved yet another problem: the hill had no fortifications. The solution was found by King Hezekiah. When Sennacherib advanced upon Judah (in 702 B.C.), Hezekiah prepared for the imminent siege, and built a broad, strong wall, which, as noted, was recently discovered by archaeologists. According to the Bible (Isaiah 22:10), Hezekiah decided

to build the wall along what he considered advantageous topographical lines, and decreed that it was permissible to destroy private homes and to build the wall through them, if this could improve the wall's defensive capacity. The prophet Isaiah was infuriated by this expropriation of private property, but it later turned out that the wall successfully withstood Sennacherib's siege.

From the description of the construction of the wall it is difficult to determine the area it encompassed. The archaeological findings, too, are not unequivocal, although in recent years most of the archaeologists dealing with the topic are of the opinion that the entire western hill was surrounded by this wall. This means that during the reign of Hezekiah the city included the whole of the western hill ("the "Mishneh"), the central valley with its slopes (the "Makhtesh" [crater, or mortar]), the Temple Mount, the Ophel and the City of David. Relatively to its time, this was a very large city. Some researchers believe the city's expansion did not include the entire area of the western hill but only a part of it. However, it is generally accepted that the city increased greatly in size from that time on. At this point there is no longer any argument as to whether the city extended westward beyond the bounds of the City of David.

Another of Hezekiah's projects was to introduce the waters of the Gihon Spring into the city. Until his time, various devices had been invented for the purpose of regulating the waters of the spring, whose flow was intermittent. We have seen that "Warren's Shaft", which was probably built during Solomon's time, enabled a limited number of people to reach the spring from inside the city and to draw water from it even during times of siege. The wall which surrounded the western hill also included the central valley of Jerusalem ("The Tyropoeon", as Josephus calls it). Hezekiah managed to cut a channel which brought water from the spring through the hill of the City of David to the Tyropoeon Valley, and into the Pool of Siloam, which had existed in this valley from much earlier times.

During Solomon's reign the city had consisted only of the City of David, the Ophel and the Temple Mount. After the division of the kingdom, the situation in the city was extremely bad. Rehoboam, who reigned during this difficult time, failed to improve conditions in the city. Efforts to reinforce the centrality of Jerusalem in the life of the nation began mainly during the reigns of Asa and Jehoshaphat. The former (911-871 B.C.) devoted himself to purging Jerusalem from foreign divinities, but during his reign Jerusalem was faced with a serious adversary, Baasha, King of Israel, who surrounded the city and fortified the Ramah, a town located on the plateau near Jerusalem to the north. Asa requested the aid of Ben-Hadad, king of Aram, who drove Baasha away in exchange for a considerable bribe. Asa used the stones from the Ramah to build and fortify Geva of Benjamin and Mitzpah, which now became the northern border of the Kingdom of Judah.

Asa's son, Jehoshaphat (873-849 B.C.), made an important contribution to Jerusalem by making it the judicial center of Judah. In addition to the system of courts that he set up all over Judah, a Supreme Court was established in Jerusalem, and Jehoshaphat himself adjudicated secular issues brought before the court. Religious issues were settled by the High Priest. Jehoshaphat also attempted to restore Jerusalem's economic glory, and to this end signed a peace treaty with Omri, King of Israel, and established ties with Tyre, with whose

Ezekiel's Vision of the Dry Bones
Detail of a wall-painting in the ancient synagogue of Dura-Europos, 244-45 A.D.

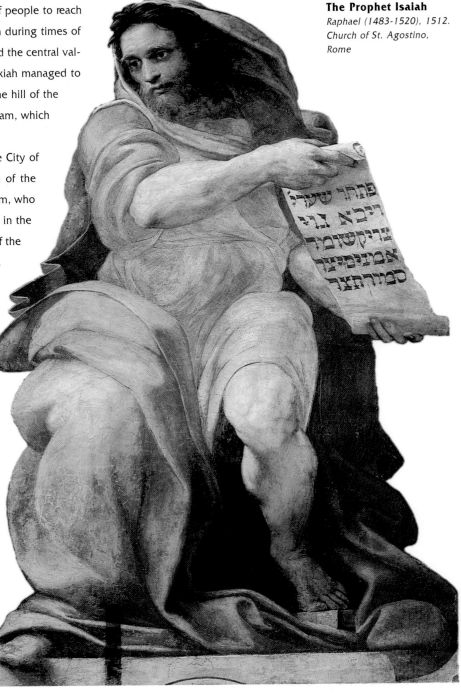

The Prophet Isaiah
Raphael (1483-1520), 1512. Church of St. Agostino, Rome

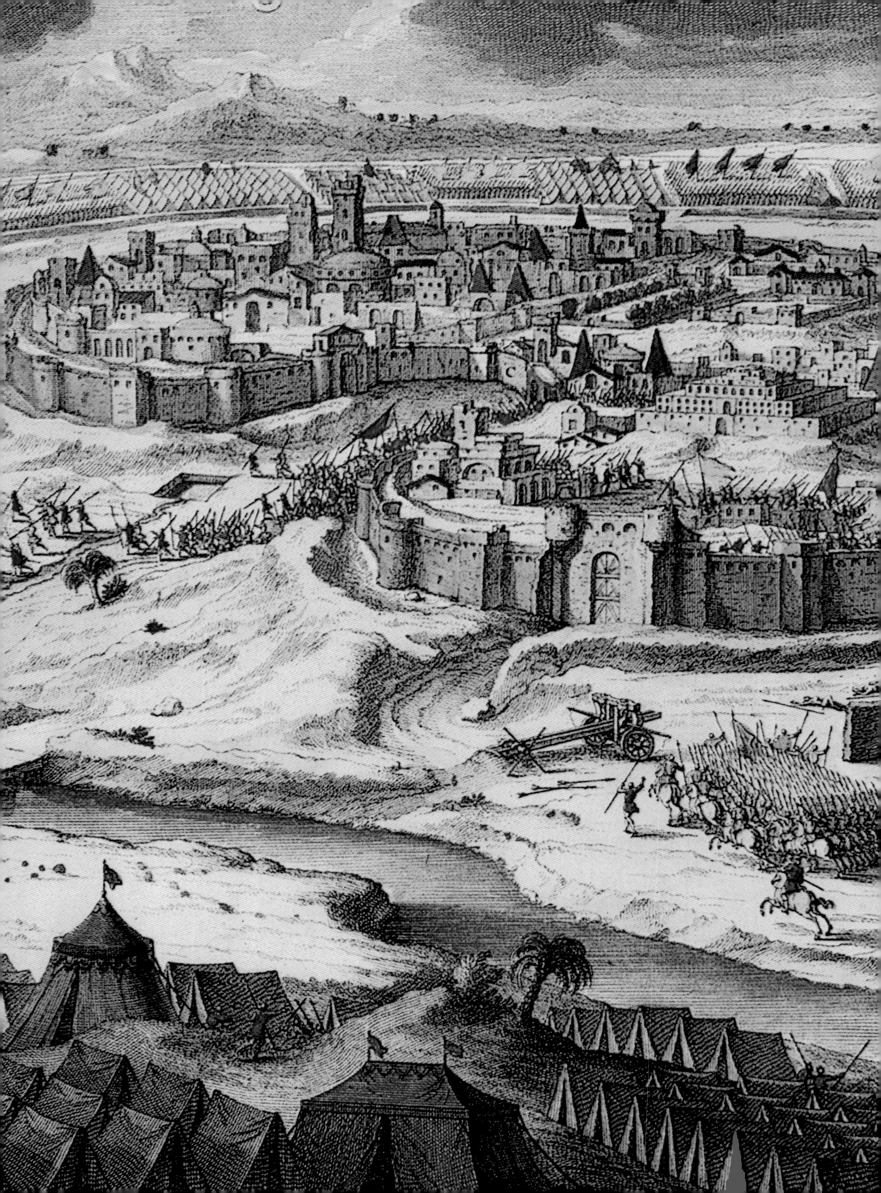

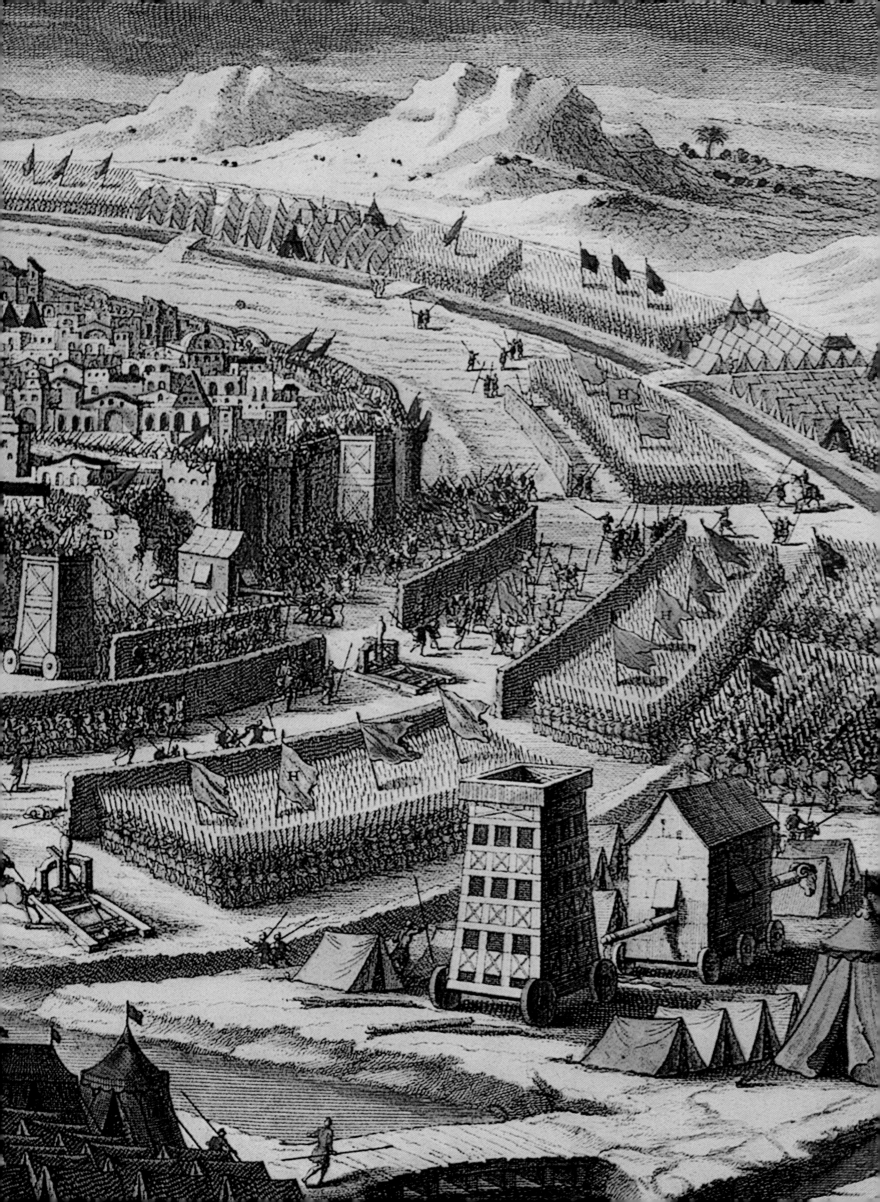

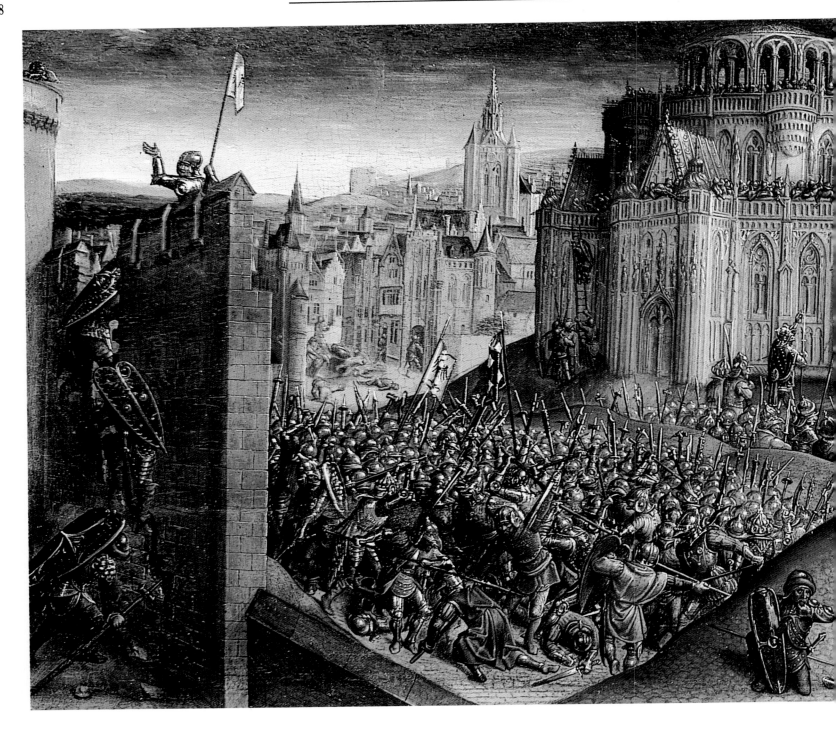

The Capture of Jerusalem
Predella of a Flemish altarpiece, late 15th century.
Museum voor Schone Kunsten, Ghent, Belgium
(detail)

Previous page:
Nebuchadnezzar's army enters Jerusalem
"Historic" map by Augustin A. Calmet,
early 18th century. Kaplan Collection

help he renewed navigation on the Red Sea, which, of course, affected Jerusalem.

The alliance by marriage between the House of David and Athaliah, the daughter of Jezebel and Omri, king of Israel, did perhaps bring the glory of Israel back to Jerusalem, but it also precipitated a grave religious crisis, when a "House of Baal" was built in Jerusalem to compete with the House of God. A rebellion which broke out against the dynasty of the House of David concluded with the crowning of Jehoash, a scion of the same dynasty. It thus appears that even when the kings of the House of David lost favor with the people, it never occurred to the rebels to crown a king who was not of the same dynasty – a fact which also reinforced the status of Jerusalem as the city of the House of David.

The eighth century was a period of physical reinforcement for Jerusalem. Although the city diminished in size, and its walls were breached by Jehoash, king of Israel, during the reign of Amaziah (II Kings 14:13), Amaziah's son Uzziah made a point of improving his foreign relations, secured his rear against the kingdom of Israel, and reinforced his southern border down to Eilat. Again Jerusalem benefitted from these deeds. Its walls were repaired, and towers were built: "And he made clever devices" (II Chronicles 26:15), which scholars believe refer to the construction of crenellations on top

Left:
Stone plaque carved with proto-Ionic capitals
From the Citadel of the Kings of Judah at Ramat Rachel, ca. 7th-6th cent. B.C.

The Mount of Olives in Messianic times according to the prophecy of Zechariah

From the "Saragossa Bible", Hebrew manuscript from Saragossa, Spain, 1404. Bibliothèque Nationale, Paris

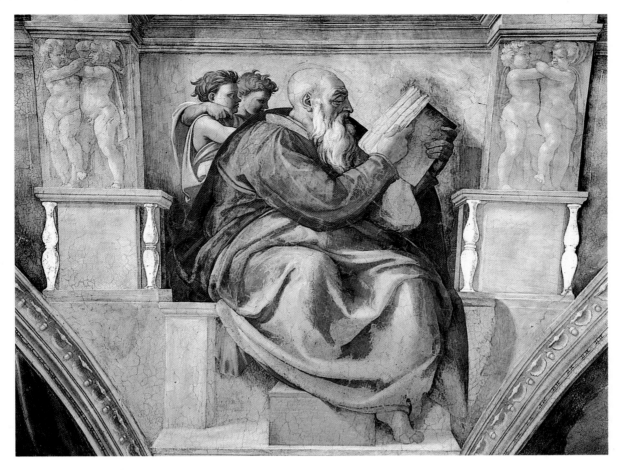

The Prophet Zechariah
Michelangelo (1475-1564), 1509. Sistine Chapel, Vatican, Rome

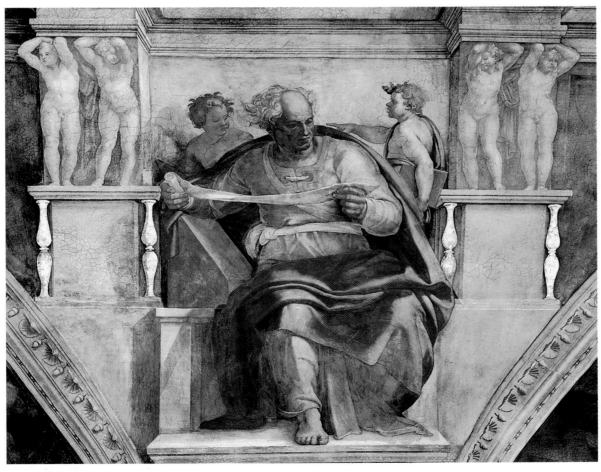

The Prophet Joel
Michelangelo, 1511. Sistine Chapel, Vatican, Rome

of the city walls to make them more effective in case of war against the city. It is worth noting that Uzziah, who in adulthood was stricken with leprosy, was not buried in the Tombs of the Kings, and his body was removed for reburial during the Second Temple period. This fact became known after a stone was found in Jerusalem bearing the following inscription: "To this place have been brought the bones of Uzziah, King of Judah – and do not open [this]" (see picture, p. 43 above).

Jotham, Uzziah's son, also did much to strengthen Jerusalem, adding supplements to the wall of the Ophel as well as "the Upper Gate of the House of the Lord" – an additional reinforcement for the Temple complex.

A recurrent theme during the First Temple period is the struggle between the monarchy and the priesthood in Jerusalem, which increased the power of the Temple and reinforced the feeling that the city was the dwelling place of the Lord and the pride of Judah, without which there could be no existence or continuity for the people.

The picture changes with the conquest of the region by the Assyrians, who made Judah a vassal state. Jerusalem was still a focus of attraction for Judeans and Israelites, who increased the city's population, but Ahaz yielded to the Assyrians and introduced foreign divinities and rituals into the city in the Assyrian manner. The fall of Samaria gave Hezekiah the opportunity to carry out reforms, and he celebrated the Passover holiday with the participation of many Israelites "from Be'er-Sheba to Dan". Hezekiah acted with great enthusiasm to strengthen the Temple in Jerusalem, by abolishing the worship of foreign deities in the kingdom's cities and villages. The pilgrims who came to Jerusalem for Passover also brought gift offerings to the Temple, thus strengthening its status. We have already mentioned the increase in the city's size during Hezekiah's reign.

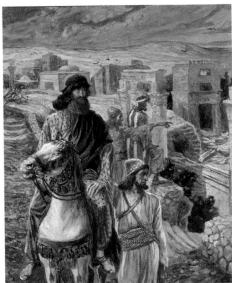

Nehemiah looks upon the ruins of Jerusalem
Probably by a follower of James Tissot (1836-1902), after 1902. Jewish Museum, New York

The reign of Hezekiah's son, Manasseh, was – according to the Prophets and the Bible – one of the most difficult periods in the nation's history. All the reforms which Hezekiah had instituted were annulled. Some think that Manasseh acted as he did because of political problems connected with Sennacherib's campaign, which weakened the cities of his state, and because he thought that if he reinstated the foreign cults in the cities this would help them recover. Even so, Jerusalem's position became strengthened during his reign as well; the only positive act which the Bible attributes to Manasseh is the construction of an additional wall in Jerusalem to reinforce the City of David.

Proto-Ionic Capital
Found in the Citadel of the Kings of Judah, late First Temple period, Ramat Rachel (Jerusalem). The Israel Museum, Jerusalem

The last great king in the history of Judah is Josiah, (640-609 B.C.), who accomplished much in the city. He renovated and restored the Temple and purified the city of the deeds of Manasseh. During this restoration, "The Book of the Law of the Lord by the hand of Moses" was discovered in the Temple, which produced an upsurge of religious feeling among the people.

The final chapter in the annals of the Jerusalem of the first Temple (from the death of Josiah in 609 B.C. to the destruction of the Temple in 586 B.C.), is marked by the figure of the prophet Jeremiah, just as the times of Hezekiah and Manasseh had been marked by the prophet Isaiah. This final period was a politically difficult one: the fall of the Assyrian empire and the rise of the Babylonian empire created political turbulence in Judah and its surroundings. Jeremiah had a great influence on Zedekiah, the last king of Judah, and instructed him to surrender to Babylon and at the same time to carry out social reforms. The king ultimately rejected Jeremiah's counsel in favor of the opinions of his court advisors, and decided on a revolt against Babylon, which resulted in the destruction of the First Temple and the subsequent Babylonian exile.

It was actually during this period of the destruction that a new spirit began to emerge among the people, the spirit of Jerusalem – not of the earthly city, but of the ideal Heavenly city with a distant vision of a Return to it; a vision which was realized only with the proclamation of Cyrus in 538 B.C.

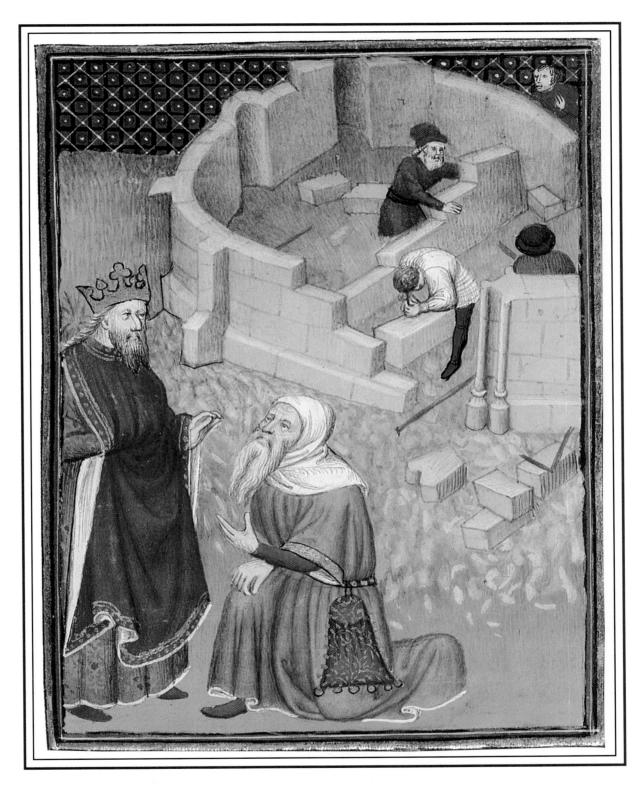

King Cyrus orders the rebuilding of the Temple
From a manuscript of Josephus Flavius, Antiquities of the Jews, France, early 15th century. Bibliothèque Nationale, Paris

GREEK RULE AND THE HASMONEAN KINGDOM

332-63
B.C. B.C.

"When the Israelites captured the land, they established several cities in it, one of which is the most famous of all and is called Jerusalem. Here they also founded a temple which constitutes a center for their worship."
(Diodorus of Sicily, 30-60 B.C.)

Scenes of the Maccabees' Revolt

The Arsenal Bible", Crusader manuscript from Acre (Israel), third quarter of the 13th century, Bibliothèque de l'Arsenal, Paris

of an expanding state. Palaces, magnificent tombs and a city wall containing towers were built in the city, and Jerusalem became the capital to which the eyes of the entire nation were turned.

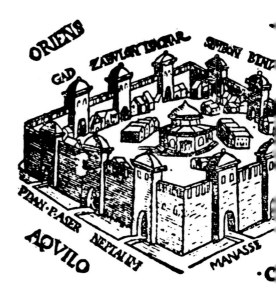

I n the year 333 B.C. Alexander the Great conquered the La

opening a new era in the annals of Jerusalem. Until then, Jerusalem had been a s

Jerusalem and the Land of Israel were included in the domain of the Ptolemaic Kingdom, as one of the three possessions which Alexander the Great bequeathed to his heirs. Sources from the Ptolemaic period tell of construction activity in Jerusalem, but almost no trace of this remains. Thus, for example, we have a description by a Jew from Alexandria who visited Jerusalem, from whom we learn of a large construction operation at the north of the Temple Mount: the capital's citadel, which was being built at that time to defend the Temple Mount and the Temple that stood upon it. The same visitor also described underground water channels which brought water to the citadel. While scholars are convinced that what we have here is a historical document, neither the nature of the buildings nor the period of their construction is clear. The source itself is dated to the beginning of the third century B.C.

The Seleucid wars, and the capture of Jerusalem by the Seleucids in 198 B.C., totally changed the picture. The city began developing more dynamically, since in the framework of the Seleucid state organization, the kings founded new cities or renovated existing ones. Generally, these cities were named Antiochia or Seleucia. Even in Jerusalem a new city was founded. The founding of a new city did not always mean starting from the outset. At times it meant renovating an existing city by introducing new rites or by duplicating the municipal institutions which were the pride of every Hellenistic city. In Jerusalem this also caused internal strife amongst various elements. The main struggle was between those who were inclined to accept the foreign culture with all its diverse characteristics, and the devotees who continued to live by the traditional culture. This conflict led to the rise of the House of the Hasmoneans (also called the Maccabeans). There is no doubt that the creation of Antiochia in Jerusalem was one of the factors which accelerated the outbreak of the "Hasmonean Rebellion" (167 B.C.), which resulted in the establishment of the independent state of Judea.

This phase in the history of Jerusalem also found expression in the city's appearance. At the beginning of this period Jerusalem did not extend beyond the bounds of the hill of the City of David – the city's historical nucleus – and the Temple Mount, which probably remained as it had been since the Return to Zion and the reforms of Ezra and Nehemiah. The Temple became a temple to Zeus and was thus defiled. Its purification by Judah the Maccabee was one of the expressions of the freedom attained by the State of Judea.

This small city began to grow, making the modest parameters of the City of David insufficient for its inhabitants. It appears that even before the outbreak of the rebellion, residents had once again begun to "spill over" to beyond the city walls, towards the central valley and the eastern outskirts of the western hill. This gradual increase in population led scholars to believe that the building of "Antiochia in Jerusalem" was the cause of the new settlement on the western hill, since the planning of the Hellenistic city was conspicuously based on a system of parallel and intersecting streets which crossed each other at right angles.

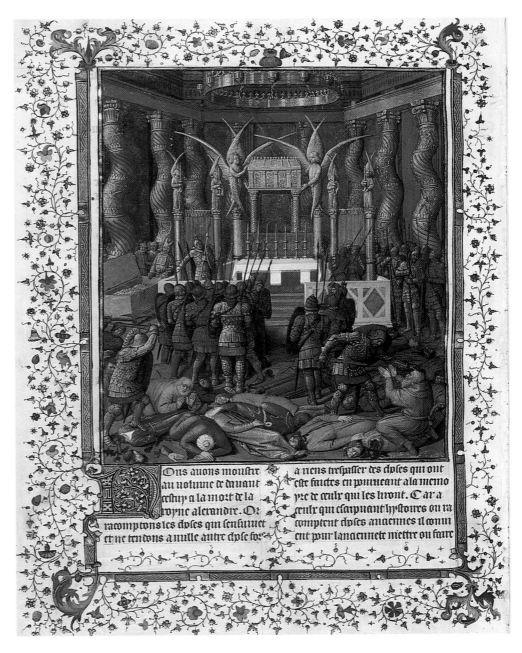

Pompey enters the Holy of Holies in the Temple

From a manuscript of Josephus Flavius, Antiquities of the Jews, illuminated by Jean Fouquet, France, ca. 1460. Bibliothèque Nationale, Paris

Judith holding Holofernes' head (right) and Judah Maccabee (left)

"The Rothschild Miscellany", Piyyut for Hanukkah, Hebrew manuscript from North Italy (Ferrara?), ca. 1470. The Israel Museum, Jerusalem

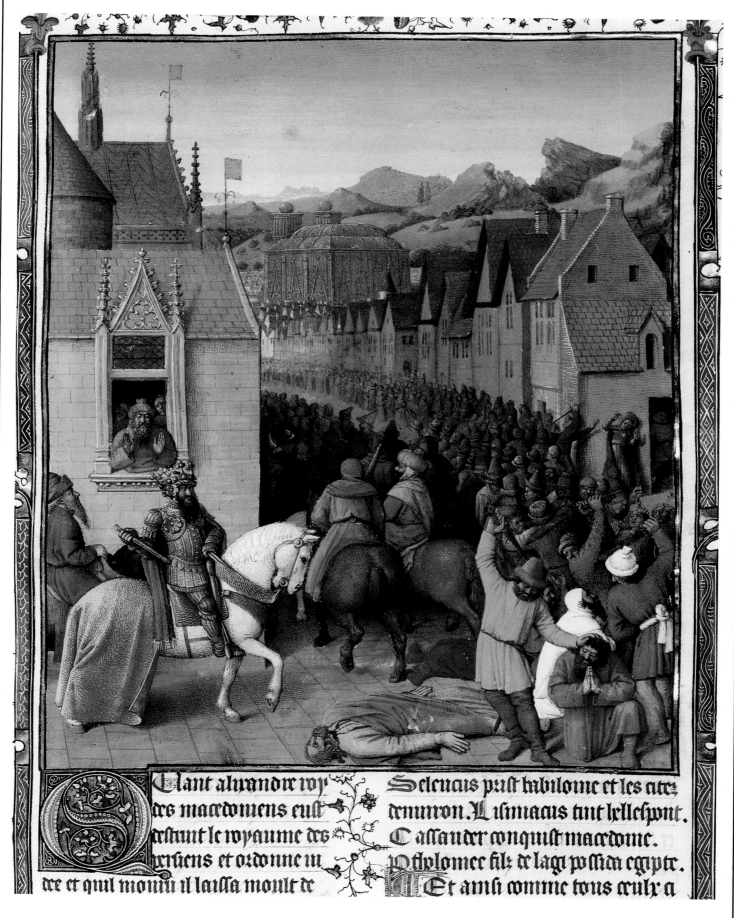

Ptolemy I Soter (or Antiochus) in Jerusalem

From a manuscript of Josephus Flavius, Antiquities of the Jews, *illuminated by Jean Fouquet, France, ca. 1460. Bibliothèque Nationale, Paris*

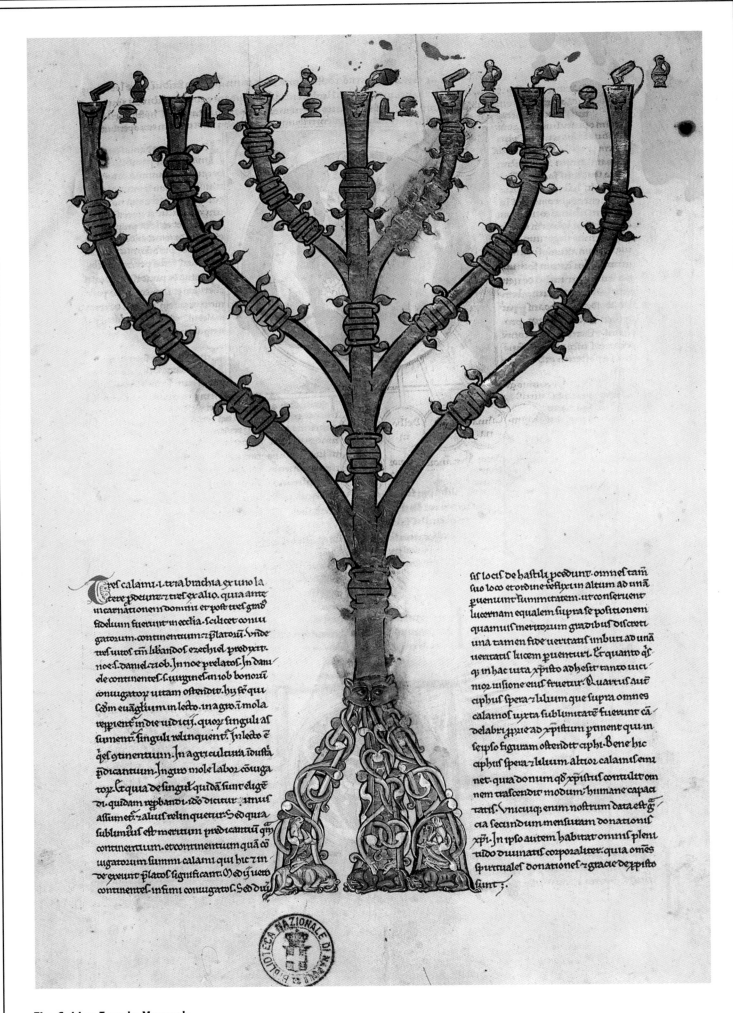

Tref calami .ſ. tria brachia ex uno la
tere pdeunt. ʒ tref ex alio. quia ante
incarnationem dominii er poſt tref gnʒ
ſideliu fuerunt in eccha. ſcilicet coniu
gatorum. continentium. ʒ platou. vnde
tref uirof tm libandof ezechiel predixit.
noe. ſ. daniel. ʒ iob. In noe prelatof. In dani
ele continentes .ſ. uirginef in iob bonorū
coniugatoʒ uitam oſtendit. hy ſe qui
cōm euāglium in lecto. in agro. ʒ in mola
repiient in die iudicii. quoʒ ſinguli aſ
ſument ſinguli relinquent. In lecto e
qeſ ʒtinentium. In agricultura iduſtā
pdicantium. Ingʒo mole labor coniuga
toʒ. ʒ quia de ſingulꝭ quidā ſunt eligē
di. quidam repbandi. ideo dicitur. unuſ
aſſumeʒ ʒaliuſ relinquetur. Sed quia
ſublimiuſ eſt meritum pdicantiuʒ qm
continentium. ʒ continentium quā cō
iugatorum ſummi calami qui hic ʒ in
de exeunt platoſ ſignificant. Medii uero
continentes. infimi coniugatoſ. Sed du

fif locis de haſtili pcedunt. omneſ tam
ſuo loco et ordine reſtict in altum ad unā
puenunt ſummitatem. ut conſeruent
lucernam equalem ſupra ſe poſitionem
quamuiſ meritoʒum gradibuſ diſcreti
una tamen fide ueritatis imbuti ad unā
ueritatiſ lucem puenturi. Et quanto qſ
qʒ in hac uita xpiſto adheſit tanto uici
nioʒ uiſione eiuſ fruetur. Quartuſ aut
ciphuſ ſpera ʒ lilium que ſupra omneſ
calamoſ uixta ſublimitatē fuerunt cā
delabri ꝓprie ad xpiſtum ꝑtinent qui in
ſeipſo figuram oſtendit ciphi. Bene hic
ciphuſ ſpera ʒ lilium altior calamiſ emi
net. quia donum qd xpiſtuſ contulit om
nem tranſcendit modum humane capaci
tatiſ. Vnicuiqꝫ enim noſtrum data eſt gʒ
cia ſecundum menſuram donationiſ
xpⁱ. In ipſo autem habitat omniſ pleni
tudo diuinatis corporaliter. quia omeſ
ſpirituales donationeſ ʒ gracie deʒ xpiſto
ſunt ;

The Golden Temple Menorah
From a manuscript of Petrus Pictavensis, Genealogia Jesu Christi, France, mid-13th century. Biblioteca Nazionale, Napoli

Such municipal planning could only be done on a flat area. It is therefore possible that "Antiochia in Jerusalem" was established on top of the western hill of Jerusalem. Some of the city's important institutions were erected there, such as the gymnasium, the municipal council building and others.

The struggle between the Hellenists and the Traditionalists over the character of Jerusalem also had demographic manifestations. It appears that the municipal settlement on the western hill consisted mainly of Hellenists, while the Traditionalists continued to live in the City of David and on its slopes.

From the very outset of the archaeological excavations on the western hill (where the Jewish Quarter stands today) in 1967, scholars have wondered about the location of the various institutions in the Hellenistic city referred to in the Book of the Hasmoneans and in the writings of Josephus – such as the temple of Zeus, the gymnasium, the city council, etc. The assumption mentioned earlier, that these were all located on the city's western hill, is not a certain one, since archaeological findings have not proven the existence of these buildings there. Kathleen Kenyon, in light of her excavations on and around the hill of the City of David, was of the opinion that the Hellenists constructed a kind of quarter which contained the main public institutions near the central valley ("The Cheesemakers Valley"), approximately opposite the center of the City of David. The archaeologists' hopes that excavations on the western hill (the "Upper City", as Josephus called it) would reveal traces of those buildings ended in disappointment. Today, scholars agree that the temple of Zeus, which is described as a place of ritual revered by the Hellenists, was in fact the Temple on the Temple Mount, which the Hellenists defiled with the foreign rites.

Terracotta oil lamp
Found in Jerusalem, Hellenistic-Hasmonean period (ca. 200 B.C.). Private collection

The archaeological research suggests that during the time of John Hyrcanus I, nephew of Judah the Maccabee, the Upper City was finally annexed to the city which until then had existed mainly on the hill of the City of David. At this time too, the wall surrounding the two parts of the city was built. This is the wall that Josephus called "the First Wall", and scholars today still refer to it by this name. Since the 19th century, archaeologists have exposed the wall section by section, and today we are familiar with almost its entire length. The question of how the wall connected with the Temple Mount is still problematic, since we possess insufficient information about the Temple Mount in that period. The wall surrounded the City of David and the Pool of Siloam at the bottom of the central valley, and ascended up to Mount Zion, encompassing it from the south and west up to the Citadel (the Tower of David) and continuing eastward from there along the Transversal Valley to the area of the present-day Western Wall prayer plaza.

Of the Hasmonean construction almost nothing remains, because Herod's construction projects went deep into the natural rock, erasing almost all traces of prior construction. However, some remnants from this period were discovered during excavations in the Jewish Quarter and at the Citadel, and these attest to the building skills of the House of the Hasmoneans.

The Temple Mount presents us with a unique problem. From various clues in the Book of the Maccabees and the writings of Josephus it appears that the Hasmoneans rebuilt the Temple Mount, replacing what had been built during the Return as a continuation of what had existed in the days of the First Temple. This Temple Mount was square in form, on an area of about 225x225 meters, and covered the entire summit of Mount Moriah. Northwest of the square's center stood the Temple itself. We know almost nothing about the construction of the Temple by the Hasmoneans, but from descriptions in the Book of the Maccabees of the purification of the Temple and its preparation for the worship of God we may infer that a variety of construction works were carried out. Building the Temple Mount involved much effort, because the construction of the immense square required the erection of huge supporting walls. This was a project on a scale previously unknown in the country. The idea of a

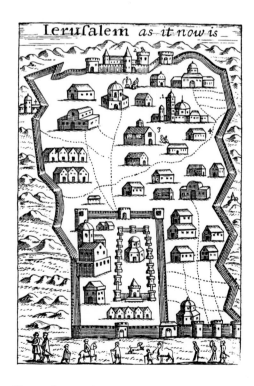

"Jerusalem as it now is"
View of Jerusalem around 1600.
From the English pamphlet "Two Journeys to Jerusalem" (published 1650)

square Temple Mount was also taken up later by Herod, who built the massive structure known to us today.

The Books of the Maccabees do not describe details of the construction, but from various sections of it we may learn that the Hasmoneans were indeed among the great builders of the Temple and of the Mount upon which it stood. Since Herod's constructions covered the entire Temple Mount, all our knowledge about the Temple Mount during the Hasmonean period is essentially conjecture, based on detailed descriptions in the Mishnah, (the tractate Middoth ["Measurements"]).

The location of the Kra Citadel which was built in Jerusalem constitutes an exceptional problem. The Seleucid commander Bacchides built this citadel as an observation post to supervise the approaches to the Temple Mount and its surroundings. To this day its exact location is not precisely clear, but most scholars agree that it was close to the southeast corner of the Temple Mount. Even if this is so, the chances of finding any traces of the citadel are very small, for Simon the Hasmonean, who captured it in 143 B.C., went on to destroy it completely, and even cut down and lowered the hilltop on which it had stood. He did this to ensure that it would never be fortified again and used against the nearby Temple. According to Josephus, the Temple Mount was connected to the Upper City by a bridge which was destroyed when Pompey captured the city in 63 B.C. It is possible that remnants of this bridge exist to this day under a street from the times of the Herodian dynasty that runs along the length of the Western Wall.

A characteristic example of Herod's attitude to the buildings erected by his predecessors has been found in the Citadel excavations. Here, near the First Wall, a residential quarter containing a street with houses along both sides was discovered. When King Herod decided to transform the area because he was building his palace nearby, he made use of an unusual tactic: he destroyed the roofs of the houses and filled the houses with earth. In this way he created a huge platform upon which he built a new street, which also had houses along both sides, although these stood in different alignment to those that had previously stood there. During excavations in the Jewish Quarter, a gate – the only one so far – was discovered at the First Wall, in the place where the Cardo was later built.

The Hasmoneans were probably also responsible for installing the water works that brought water from Solomon's Pools to Jerusalem. The project appears to have been carried out by Alexander Janneus, although this remains to be clarified. In this period, too, the large cemetery on the Mount of Olives began to develop, and the monument known as Zachariah's Tomb was probably carved during the Hasmonean period.

The Hasmoneans' palace, "The Baris", was probably built by John Hyrcanus I (Antiquities of the Jews, 18:91). The Hasmoneans occupied this palace until they built another one in the Upper City opposite the Temple Mount. Just prior to the destruction of the Second Temple (70 B.C.), Agrippas II dwelt in this new palace.

However, disputes within the Hasmonean family – also between the two sons of Alexander Janneus, John Hyrcanus II and Judah Aristobulus – ultimately brought Pompey the Great to Jerusalem, thus hastening the end of Judean independence.

Pagan sculpture of a head with a laurel wreath
Eretz-Israel, Hellenistic period.
Reuben and Edith Hecht Museum, Haifa

Messianic Jerusalem
From the Hebrew book "Thrones of the House of David", printed in Verona, 1646

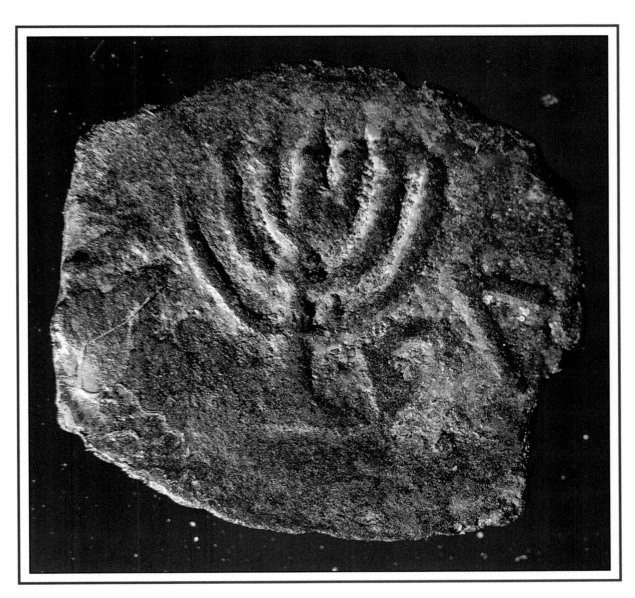

Hasmonean bronze coin with an early representation of the Menorah
Struck by the last Hasmonean ruler, Mattathias Antigonus, Judaea, 40-37 B.C. The Israel Museum, Jerusalem

HEROD'S CAPITAL: THE CITY AT ITS MOST MAGNIFICENT

63-70

B.C. A.D.

"The rest of Judea is divided into local governments [...]
and the district which once included Jerusalem, since the beginning of time the most
famous city in all the East, and not only in Judea."
(Pliny, 70 B.C.)

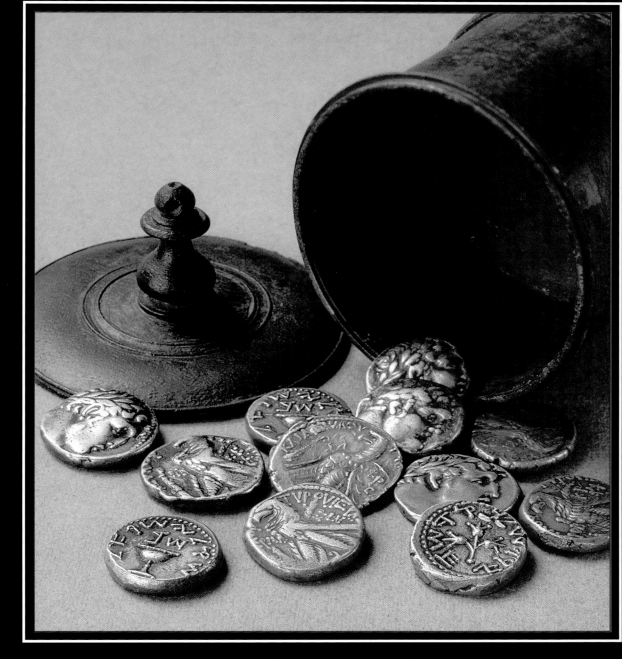

Hoard of coins from 66-70 A.D.
Found in Siloam, Jerusalem. The Israel Museum, Jerusalem

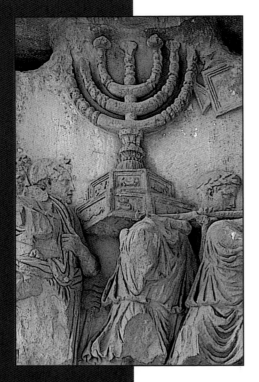

The Gold Menorah in the triumphal procession of Titus in the streets of Rome
Arch of Titus, Rome, ca. 90 A.D.

Right:
Decorative gable of the "Tomb of Jehoshaphat"
Kedron Valley, Jerusalem, 1st century A.D.

When Herod ascended the throne, Jerusalem was still encompassed by the "First Wall", inside which were the Upper City and the City of David. During his reign, the city grew extensively. He added the "Second Wall" and erected many buildings within its bounds.

His crowning achievement was the reconstruction of the Temple Mount and the Temple, as well as the construction of magnificent residential neighborhoods.

Herod's grandson, Agrippas I, continued the construction of public buildings in the city, and also built the "Third Wall".

All these construction projects brought Jerusalem to its height of attainment in the artistic and municipal spheres, and of its importance as a center for the nation.

During this period, Jerusalem reached the height of its development, to a point reached again only in the 19th century, when Jewish settlement spread beyond the confines of the Old City.

Pompey's conquest in 63 B.C. caused some destruction in the city, although the Upper City was surrendered to Pompey by the supporters of John Hyrcanus, and the war was fought mainly on the Temple Mount – which was breached probably on the Day of Atonement in 63 B.C. The last Hasmonean rulers were by then too weak to revitalize life in the city.

In 40 B.C. the Romans crowned Herod King of Judea. A struggle for power began between Herod and the Hasmoneans, which ended with Herod's victory in 37 B.C. The king also married Mariamme the Hasmonean and thus became part of the royal house and a legitimate heir to the throne.

During the reign of Herod, as stated, Jerusalem reached the height of its development. It was Herod who turned Jerusalem into the city of which it was said that of the ten measures of beauty sent

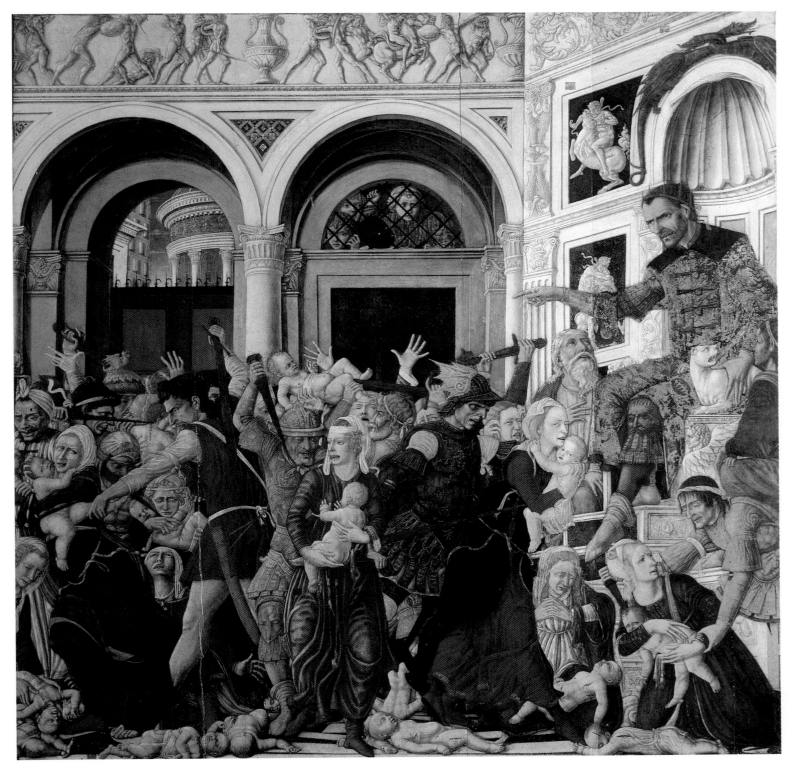

down to the world, Jerusalem took nine and the rest of the world took the remaining one. Herod was motivated by the aspiration to immortalize his own name, and sought to do this by endearing himself both to the Jews, and, through his predisposition toward the Hellenistic-Roman culture, to his Roman masters, in whose name he ruled Judea. His immense economic success increased his assets. Until Herod's time, Jerusalem had consisted mainly of the Upper City, the City of David and the Temple Mount, but now, Herod's great works could be seen in every part of the city. The major project of his very active life was the rebuilding of the Temple Mount and the Temple that was situated there. These formed the center of Jerusalem's political, economic, social and religious life, and Herod saw this undertaking as his opportunity to win over the hearts of the people. The Midrashic saying, "He who has not seen Herod's building has never seen handsome building in his life" (Baba Batra, 4A; Sukkah, 51B), attests to Herod's great success.

We have already learned that it was the Hasmoneans who first built a square Temple Mount

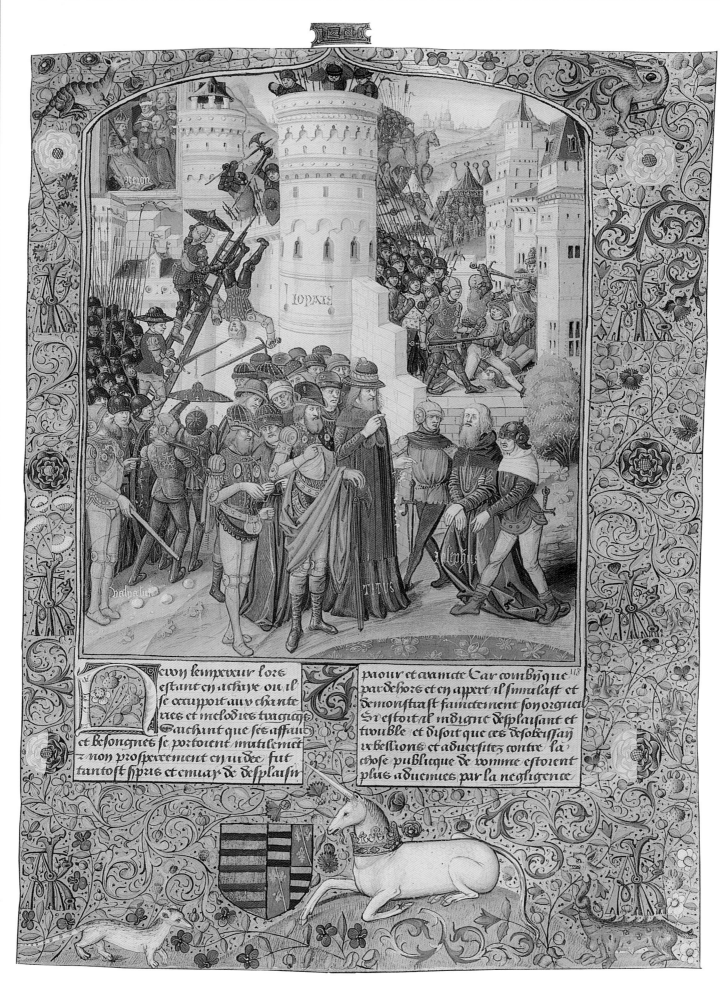

Nero sends Vespasian to fight the Jews; Capture of Jotapata; Josephus Flavius falls into captivity

From a manuscript of Josephus Flavius, Wars of the Jews, France, late 15th century, Musée Condé, Chantilly (France)

(approximately 225 X 225 meters) on Mount Moriah, the construction of which required the erection of supporting terraces. Herod, who thought it fitting to enlarge the structure, both in order to propitiate his subjects and to create room for the tens of thousands of pilgrims visiting the city, decided to increase the area of the Mount. Today it is about 480 meters in length and its width ranges from 290 meters in the south to 320 meters in the north, so its dimensions have increased considerably. Archaeological studies have shown that the extensions were carried out in the north, the south and the west. In the east, probably because of the extremely steep incline of the mount towards the Kedron Valley, it was next to impossible to extend the area, and the original Hasmonean colonnade remained here during Herod's reign as well. Because of its antiquity it was known as "Solomon's Colonnade", since its construction was attributed to King Solomon.

The extension of the Temple Mount was an immense and unparalleled undertaking, since Herod had to annex external areas to it. The areas which were lower than the Mount had to be filled in, and the areas which were higher (to the north) had to be cut down and removed in order to create a huge level surface, 14.4 hectares in area. Herod filled in two valleys encircling Mount Moriah, and built huge supports, which in some places rose to a height of more than 70 meters. This construction project was probably one of the largest in the world at that time.

Tile inscribed with "Legio X Fretensis" – the name of the Roman legion which destroyed Jerusalem
Studium Biblicum Franciscanum, Jerusalem

According to Josephus, Herod began building the Temple in the 18th year of his reign, probably in 19 B.C. Josephus says that the construction took six years, but the New Testament (John 2:20) says it lasted 46 years. The latter duration is probably the correct one, because when Herod's grandson came to the throne (41-44 A.D.) the construction work was not yet completed and it was necessary to repair the eastern colonnade (Antiquities 20:219). From the archaeological excavation along the length of the Western Wall we learn that its construction was in fact never completed. Porticoes were erected around the Temple to provide resting space for the many pilgrims who came to

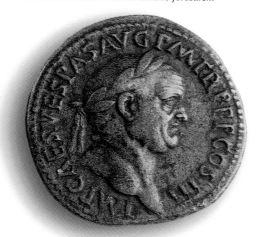

"Judaea Capta" coin with head of Roman Emperor Vespasian
Struck in 71 A.D., following the crushing of the Great Revolt against the Romans and the destruction of the Temple. The Israel Museum, Jerusalem

Jerusalem and could find nowhere to stay. According to various accounts from this period, houses in the city were rented out to pilgrims, but there was still insufficient space for them all. However, no-one said "There is no space for me to stay in Jerusalem". It appears that the problem was solved by Herod's construction projects in the city, which also added new residential quarters.

The most magnificent of the porticoes was the southern one, which was known as "The Royal Portico". This structure was built to serve as a center for civic life, and contained the court of justice, a place for public debates on municipal matters, and so on. It also expressed Herod's desire to glorify one structure even more than the Temple itself, to which access was denied to him.

The area that Herod added to the existing Temple was not considered entirely sacred, and entry to it was permitted to Gentiles as well. Between the two areas, the Hasmonean and the Herodian, a stone wall was erected with inscriptions on it, alternately in Greek and in Latin, prohibiting the entry of Gentiles into the sanctified area and warning trespassers of punishment by death. Because of the unusual topography of the Temple Mount, the approach to the Temple itself necessitated ascending a staircase to reach it. The enclosure comprising the staircase, the area above it, and the wall, was called the "Chel". If science succeeds in determining the exact location of this enclosure, this would be a major achievement which would enable scholars to determine once and for all the exact location of the Temple.

Today scholars agree that the Muslim Dome of the Rock is located on the site where the Holy of Holies stood. This conjecture is plausible not only for topographical reasons (since it is the highest point on the Temple Mount), but also because of testimonies by pilgrims and the Christian Church Fathers.

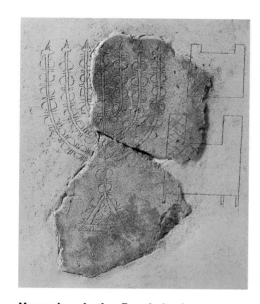

Menorah and other Temple implements
Incised on plaster of a house wall found in the Jewish quarter of old Jerusalem, Herod's time, ca. 40-48 A.D. The Israel Museum, Jerusalem

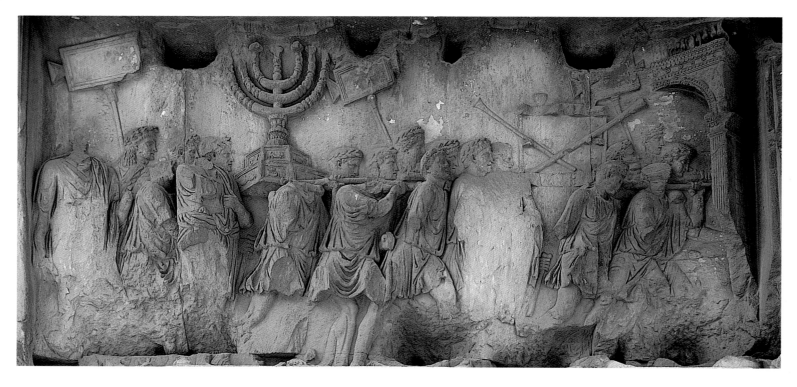

The procession of the spoils of the Temple in the streets of Rome
Arch of Titus, Rome, ca. 90 A.D.

View of the Temple
From a Yiddish translation of Sepher Josippon, printed in Basel, 17th century

The eastern entrance to the Temple, "The Beautiful Gate", is mentioned in Christian sources as the site where Jesus' disciples, Peter and John, performed the miracle of the beggar's recovery. This was probably the gate giving access to the "Court of the Women", located in the eastern forefront of the Temple. Women were permitted entrance to this area, which was the closest point to the Sanctuary. A staircase led to the "Court of Israel" (for non-priestly worshippers), the smallest of the courts (11 x 135 cubits), which was separated from the "Court of the Priests" either by wooden beams or by the difference in height between the two chambers. In the "Court of the Priests" (135 x 187 cubits), which surrounded the Holy of Holies, there were various chambers. To the front of the structure housing the Holy of Holies stood the altar, on the left, and the tables on which the sacrificial meat was prepared, on the right. We do not know what was inside the Holy of Holies, and even the Sages, who pondered much on this subject, were unable to resolve this question.

It is clear, however, that the sacred structure was most magnificent. Herod spent a long time on its construction. It was painted white "as the snows of Lebanon" and its beauty could be seen from afar. All the subterranean passageways that Herod built leading to the Temple Mount have remained intact. To the south he constructed two passageways which are known today as "The Double Gate" and "The Triple Gate", in which traces from Herod's reign remain to this day.

Josephus also described the four western gates of the Temple Mount. It is clear that these are identical to those known to us presently by the names given to commemorate their first modern discoverers: Robinson, Barclay, Wilson and Warren. The street which ran along the length of the Western Wall is well known to us. It was first discovered in the 19th century in a shaft excavated by the English archaeologist Charles Warren under Wilson's Arch. Warren broke a few of the paving stones in the shaft in order to expose the foundations of the Western Wall, and discovered both the street and the stones of the archway which had existed prior to the one known to us today as Wilson's Arch. A section of the street, with its large paving stones and its western margin, was exposed in the excavations of the Western Wall. The street began in the south with a few stairs which led to it from the street running along the length of the Southern Wall. From there it ascended northward to the point where its construction had been halted, just as construction of the Western Wall had been discontinued, probably after Herod's death. The extremely large and well-hewn paving stones give us some indication of the magnificence of the building in this street. In the northern part of the street two columns were also found, and it is probable that here the street met a city square. According to Josephus, this area housed the city's store-

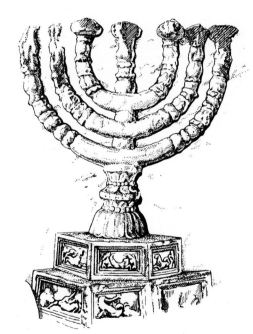

houses, as well as its markets and workshops, which were generally arranged around the city squares.

North of the Temple Mount towered the city's largest citadel, the Fortress of Antonia, which became very famous in the Christian world, since tradition has it that it was here that Pontius Pilate conducted the trial of Jesus. Earlier there had been another citadel in the same area, the Baris [Habirah], which had served as the palace of the Hasmonean rulers. This citadel was completely destroyed in the course of the changes wrought by Herod on the Temple Mount. All that remains of it today is the rock on which it stood, hewn on all sides so as to totally prevent any possibility of penetrating the citadel. The function of the Fortress of Antonia was to protect the Temple Mount from the north. This became clear during the siege of Jerusalem, when the Romans attacked the Temple Mount from the direction of this fortress, and only succeeded in capturing the Mount after taking the fortress.

The triumphal entrance of Titus in his Imperial quadriga, commemorating the victory in Judea
Arch of Titus, Rome, ca. 90 A.D.

It is worth pausing over "David's Tomb", which has given rise to many questions. Josephus referred to this area as "Zion". According to the Bible, too, the tombs of the House of David were housed in Zion. It is no wonder, therefore, that Josephus mentions David's Tomb in this context. This tomb played an important role in the city's history. According to Josephus, the tomb was very well known, and John Hyrcanus I penetrated it to take silver from there. He used this silver to bribe Antiochus to raise the siege he had placed on Jerusalem. Later, Herod broke into the tomb to remove other treasures (aside from the silver, which had already taken by Hyrcanus) to finance his great construction works. Josephus recounts that the shame Herod felt over this deed led him to construct a large and beautiful monument at the site – and this monument was still standing during Josephus' time. It is therefore clear to us that at some place on the mountain Herod built a monument to mark the site of David's Tomb. At present we do not know where this was, but some scholars are of the opinion that the David's Tomb of today indicates the location of the monument referred to by Josephus.

Relief of the Temple Menorah
Based on the Arch of Titus

The most important structure that Herod built in the Upper City was his own palace. As heir to the Hasmonean royal house (having married Mariamme the Hasmonean), Herod at first lived in the new palace of the Hasmonean kings which had been built in the area where the Jewish Quarter of today is situated. Josephus describes Herod's palace as most magnificent, and from his account we learn that the palace was divided into two wings. One was called the Caesarion, after Julius Caesar, and the other the Agrippion, after Herod's Roman friend. The archaeological excavations conducted in the Armenian Garden of our day have revealed only remnants of walls of the supporting structure upon which the king built his palace.

In order to protect the palace at its weak point – its north – Herod embarked upon an additional project, on which Josephus lavishes high praise: the construction of three huge towers on the section of the wall adjacent to the tower at the north of the palace. Archaeological excavations have revealed that in this section of the "First Wall", towers had already been built by the Hasmoneans. When Herod became aware that there was a weak spot there – primarily due to the topographical weakness of this section – he decided to erect three mighty towers on this spot. Herod named the towers after people close to him: his good friend Hippicus; his brother Phasael, who was killed in a battle to seize the throne; and his beloved wife, Mariamme. Of the three towers, all that remains today is the base of one of them, the Hippicus Tower. It was in the Byzantine era (probably around the 5th century) that this important remnant began to be known as "David's Tower", the same name we know it by today.

Excavations carried out at the citadel have exposed the "First Wall" and, inside and abutting the city, a small residential quarter which was first built by the Hasmoneans and later renovated and improved beyond recognition by Herod.

Although the question as to whether Herod extended and fortified the entire area of the city cannot be resolved beyond doubt, the answer does seem clear. It is difficult to believe that Herod did not enlarge the city. Although very few remnants of the "Second Wall" have survived and our knowledge of its course is most meager, one vestige – a small section of a tower or perhaps a gate-tower, discovered near the Damascus Gate – may have been part of this wall. Here, remnants of a wall built of stones from Herod's time were found. Josephus described the "Second Wall" and mentioned its extremities at the Fortress of the Antonia and the "Genneth Gate" in the "First Wall", but we have no proofs as to the actual course of the "Second Wall". Christian scholars have also deliberated a great deal about this wall, because it was the northernmost wall of the city during the time of Jesus, and its course is decisive for the credibility of the claim that the Church of the Holy Sepulcher stands on the site of the crucifixion and the burial of Christ. It is clear that in Jesus' time, the site would have had to be outside the city – that is, beyond the "Second Wall", but as long as the course of this wall is uncertain it is impossible to prove the

Cast of the top of a stone vessel incised with two doves and the Hebrew word KORBAN ("sacrifice")
Found in excavations at the Wailing Wall, Jerusalem, Herodian period. The Israel Museum, Jerusalem

Three bricks from Jerusalem stamped "Legio X Fretensis", the legion which destroyed Jerusalem
Reuben and Edith Hecht Museum, Haifa

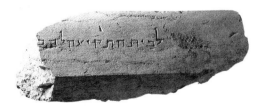

"To the place of trumpeting..." – Hebrew inscription from the southwestern corner of the Temple Mount
Jerusalem, Herodian period. The Israel Museum, Jerusalem

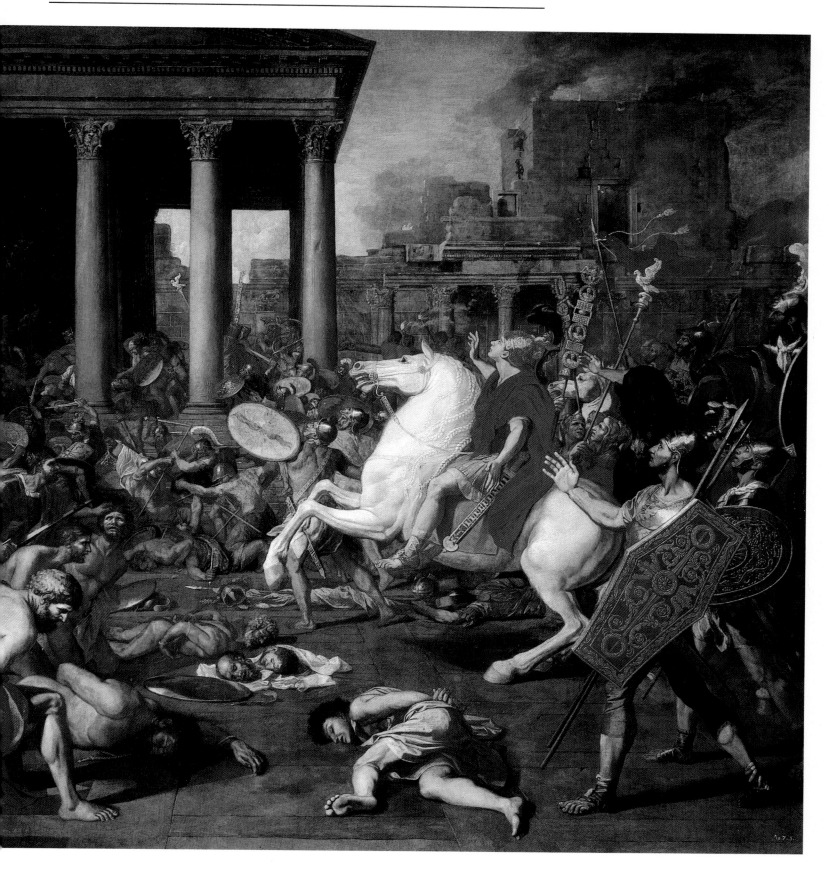

Titus in front of the destroyed Temple
Nicolas Poussin (1594-1665), 1638.
Kunsthistorisches Museum, Gemäldegalerie, Vienna

authenticity of the Church of the Holy Sepulcher. Following renovations to the Church which necessitated an archaeological examination, it was discovered that there are several burial caves at the site dating from the Second Temple period (the 1st century A.D., i.e., from the time of Jesus). Therefore it is possible that Jesus was indeed buried at this site.

If indeed it was Herod who built the "Second Wall", then it appears that he took care to encompass that part of the city where the markets, workshops and storehouses were concentrated.

Among the most important artistic remnants from this period we should note some of the magnificent tombs in the burial fields that surrounded the city. The most important of these are,

Jewish Ossuary
Jerusalem, 50 B.C. – late 1st century A.D.
Private collection

of course, the tombs that were carved out in the Kedron Valley: Absalom's Tomb, Benei (the family of) Hesir, and Zechariah's Tomb.

After Herod's death in 4 A.D., the splendor of Jerusalem did not cease to impress visitors to the city. A fine example of this is the block of residential houses exposed in excavations on the eastern slope of the present-day Jewish Quarter, facing the Temple Mount. Although almost none of the houses have been completely excavated, the large area exposed is sufficient for us to understand that the houses there were organized in blocks encompassed on all sides by streets. Also discernible here is the classical planning of streets running along the slope and intersected by alleys descending perpendicular to them. The houses were ornamented with handsome mosaic floors and their walls were decorated with murals (frescoes). Sections of the ceiling plaster found at the site also made possible a reconstruction of the ceiling of the house. In one place, an inscription was found engraved on the stone lid of a jar. The inscription, reading "Property of Bar Kathros," probably indicated the name of the owner of the house. The Kathros family was a well known priestly family in Jerusalem. It is also probable that the families of the city priesthood lived in these stately homes.

Agrippas, Herod's grandson, also began to construct a new wall, which is called the "Third Wall". This wall was intended to encircle the northern part of the city. The northern side, which was the weak spot in the city's fortifications, had already been strengthened by the "First Wall" and the "Second Wall". It is probable that the city continued to expand, and that due to topographical limitations it was only possible to extend it northwards. From the remnants that have been exposed so far, we can learn that this wall was built of anything that came to hand, with stones brought from various places and possibly also by dismantling existing structures. To date, only the northern line of this wall has been discovered. No traces have yet been exposed which might reveal how the northern line connected with the existing walls, and our impression is that the construction of this wall was never completed, although later it did withstand the Roman siege. We know from Josephus that while the wall was being built, orders were sent from Rome forbidding continuation of the construction. The Romans probably feared that one day this wall would present an obstacle to their

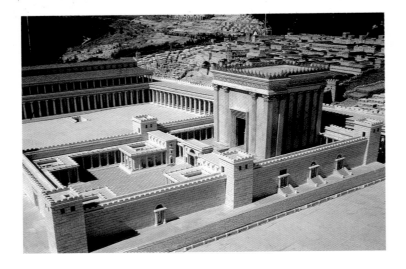

Herod's Temple
From the model of Jerusalem in the late Second Temple period, scale 1:50.
Garden of the Holyland Hotel, Jerusalem

army if it became necessary to intervene in matters pertaining to Jerusalem.

In view of the findings, it may be determined with a fair degree of certainty that the part of the city which was encompassed by the "Third Wall" contained very few buildings, and that Agrippas had set his sights on building a much larger city. This was the last major construction project undertaken in Jerusalem by the House of Herod. With the onset of the rebellion, Herod's great-grandson, Agrippas II, attempted to dissuade the inhabitants of Jerusalem from rebelling. He did not succeed in this, however, and Jerusalem entered the tumults of the rebellion, which concluded with its surrender. Of all the magnificence of the reign of Herod, only a very few vestiges remain.

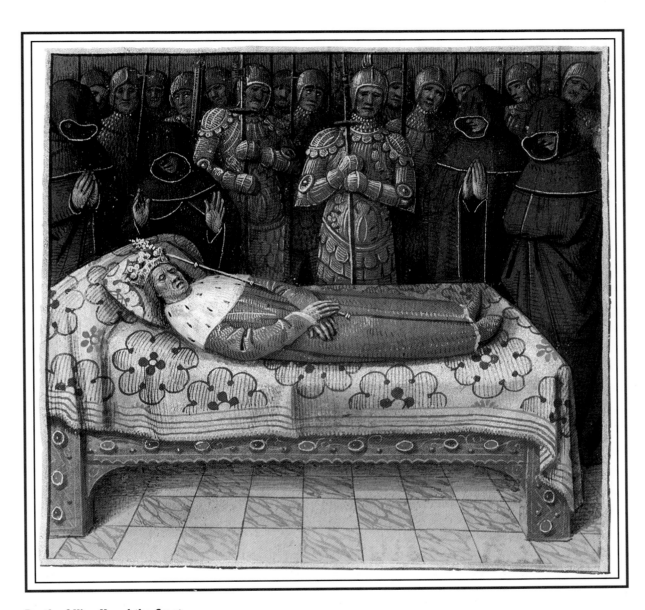

Death of King Herod the Great
From a manuscript of Josephus Flavius, Wars of the Jews, France, late 15th century. Bibliothèque Nationale, Paris

AELIA CAPITOLINA: PAGANISM AND CHRISTIANITY

71-323
A.D. A.D.

"He [Hadrian] destroyed the Temple of the Jews in Jerusalem and built there
public baths, a theater, a Tricameron, a Tetraninymphion and Dodecapylon
which was formerly called stairs and the codra."
(Description from the Paschal Chronikon Hadrianus, 6th century A.D.)

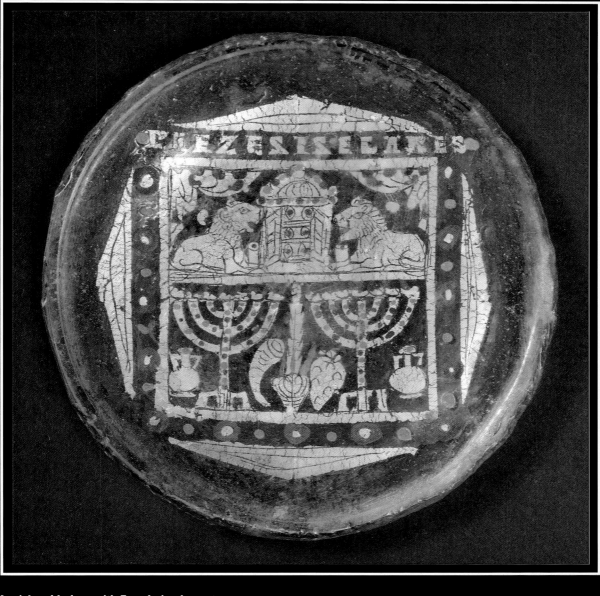

Jewish gold glass with Temple implements
Found in a catacomb in Rome, late 3rd to early 4th century. The Israel Museum, Jerusalem

During this period Jerusalem arose from its ruins. Upon the rubble of the magnificent city from the time of the Second Temple, a pagan city was erected, according to planning principles customary in Roman cities at that time (2nd century A.D.). Very little is known about this city, but from the little that remains – the triumphal arches, temples, streets, etc. – it is evident that it was a magnificent city. A Roman legion was stationed in the city, in an encampment of its own. The transfer of the legion out of the city at the end of the 3rd century marked a turning point in the city's development.

Jesus' entry into Jerusalem (upper panel); His Ascension (lower panel)
Giotto di Bondone (1267?-1337), ca. 1310, fresco in the Scrovegni Chapel, Padua

Right:
Symbolic view of Herod's Temple and its implements during the Pilgrimage Holiday of Sukkot
*Jewish gold glass found in Rome, late 3rd to early 4th century.
Museo Sacro, Vatican*

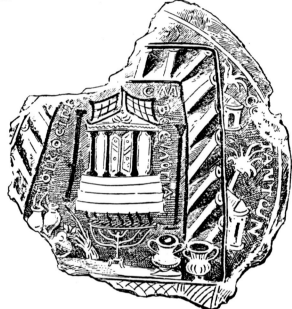

After the destruction of the Second Temple, the city remained in ruins for a long time. Some knowledge about the first sixty years after the destruction has come to us from the writings of Josephus Flavius, who relates that Titus spared the three towers which stood in the west of the city, deciding to leave them undamaged, together with a section of the adjacent wall. Josephus claims that Titus' motive in doing this was to show future generations the power of the Jerusalem he had subdued, and also so that they could serve as protection for the garrison of the Tenth Legion, which had been left in Jerusalem to guard the city.

Very few remains from this chapter in the city's history survive today. Two inscriptions found in the area of the excavations southwest of the Temple Mount are dedications to Vespasian and Titus. Also, in several places such as the Citadel, the modern Jewish Quarter, and near today's National Convention Center, archaeologists have found roofing tiles bearing the seal of the Tenth Legion, evidence that they were produced by the legion.

A question which has not yet been satisfactorily resolved is that of the size of the Roman garrison. The generally accepted opinion is that the camp occupied the westernmost section of the western hill, i.e., most of what is known today as the Armenian Quarter, with the line of the Cardo as its eastern boundary. Some scholars, however, believe that the camp also extended over the eastern part of the western hill, thus including the present-day Jewish Quarter. Results of archaeological excavations in the Jewish Quarter do not provide a decisive answer to the question about the extent of the Roman camp. At any rate, the Tenth Legion remained in Jerusalem until the end of the 3rd century (probably until 289, when it was transferred to Eilat).

In 129, the Emperor Hadrian (reigned 117-138) made a tour of the eastern part of the Roman Empire. He arrived in Judea early in 130 and, as he had done in other places, decided to establish a new city, to be called Aelia Capitolina: Aelia after his own name (Aelius) and Capitolina after the Capitoline trinity, Jupiter, Juno and Minerva, who were made the gods of the city. It is known that the city also contained temples to other gods, including Aphrodite, goddess of beauty, Aesculapius, god of healing, and Tyche, goddess of fortune.

The founding of a Roman city was marked symbolically by the plowing of a furrow by the city's founder. The Jews viewed this act on the part of Hadrian as an injury, for to them it seemed to be the fulfillment of the prophecy about Jerusalem's destruction, "Zion shall be plowed like a field". (Jeremiah 26:18). As a consequence of this and other anti-Jewish measures by Hadrian, the Bar-Kokhba revolt broke out, and went on for about four years. Opinions are divided about what role Jerusalem played in this revolt, but there can be no doubt that the dream of restoring Jerusalem was an important factor – as is indicated even by the coins minted during that period, since they bear images of the Temple and some of its appurtenances.

It was only after the revolt was suppressed that the Romans returned to the construction of their new city, Aelia Capitolina. As long as the Legion garrison remained in Jerusalem, the city had no need of fortifications; indeed, scholars are of the opinion that the walls of the Roman city were built only after the Legion was transferred from Jerusalem to Eilat. For more than two hundred years Jerusalem was a demilitarized city.

A question which preoccupies scholars is what took place within the precincts of the Temple Mount during the period of Roman construction. Due to an almost total lack of archaeological data or of accounts by historians about affairs in the city during this period, we can only base our assumptions today on the writings of the Church Fathers, who lived at a later period and described things that had happened in the city prior to their own time. Thus, for example, the mid-3rd-century historian Dio Cassius writes that there was a temple to

Tombstone of a legionary of the XVth Legion Apollinaris, which participated in the siege and destruction of Jerusalem *Ca. 80 A.D.*

"Sposalizio" – Marriage of Jesus' parents, Mary and Joseph, in front of the Temple *Raphael, 1504. Brera Gallery, Milan*

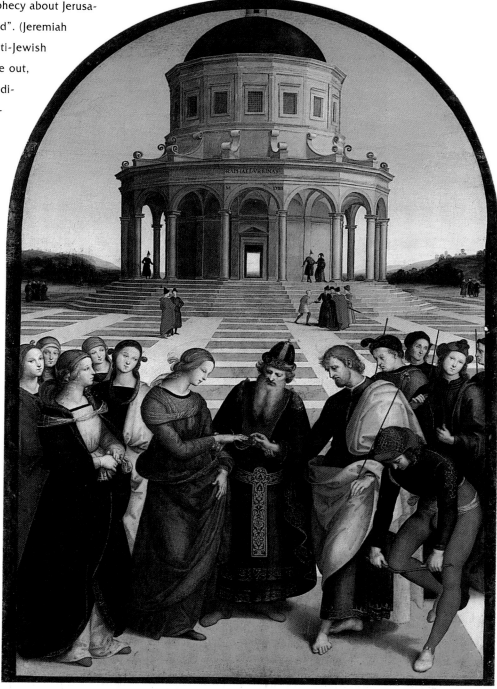

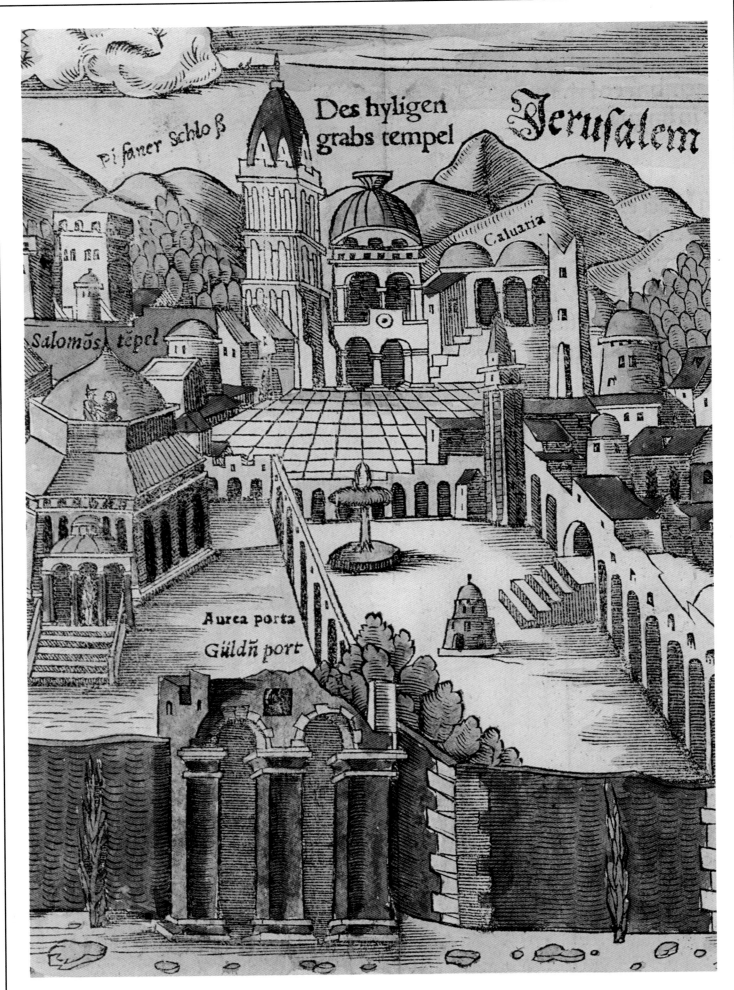

Pi faner Schloß Des hyligen grabs tempel Jerusalem

Caluaria

Salomõs tẽpel

Aurea porta
Güldñ port

Map of Jerusalem (with the Church of the Holy Sepulcher at the center)
From a book by Sebastian Münster, printed in 1544, at Basle. Gross family collection, Tel Aviv (detail)

Meeting of Mary's parents, Joachim and Anne, at the Golden Gate of Jerusalem
Giotto di Bondone, ca. 1310.
Fresco in the Scrovegni Chapel, Padua

Façade of the Temple with the Ark of the Covenant
Jewish coin struck during the revolt of Bar-Kokhba against the Romans (132-135 C.E.)

Jupiter on the Temple Mount, which seems probable in light of the description by a traveler who visited the Temple Mount early in the 4th century, which speaks of a statue of Hadrian standing on the mount, evidently to the east of this temple. On the other hand, St. Jerome, one of the more eminent Church Fathers, writes that the temple to Jupiter which was built by Hadrian stood on the site of the Church of the Holy Sepulcher. The temple to Aphrodite, generally accepted to have been situated there, was, according to Jerome, no more than a statue of the goddess standing on top of a natural rock (probably the Hill of Golgotha) that rose above the temple situated there. As already noted, the state of present-day research does not make it possible to reach any decisive conclusions on this matter. On the Temple Mount itself no traces from this period remain.

A most interesting issue is that of the city planning, since present-day Jerusalem (the Old City) still retains the street plan of the Roman period. The city extended mainly over the northern half of today's Old City. It is in this area, too, that most of the inscriptions from this period have been discovered, mainly on monuments or tombstones of Roman soldiers who served in the city. Some of the inscriptions are fascinating to anyone interested in learning about the routes traversed and the areas served in by the Roman soldiers who finally reached Jerusalem. Not one of the inscriptions was found in its original place. In later periods, the stones they were inscribed on were used as building stones, and that is where they were discovered.

Hadrian established a center at the present-day Damascus Gate. Here a magnificent gate was erected, part of which can still be seen today. Inside the gate (to the south), a beautiful square was built, the paving of which has largely been preserved. From the square, two streets led out to the south. One of these, the broader and longer of the two, extended on a north-south axis as far as the

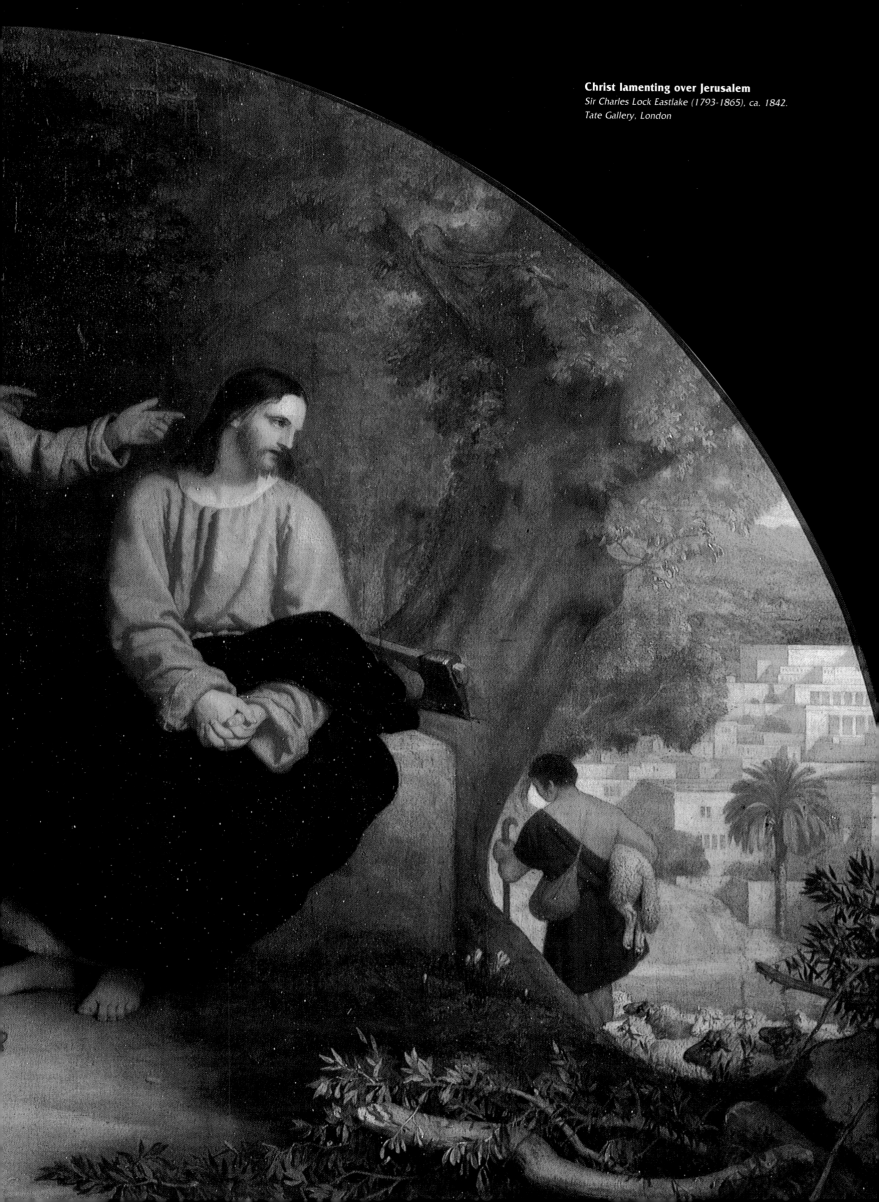

Christ lamenting over Jerusalem
Sir Charles Lock Eastlake (1793-1865), ca. 1842.
Tate Gallery, London

CONTVRBATIO · IESV · CHRISTI · LEGISLATORIS

The Delivery of the Keys
Behind Jesus and St. Peter is the polygonal Temple of Jerusalem, Perugino (active ca. 1472-1523), 1481. Fresco in the Sistine Chapel, Vatican, Rome

Portrait of Emperor Hadrian on a bronze coin
Struck in Gaza to commemorate Hadrian's visit to Judea in 130-131 A.D. The Israel Museum, Jerusalem

center of today's Old City. On each side of this well-paved street was a row of columns which supported roofs that covered both sides of the street, to protect pedestrians from the summer sun or the winter rain. In Latin, a main thoroughfare such as this, running from north to south, is called a "cardo", which means axis (i.e., the central axis around which the entire city was built). A second Cardo descended from this gate towards the site of today's Western Wall plaza, and stopped there (it is possible that at a later stage in this period the street was extended towards the area of the Siloam Pool). On the 6th-century Madaba map, which shows Jerusalem with all its streets, a row of columns appears only on the eastern side of this street – but probably this is due to a technical problem involved in drawing the map, and this street too had two rows of columns. Generally these main streets were connected to a street passing through the city's breadth (called in Latin the "decumanus"). It was commonly believed that in Jerusalem too there had been such a street at its southern limit, for the camp of the Legion was situated just south of it. However, despite all the explorations and examinations conducted along this axis of the city, no traces of such a street have yet emerged, and the question of the city's southern limit in this period remains unresolved.

Another street which was probably put down at this time, although its paving was delayed until somewhat later, is the street running the length of the present-day Christian Quarter Road. Going by the appearance of the network of streets found today in the northeastern section of the Muslim Quarter, it may be assumed that these streets were built on top of streets from the Roman period, so that in general terms the city plan is clear.

Hadrian also adorned the city with four gates shaped like triumphal arches. One of these, the Damascus Gate, later – when the wall around Jerusalem was built – became an actual city gate. A similar triumphal arch was built far to the north, at the place where Jerusalem becomes visible to

travelers approaching from this direction. Architectonic remains, such as columns, etc., have been discovered at this site, attesting to the existence of this arch here. Two additional gates were found inside the city; these had served as entrances to its two market squares. The eastern market square was northwest of the Temple Mount, and remnants of its paving are known from the Convent of the Sisters of Zion and the Monastery of the Flagellation; in both places, it is (mistakenly) assumed that this is the paved courtyard of the Fortress of Antonia. West of this marketplace stood the triumphal arch which today is called the "Ecce Homo Arch" because of the Christian tradition which views it as the gate to the Fortress of Antonia, where Jesus is said to have been tried and then brought out to the people waiting outside the citadel. This, according to the New Testament, was when Pontius Pilate, the Roman governor, said to the people, "Behold the man whose soul ye seek" ("Behold the man", in Latin, is "Ecce Homo"). Nonetheless, for a long time now it has been known that this gate was built in Roman times. Already in the 19th century, the foundations of yet another gate were discovered within the grounds of the Russian Church, which abuts on the Church of the Holy Sepulcher from the east. This gate served as an entrance to the city's central market-place, a large square bounded by the Church of the Holy Sepulcher to the north, David Street to the south, the markets to the east and the Christian Quarter Road to the west.

The foundation of Aelia Capitolina by Hadrian
Symbolic scene showing the Emperor plowing the first furrow – determining the boundaries of the new city. The standard of the Roman legion appears above the oxen. Bronze coin, 130-138 . The Israel Museum, Jerusalem

This was the city's main square. With each new excavation in the area, more of its paving is uncovered. As befitting a Roman market square, ("forum", in Latin), a temple was located nearby. We have noted above that scholars are still debating whether this was a temple to Jupiter or to Aphrodite, but that there was a temple here is clear to all. This market square remained in use until Crusader times. Visitors to the Roman city would walk along the Cardo to this magnificent gate, and pass through it into the market square. It thus appears that Hadrian's planning of the city was so effective that its imprint has been preserved in the city to this day, in the existing network of streets.

Insignia of the Roman Tenth Legion
(this legion was brought in to suppress the Bar-Kokhba Revolt). Roof tile and brick discovered in excavations in Jerusalem, 3rd century. The Israel Museum, Jerusalem

Hadrian built a large temple on the site of the Church of the Holy Sepulcher. This temple was destroyed after the triumph of Christianity and Constantine's construction of the first Church of the Holy Sepulcher early in the 4th century. There remain a few vestiges of the large supporting structure built by Hadrian, who used stones taken from the walls of the Temple Mount to create a large rectangular area here. Since the surface of the ground was pitted with waterholes and remains of quarrying works, he preferred to fill in the whole area with earth, to create a large elevated plane in the heart of the city. We have very little knowledge about the temple that stood there. It was probably built in the style familiar throughout the Roman Empire in the 2nd century, i.e., a rectangular structure surrounded by columns, with two rows of columns across its façade. To reach the building, one ascended stairs leading westward to the gate, which faced east, as was customary in Roman temples.

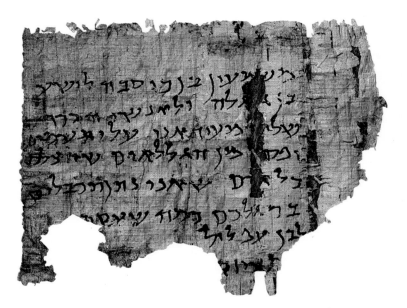

Another temple, the location of which is known though only very few vestiges remain, was the temple to Aesculapius, the god of healing. This temple stood near the Bethesda pools. There was also a temple to the goddess Tyche, goddess of fortune, but its location is unknown.

Letter sent by Bar-Kokhba to Joshua ben Galgula
In the letter Bar-Kokhba threatens to put Joshua's feet in irons if he disobeys his orders. Written in Hebrew on papyrus, discovered in Wadi Muraba'at, the Judean Desert. The Israel Museum, Shrine of the Book, Jerusalem

Cuirassed bronze statue of Emperor Hadrian
*135-138, found near Beth Shean (Scythopolis).
The Israel Museum, Jerusalem*

Right:
The Crucifixion of Jesus and the Two Thieves
*Additional episodes in the life of Jesus appear in the
frame; from a Medieval Latin manuscript.
Biblioteca Marciana, Venice*

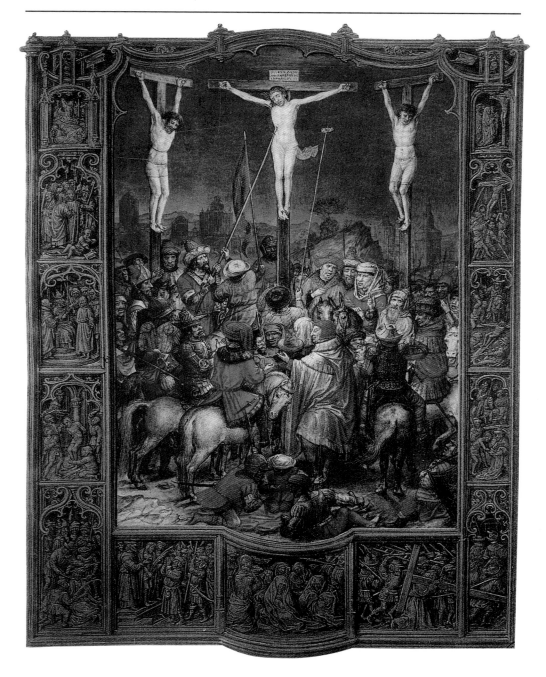

**Section from the frame of the fresco in the
Scrovegni Chapel, Padua**
(see p. 78 above)

It is probable that during this period a Christian community managed to subsist in Jerusalem, even though Jews were strictly forbidden to live in Jerusalem or its nearby environs, and the Romans did not relate to Christians differently than to Jews. A traveler from Bordeaux, the first Christian pilgrim known to have visited the city – in the year 333 – recounts that there had once been seven synagogues on Mount Zion, of which only one remained at the time of his visit. In his usage, "synagogue" meant not a Jewish place of worship, but a place of gathering for Christians living in the city. Some scholars consider the site of David's Tomb as being that of that one remaining "synagogue", but there exist no proofs for this. Beneath Helena's Chapel in the Church of the Holy Sepulcher, a drawing of a ship was discovered, with an inscription beneath it in Latin: "Oh Lord, we are going". Most scholars agree that this relates to a Christian pilgrim who had come to the pagan temple situated on the site of the Church of the Holy Sepulcher, which Christians already believed was the place of Christ's crucifixion and resurrection. The drawing of the ship is thought to date from the 2nd century, making this the oldest known Christian vestige in Jerusalem. Various interpretations have been suggested as to its meaning, such as that it was made by a merchant who drew the ship to depict how he had made his way to Jerusalem, but this possibility seems most tenuous. Nevertheless, the discovery of the drawing is proof of a sort that pilgrims believed this to be the site of Christ's sepulcher. It is probable that the Christian population of Jerusalem continued to increase towards the end of the 3rd century, and that this created the background for the rise of Christianity in the city.

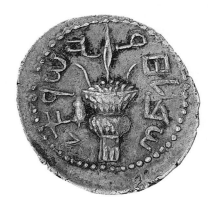

Above and below:
The "Four Species" of the Pilgrimage Holiday of Sukkot, and the Temple façade
Bronze coin, struck after the liberation of Jerusalem by Bar-Kokhba, inscribed with "Second Year to the Freedom of Israel", 134-135.
The Israel Museum, Jerusalem

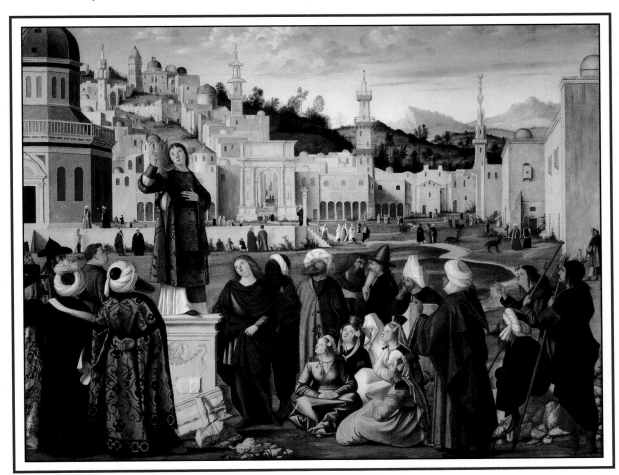

The Sermon of Saint Stephen outside the walls of Jerusalem
Vittore Carpaccio (ca. 1460-1526), ca. 1514. The Louvre, Paris

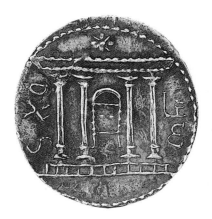

THE BYZANTINE HOLY CITY

324-638
A.D. A.D.

"Jerusalem has become a patriarchate because it is the city of the Great King, the Christ, the true Son of our God."
(From a description of the distribution of bishoprics of the Patriarchate of Jerusalem, 6th century)

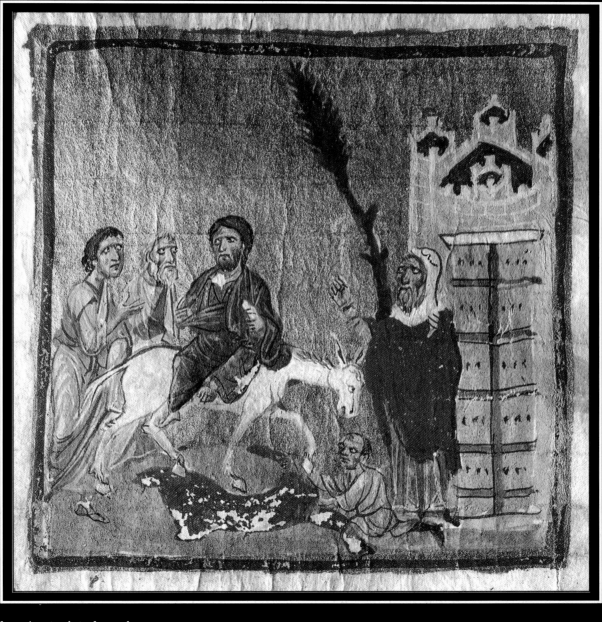

Jesus' entry into Jerusalem
From "The Four Gospels", a Byzantine manuscript written and illuminated in the second half of the 12th century in one of the monasteries of Mount Athos. National Library, Athens

When Christianity became the religion of the Empire, Jerusalem attained a greatness. Although it was not the capital of the kingdom, it undoubtedly acquired a degree of sacredness which led to an accelerated development of the city, thanks to which it rapidly returned to its size during the Second Temple period. The number of inhabitants increased, and many sacred buildings, churches and hostelries were built. Kings and rulers adorned it and added to its splendor, and it became a most magnificent city.

Christian clay oil lamp
*Eretz-Israel, late Roman –
early Byzantine periods.
The Israel Museum,
Jerusalem*

Right:
**The Temple of
Jerusalem**
*(In the center the Holy of
Holies, below it the altar
with burnt offering); floor
mosaic in the Theotokos'
Chapel, Church of Mount
Nebo, Jordan, early 6th
century*

Iready in the Roman period there existed in Jerusalem a Christian community, which we have very little knowledge about. As noted in the previous chapter, a pilgrim who arrived in Jerusalem in 333 A.D. mentioned some "synagogues" of the Christian sect, located on Mount Zion. Hardly anything is known about how this sect lived. Likewise, the beginnings of the Byzantine era are still shrouded in mystery. It is probable that the great change in the city occurred in 289 A.D., when the Roman Tenth Legion, which had been stationed in Jerusalem until then, was transferred to Eilat, and the city was probably fortified at that time. Its streets were paved then, if they had not been paved earlier, and new people began to stream into the city.

Roman Jerusalem was a relatively small city. Although it contained public buildings, temples, streets and marketplaces, its population was most probably mainly connected with the large Roman garrison. When Jerusalem became a focus for the entire Christian world, many pilgrims came to the city, and some even settled there. In this way its population increased, as did

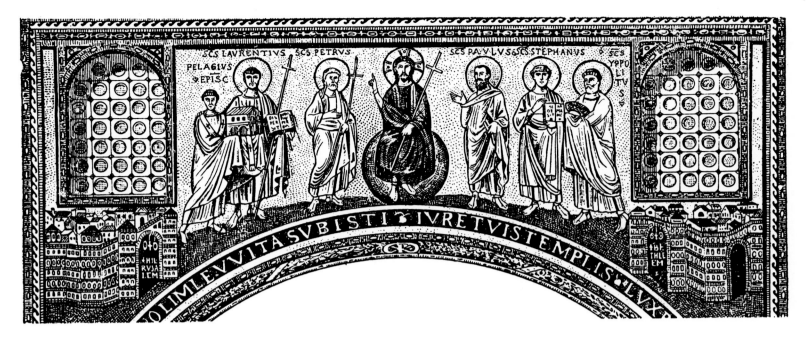

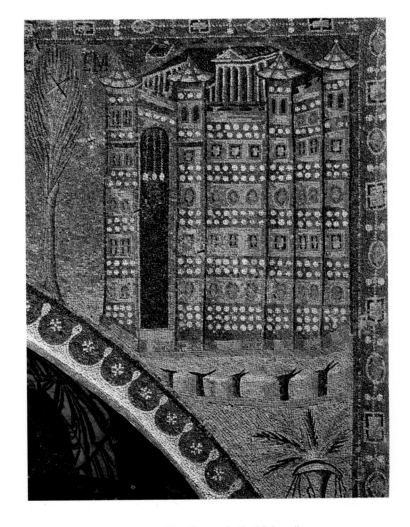

View of Jerusalem and Bethlehem on a triumphal arch
Mosaic, 579-590. Church of San Lorenzo Fuori La Mura, Rome

the economic activity in the city.

It is possible that during this period the population began overflowing beyond the city walls as the city continued to expand. The first large construction project in the city was the building of new churches during the reign of Emperor Constantine the Great. We must bear in mind that during the city's Roman period, until the time of Constantine, Jerusalem was less significant to Christians than, for example, Caesarea. This was because Caesarea was the administrative capital of the country, and also because among the Christians there was a gradual increase in the number of believers stemming from pagan origins in relation to the bulk of the older Christian population, who were for the most part of Jewish origin.

Little is known about the Christianity of Constantine the Great, who was sole emperor from 324 to 337. Some scholars are of the opinion that he regarded his victories throughout the world as the result of his being especially favored by the God of Christendom; while others believe he only converted to Christianity on his deathbed.

In any event, upon becoming sole emperor in the East, Constantine began building churches in Jerusalem, especially the Church of the Holy Sepulcher. The construction of this church also had important political implications, since for many years there had been disputes throughout the Christian world as to whether Jesus was an earthly or celestial being, or both. This dispute, which threatened to split the Christian world, ended when the church congress moved to Jerusalem to celebrate the inauguration of the church in 335. Regarding the true location of the Church of the Holy Sepulcher, it appears that doubts were already current in Constantine's time as to whether this was in fact the site known from the Gospels as that of Christ's crucifixion and resurrection. It was only at the end of the 4th century that the story (which is still known today) began to spread that Constantine's mother, the Empress Helena, had visited Jerusalem and had found relics of the crucifixion at this site: the cross, the nails, the crown of thorns, the sponge and the rod. This, however, is a later story. Constantine himself described a cross he found at the site, but even the historian of his period, Eusebius, Bishop of Caesarea, did not relate to Constantine's account.

"The Heavenly Bethlehem"
Detail of the triumphal arch mosaic in the Church of San Vitale, Ravenna, Italy, 526-547

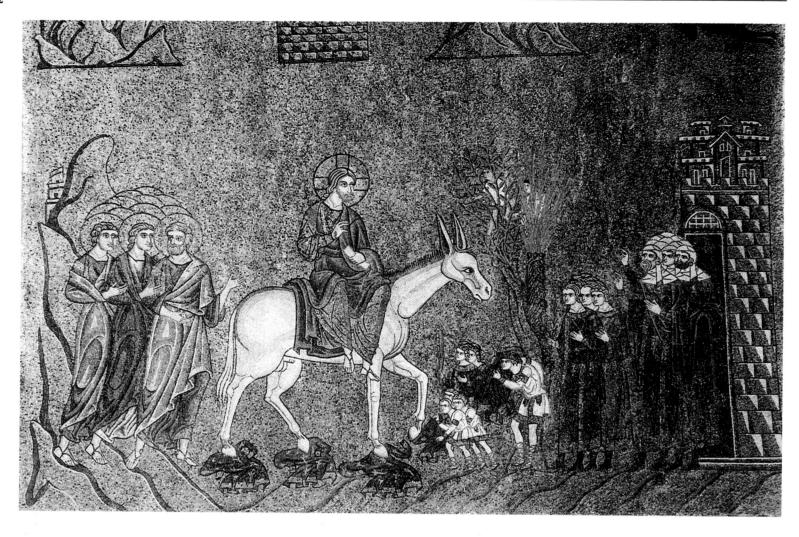

Jesus' entry into Jerusalem
Mosaic in the Church of San Marco, 13th century. Venice

The Nea Church
Detail of a mosaic floor, 6th century.
The Church of St. George, Madaba, Jordan

The Church of the Holy Sepulcher was a very large structure which extended from the city's main street, the Cardo, to the Street of the Patriarch, which is today's Christian Quarter Street. The church had several important sections: the atrium, the large prayer hall (the Martyrion, or Basilica), the Holy Garden (or Triportico) which included the Hill of Golgotha, and the round structure in the center of which was the tomb, the Anastasis, which in Greek means the Resurrection. It is possible that the latter section, which was the heart of the structure, was built by the Emperor at a later stage. Constantine also built a church on the Mount of Olives, at the place where Jesus introduced his disciples into the bosom of the Christian religion; this church was named Eleona (the Church of the Mount of Olives). Later, another church was erected nearby. This was the Church of the Ascension, which marked the place of Jesus' ascension to heaven.

The city was now so full of pilgrims and monks that it aroused opposition, for example, among the zealous Christians. St. Jerome therefore moved to Bethlehem, where there was a somewhat smaller influx of pilgrims. This in itself explains the growth of Jerusalem in the course of the 4th century.

Christianity became so deeply entrenched in the Roman Empire that during the latter part of the 4th century, a last desperate attempt was made (by the Emperor Julian, 361-363) to restore the pagan religion in the empire and to diminish Jerusalem's status in Christendom through an attempt to reconstruct the Jewish Temple there. The Jews viewed this as the beginning of the Redemption, but Julian's death soon dashed this hope. The rebuilding of the Temple was meant to deal a blow to Christianity, for Jesus had prophesied its destruction. Furthermore, it would have cancelled out the uniqueness of the Church of the Holy Sepulcher, which had only just been constructed.

The beginning of the 5th century was marked by the completion of the Mount Zion Church, one of the more important Christian institutions. Here Jesus had appeared to his disciples on the fiftieth day after his crucifixion, on Pentecost (the Feast of Weeks). The church which stood on this spot was one of the first churches ever built in the Christian world, if not the very first.

Renewed construction in the city was intended to demonstrate Jerusalem's supremacy over other cities in the country, in order to make it the principal Christian city. It was no coincidence that the remains of St. Stephen, the first martyr, were discovered at the same time that a church conference was held at Lydda. All the participants went out to view the finding, and a building was erected adjacent to the Mount Zion Church, to preserve the martyr's remains.

One characteristic aspect of life in Jerusalem during the Byzantine period was the many miraculous deeds which were said to have taken place there, such as the appearance of a radiant cross in the sky. On another occasion, Jesus was said to have been seen on the Mount of Olives, and there were other, similar events.

A change in the status of Jerusalem occurred with the appointment of Bishop Juvenalis to the bishopric in Jerusalem (420-458). The latter endeavored at every church conference to enhance the status of Jerusalem, and to raise it above all the other bishoprics in the Roman world. He was assisted in all his efforts by the Empress Eudokia, who during her sixteen years in Jerusalem (444-460) effected many changes in the city's appearance. Eudokia was the wife of Emperor Theodosius II, and had been exiled from her court because of a quarrel with her husband. She invested many efforts to improve the face of the city, and established welfare institutions for the ill and the aged. She also erected the House of the Patriarch in Jerusalem and, most importantly, built the city's southern walls. It is known that she initiated many building projects, inspired by the verse from Psalms (51:18): "Do good in thy good pleasure to Zion: build thou the walls of Jerusalem" ("Eudokia" in Greek means "good pleasure".) This verse persuaded the Empress to build a wall in Jerusalem.

The Empress Eudokia also treated the Jews favorably. Since the time of Hadrian, and again during the time of Constantine, Jews had been forbidden to enter Jerusalem. They were only allowed to visit the city on one day a year, on payment of a very high price, to mourn the destruction of the Temple, probably on the 9th of Av. The Jews of the Galilee appealed to Eudokia to permit them more frequent visits to Jerusalem during the course of the year. Eudokia consented, and the Jews rejoiced. Critics of this Empress claim that she only did this for profit, in order to carry out her great construction works in Jerusalem. Others attribute her acquiescence to her liberal nature. The wall that Eudokia built was a reconstruction of the "First Wall" from the time of the Second Temple, and encompassed both Mount Zion and the City of David. With the construction of this wall, the city once again became as large as it had been during Herod's time. One of the reasons for building this wall in particular was that the Empress had built a church at the Pool of Siloam, where Jesus had performed the miracle of healing the blind man.

Eudokia also built a basilica, to which the remains of St. Stephen were transferred. Until then they had been kept in the small edifice which had been erected near Mount Zion Church when they were first discovered more than a century earlier. The new church stood on the site where tradition

Christian bronze oil lamp
Found in Beth Shean, 5th to 6th century.
The Israel Museum, Jerusalem

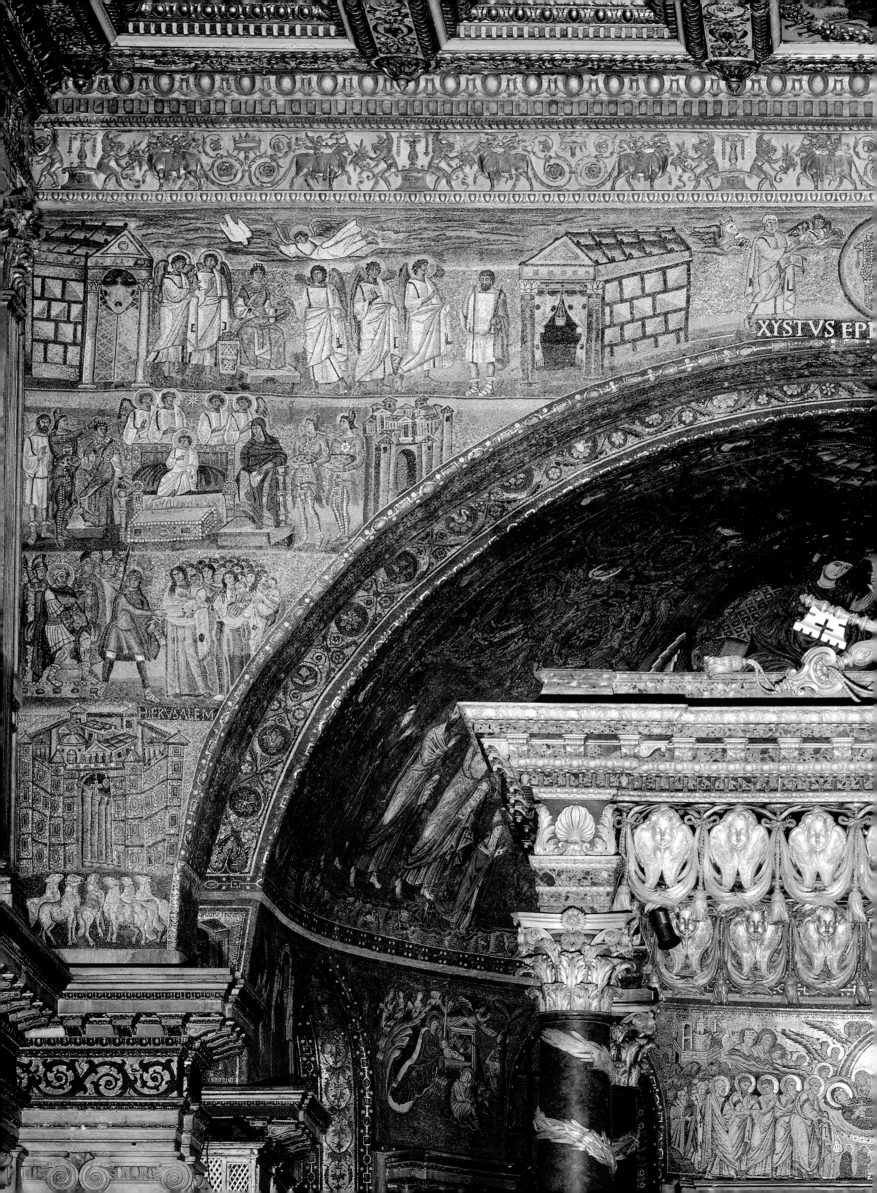

XYSTVS EPI

HERVSALEM

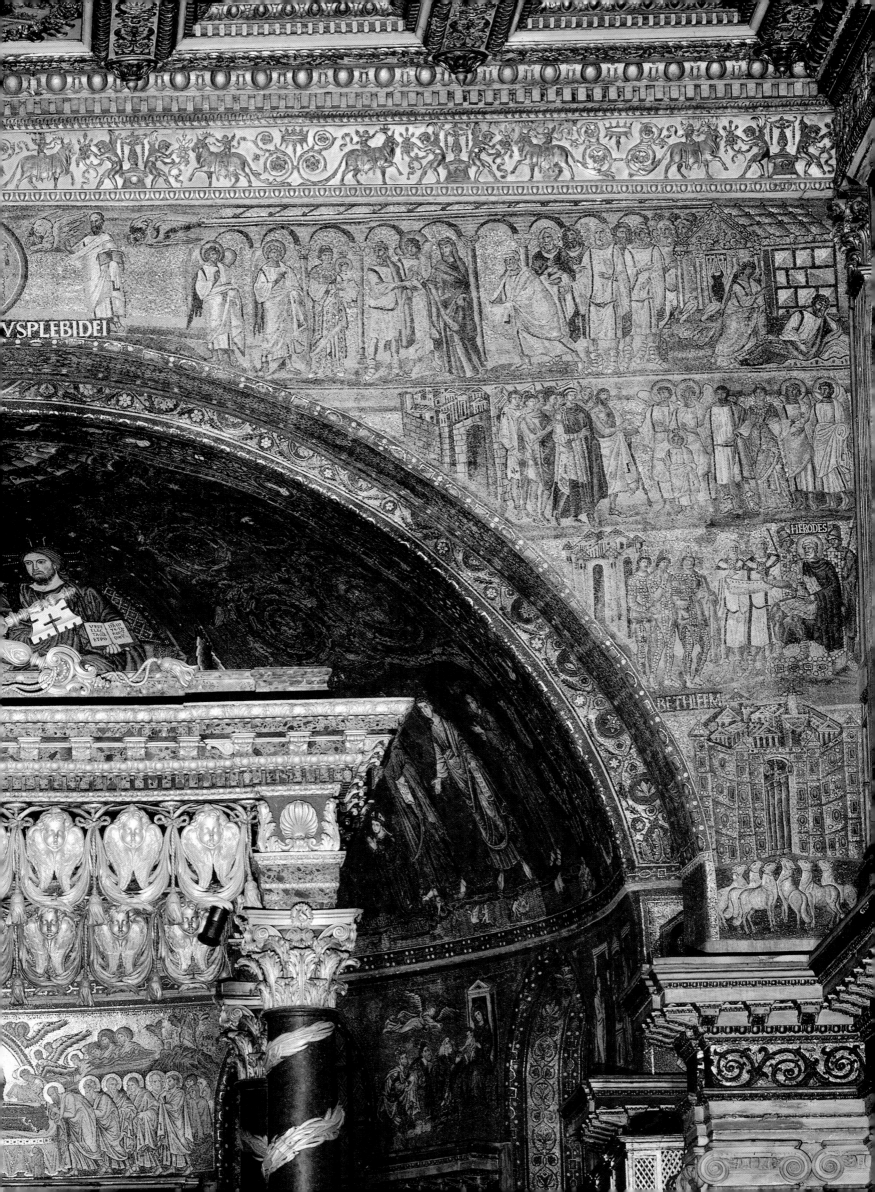

ORIENS

SEPTENTO.

MERIDIES.

OCCIDENS

Seventh-century view of Jerusalem
Image from a 12th-century manuscript from Prüfening, Germany, based on a sketch by the early Christian traveller Arculf, who visited the Holy Land ca. 670. Bayerische Staatsbibliothek, Munich

held that this saint had been stoned. One source also recounts that Eudokia herself was buried in St. Stephen's Church (which stands to this day on the Nablus Road). By dealing in this way with St. Stephen's remains, Juvenalis and Eudokia aspired to establish a precedence for Jerusalem, and not only because of the events connected with Christ. Thus they also spoke of Jerusalem as the locale of events connected with the lives and sainted deaths of the Apostles. In this way they sought to elevate Jerusalem's status over other cities where there were bishoprics and patriarchates. Juvenalis, with great cunning, even managed to obtain the title of Patriarch, and from that time on Jerusalem became a patriarchate, like other important cities in the empire.

The sixth century was marked by many construction projects in Jerusalem, the most famous of which is the fine church built by the Emperor Justinian in 543, which was named the New Church of the Mother of God (or the "Nea" [New, in Greek] Church). The construction of the church was financed by tax revenues, and the Emperor built it at the request of his grandfather, who was the most important monk in his day. This was an enormous structure built at the southern end of the Jewish Quarter, on the steep slope descending eastward. Huge stones were used to construct the building, and a miracle was even said to have occurred there. The emperor – or rather his architect Theodorus – could not find columns suitable for the building, and these were ultimately located after the Emperor dreamed where

Previous pages:
Triumphal arch in the Church of Santa Maria Maggiore
The mosaic covering the archway before the apse depicts events in the childhood of Jesus; at bottom left, Jerusalem, and at bottom right, Bethlehem. 432-440, Rome

they could be found. This church became a focus for religious processions, which set out from the Church of the Holy Sepulcher. The Emperor consequently lengthened the Roman Cardo, which began at the Damascus Gate, and in Roman times had extended only as far as the market center. Justinian continued it as far as the magnificent new church he had erected in honor of the Mother of Christ (The Church of the Blessed Virgin). This edifice comprised not only the church but also housing for the poor, hospitals and other important public institutions.

Today we cannot always determine with certainty the date of construction of the various buildings in the city, but we know that the number of religious buildings – monasteries and churches – in the city was very great. We know this to be true from the extensive literature left behind by the many pilgrims who arrived in Jerusalem.

These pilgrims visited the Church of the Holy Sepulcher, the Mount Zion Church, the churches on the Mount of Olives and others. The status of the Temple Mount, however, was unique. The Christians left it deserted, and, as already noted, wished to see its destruction as the fulfillment of the prophecies of Isaiah (64:10) and of Jesus (Matt. 26:21). This approach also facilitated the establishment of the Church of the Holy Sepulcher as the most sacred Christian site in Jerusalem. Nonetheless, there were several sites on the Temple Mount which pilgrims did visit. One such site was the corner of the Temple Mount where Satan tempted Jesus, and another (which also appears on the Madaba Map), was the Church of Simon the Just, which stands on the site of Mary's purification following the birth of Jesus.

There is also some data about a convent which was located beneath the Temple Mount, probably in the area of Solomon's Stables, but all the fixtures connected with it have long since been destroyed.

The city grew wealthier over the years through donations which arrived there, and its treasures became known far and wide. There is an exceptional story about the Temple vessels, which the Vandals, after their conquest of Rome, took away to their own territories. When Justinian conquered their centers in Tunisia, he took the Temple vessels, but on the advice of his ministers, who told him that anyone who held these vessels would be cursed with destruction (like Rome, and afterwards the Vandals), he decided to transfer the vessels to Jerusalem, to a church which he built there.

From the archaeological excavations conducted in Jerusalem, we now obtain a picture of the city's development after the Roman period. At the end of the Byzantine period, Jerusalem was a large city, almost three times its size in Roman times. Its walls had been extended southwards, and it had also expanded extensively to the north, though there it was not enclosed by walls. In its northern part there were monasteries, bath-houses, burial chapels and other similar structures.

Inside the walled part of the city, the archaeologists discovered the principal network of streets, based on the Roman pattern, with main streets running north to south. Some of these streets were quite magnificent, lined on both sides with columns, so that it was possible to walk there without getting

View of Jerusalem and Bethlehem in a lost apse mosaic
Church of St. Peter, 5th century. Rome

Left:
Clay oil lamps with Jewish and Christian symbols (Menorah and Cross)
Eretz-Israel, late Roman and early Byzantine periods. The Israel Museum, Jerusalem

wet in the winter or suffering from the heat of the sun in the summer. A special feature was a drainage system to catch rainwater and channel it to large water cisterns. The central market continued to be located in the large square in the heart of the city, which had been built in Roman times. Residential houses from this period have been found in many places in the city, such as south of the Temple Mount and on the hill of the City of David. The scene evoked by these houses is that of a flourishing city, its economic life represented by domestic devices such as grinding and crushing stones, dyeing utensils, and other items. The houses – some of which were also ornamented with mosaic floors – indicate that this was a prosperous city. The city also had a civil governor (not under the aegis of the Church), whose task was to ensure the city's defense. His seat was probably in David's Tower and the buildings adjacent to it, since at that time the citadel had not yet been built in its present form.

There were many churches in the city, but not all of them have been discovered in the excavations, also because in Crusader times the sacred traditions were continued in them, and the Crusaders rebuilt them, thereby destroying every vestige of the Byzantine churches.

The decline of Byzantine Jerusalem began in 614, when the city was captured by the Persians. Persia was ruled by the Sassanid dynasty, which since its rise to power in 226 had been constantly at war with the Byzantine empire, among other things for control of the kingdom of Armenia. Moreover, Christian attempts to convert communities living on the borders of the Persian kingdom did little to ameliorate relations between the two states. Thus, for hundreds of years, wars were waged between them. Attempts to reach settlements and make treaties were short-lived, and the Persian king, Chosroes II, aspired to reach Jerusalem, having heard of its great treasures. He was motivated no less by the thought that a blow to Jerusalem, the cradle of Christianity, would weaken the spiritual power of the Christian Byzantine state. When the Persian commander Sahar-Baraz reached Jerusalem, its gates were opened to him and he took the city without any bloodshed. When he left the city, leaving only a garrison behind him, the inhabitants rebelled. According to the Christian authors, the rebellion broke out because the garrison was composed mainly of Jews. The Persian commander then returned and imposed a twenty-day siege on the city, which ended with the brutal slaughter of many of its inhabitants, especially of the clergy. The Christians blamed the Jews for provoking the rebellion and for the slaughter, but it is difficult to discover details about this because the sources do not describe the role of the Jews in the Persian forces. Surviving written sources report on this brutal slaughter, and although they exaggerate the numbers – claiming more than 30,000 people killed – they do indicate its severity. Only a few years later, the Persians came to favor the Christians over the Jews and expelled the remaining Jews from the city. The Patriarch of Jerusalem, Modestus, began to rehabilitate the city, to restore its churches, and to try to renew its religious life. The rise to power of the Emperor Heraclius in Byzantium marked the beginning of the end of the Persian period. In 628 he began campaigning to restore Byzantine control of Jerusalem, and in 629 he signed an agreement with the Persians which returned Jerusalem to his empire. In 630, the Emperor arrived in Jerusalem for a royal visit. It is probable that the Golden Gate was built in honor of this visit, since Heraclius brought the Holy Cross, which had been taken from Jerusalem by the Persians fifteen years earlier, back to the city.

The rule of the Byzantine emperors did not continue for much longer, for in 638 the Muslim armies arrived in Jerusalem.

Greek inscription from the Nea Church in Jerusalem
The inscription testifies that the building of the church was initiated and funded by the great Byzantine Emperor Justinian; ca. 549-550. Israel Antiquities Authority, The Israel Museum, Jerusalem

The Church of the Holy Sepulcher
Detail from the Madaba mosaic map, ca. 565. Jordan

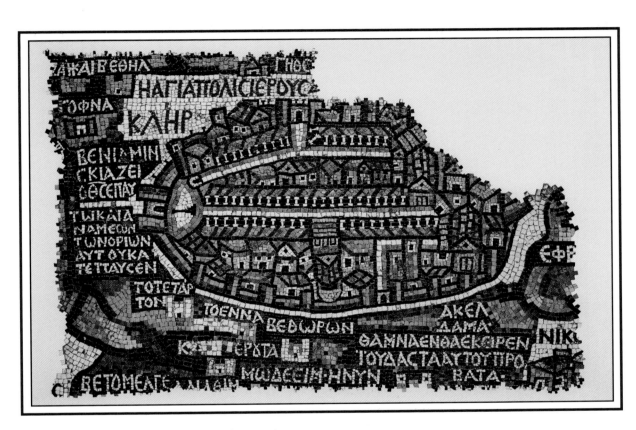

"The Holy City of Jerusalem" – the Madaba mosaic map

This early map is the most important source for the character and topography of Byzantine Jerusalem; the scale of the map is about 1:1650; ca. 565. The Church of St. George, Madaba, Jordan

THE RISE OF THE CRESCENT: BEIT AL-MAKDAS

638-1099

A.D. A.D.

"Paradise yearns and longs for the Temple (Beit al-Makdas),
and the Temple is a part of Paradise, and is the Earth's Navel."
(Al Omri)

Two priests performing the sacrifice outside the Temple, shaped as the Muslim Dome of the Rock
Title-page of "The Book of Worship" from Maimonides' Mishneh Torah, Hebrew manuscript from North Italy, late 15th century.
Private collection, New York

After the Muslim conquest, Jerusalem became a sacred city for Muslims as well, by virtue of the legend which tells how Muhammad ascended to the Seven Heavens from Jerusalem. During the centuries of Muslim rule Jerusalem lost much of its political importance, and was not even a capital city – the Muslims founded the city of Ramlah and made it their capital. All that remains intact today of the early Muslim city is the Dome of the Rock, which bears witness to the city's former importance and beauty.

Panel of carved wood from the Al-Aqsa Mosque
8th century

Right:
View of the Dome of the Rock in the 16th century
From the travel book of the German pilgrim Johann Helfrich, who visited the Holy Land in 1565

I n 638 the Muslims captured Jerusalem from the Byzantine empire, which had held the city again for about nine years after the Persian rule. This was a twilight period for the Byzantine city.

Jerusalem had already been known to the Prophet Muhammad, and during the years he spent in Mecca, he had established Jerusalem as the place toward which Muslims should turn while praying. A short while after his flight to Medina, Muhammad changed this instruction, directing worshippers to face Mecca. Nevertheless, it is the case that for sixteen months Muslims had been directing their prayers towards Jerusalem. The Koran describes Muhammad's "night journey" to a place at "the edge" ("al-Aqsa"), and many Muslim scholars have agreed that at the time this referred to Jerusalem, although other traditions were also current. Moreover, the Holy Land was thought of as a "nearby country" or a "neighboring country", so the "place at the edge" was almost certainly not Jerusalem.

According to the sources, the siege of Jerusalem lasted for two years until the Muslims captured the city. After this victory, the Muslim conqueror, Abu Abeidah, invited the Caliph Umar to

come in person and witness the surrender of the city.

Umar promised the Christian inhabitants of Jerusalem that he would not harm their possessions, would guarantee their safety, and would not permit Jews to live in the city. He did so to in an attempt to draw the inhabitants over to his side, but he also promised the Jews that he would enable them to return to their city after centuries of having been denied entry.

The Muslims continued to call Jerusalem Aelia, as it had been called during the Byzantine period, at times with the addition of the term "Beit al-Makdas" (The Temple), and later, "Al-Quds" (The Holy). Tradition has it that Caliph Umar, upon his entry to Jerusalem, was guided by a converted Jew named Ka'ev al-Akhbar, who pointed out the position of the Temple and even suggested a site for the building of a Muslim house of prayer. After extensive negotiations, a mosque was built, probably on the site of the present-day Al-Aqsa mosque. Umar also permitted seventy Jewish families from Tiberias to settle in Jerusalem, to the great dismay of the Christians. The Jews took part in the cleaning of the Temple Mount and in bringing oil to the candelabra which illuminated it. The permission to ascend the Temple Mount, which had been granted to the Jews by Umar, was rescinded by Caliph Abd al-Aziz (717-720). The Jews settled in the southern part of the city, on the hill of the City of David, close by the Siloam Pool and their place of prayer beside one of the walls of the Temple Mount. Little damage was done to the city, and we know only that the Muslims removed crosses from some of the churches, and probably destroyed or seriously damaged the New Church of the Mother of God.

Jerusalem acquired importance in the kingdom of the Umayyad caliphs (661-750). It was here that Mu'awiyah was proclaimed caliph, and here too, that an attempt was made on his life while he was praying. The Umayyad dynasty was not universally accepted throughout the Muslim world, and was occasionally beset by rebellions, but its building activities in Jerusalem never ceased. This was a period of prosperity for the city. The lives of the Christians continued without interference, and aside from damage that had been caused during the conquest, no major change occurred in the city's life.

Abd al-Malik began construction of the Dome of the Rock in 688, and completed it three years later. Scholars are divided in their views as to the reasons for the construction of this magnificent building, which is the acme of Muslim construction in the city. There currently exist two main hypotheses. One of these claims that since it was built in imitation of the Church of the Holy Sepulcher, it was erected in order to demonstrate the superiority of Islam over Christianity. The shape of the building recalls the round structure of the church, where Christ's sepulcher stands in the center. Here, in the center of the mosque, stands the Sacred Rock, surrounded by an octagonal structure which, in its size and the height of its dome, surpasses the structure of the Church of the Holy Sepulcher. Furthermore, the scholars who propound this view find reinforcement for it in the fact that the dedication inscribed on the building refers to a rejection of Christianity. If the mosque was indeed built to compete with the Christian church, then it is possible that the present-day Temple Mount was originally planned during the time of this caliph. It is also possible that the plan included the Al-Aqsa mosque, which parallels the structure of the basilica of the Church of the Holy Sepulcher, although this part of the plan was only executed during the reign of Abd al-Malik's son, Al-Walid (705-715).

The other hypothesis about the reason for the construction of the mosque stems from the fact that during the early days of Abd al-Malik's rule, the holy cities, Mecca and Medina, were under the rule of Ibn al-Zubayr, the political rival of the Umayyad dynasty. Abd al-Malik feared that the inhabitants of

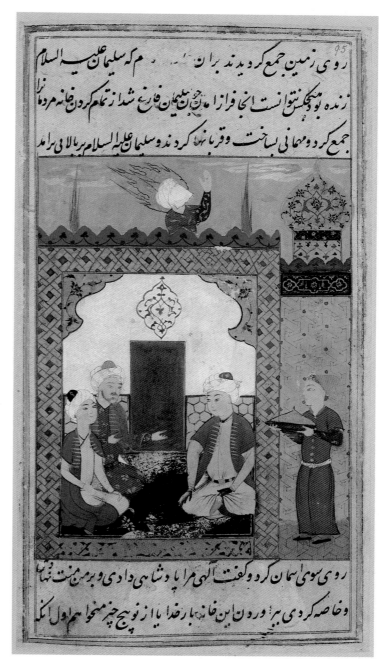

King Solomon (Suleiman) praying to God after the building of the Temple
From a Turkish manuscript, Istanbul, 1574-75.
Chester Beatty Library, Dublin

The Dome of the Rock, labelled in German "Der Tempel Salomonis"
Print from a German book printed in 1694

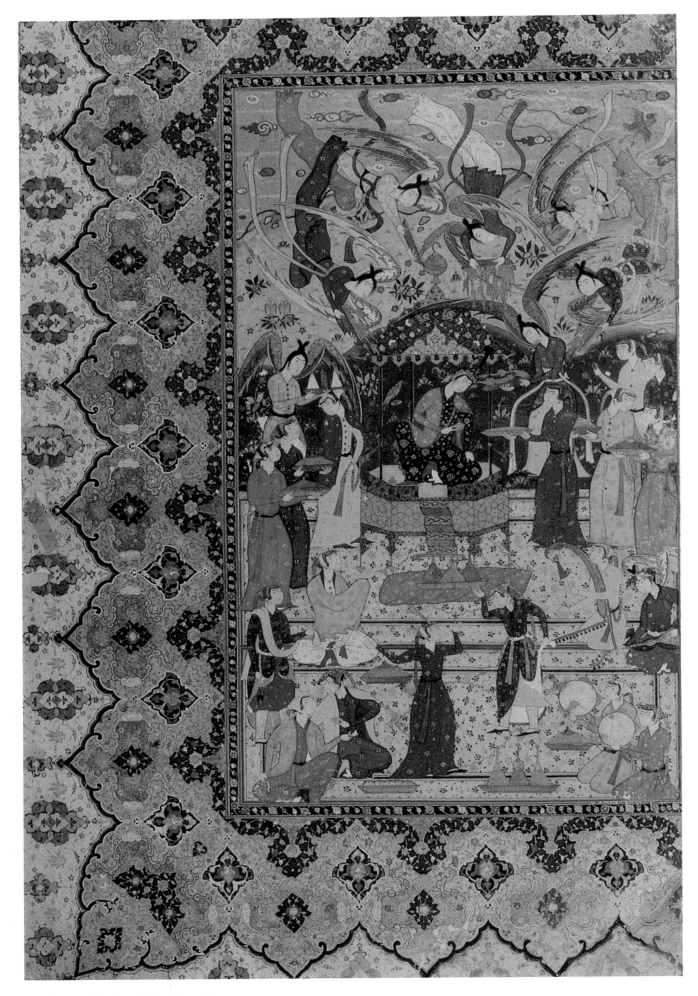

The Queen of Sheba visiting King Solomon
As seen by a Persian artist of Shiraz; illuminated manuscript of Firadusi's Shah-nameh ("Book of Kings"), late 16th century. British Library, London (detail)

his kingdom, who had to pass through his enemy's territories to make their pilgrimages, would be exposed to anti-Umayyad propaganda and might become subversive elements within his kingdom. The construction of the Dome of the Rock was thus intended to serve as an alternative to the holy cities as a focal point for pilgrimages.

During the reign of Abd al-Malik's son, Al-Walid, many additional buildings were erected in the city. On the Temple Mount itself, the Al-Aqsa mosque was built. Its construction is not mentioned in accounts of that period, probably because an earlier mosque stood on the site – perhaps the one built by Umar. Thus, the building of Al-Aqsa may have been considered rather as a renovation of an existing structure. It was a large mosque, built to the proportions customary in early Islam: a broad lateral structure capable of containing the entire community of men living in the city for the Friday prayers. Next to the Temple Mount, Al-Walid also built a government complex which contained a number of magnificent palaces, remains of which have been discovered in archaeological excavations of the southern wall.

This government complex attests to the great importance attributed to Jerusalem by the Umayyads, whose capital was Damascus. Likewise, milestones have been found on the road which connected these two cities. It should be recalled that it was the Umayyads who founded Ramlah, to serve as the political capital of the Holy Land.

In 750, the attempts to rebel against the Umayyads were finally successful, when in a decisive battle at Rosh Ha'ayin, not far from Jerusalem, the Umayyad dynasty was defeated and its descendants executed. The Abbasid dynasty took over the caliphate and ruled the Muslim world for centuries thereafter.

Visits to Jerusalem by the caliphs became increasingly rare, and each such visit led to persecutions and the imposition of additional burdens on the city's non-Muslim inhabitants. The persecutions involved the destruction of external symbols in the Christian churches, prohibition of nocturnal prayers, and the levying of increasingly heavy taxes, on church people as well. Because of these difficulties, the Christians of Jerusalem appealed to Charlemagne (797-800) for help, especially since he had connections with Haroun el-Rashid (caliph in768-809). Charlemagne responded by building monasteries, hostelries for pilgrims, gardens in the Valley of Jehoshaphat, and other edifices.

The difficulties caused by the Abbasid dynasty were compounded by various natural disasters such as an earthquake, famine, and locusts, which plagued the city in the early 9th century. Nevertheless, reports by Christian pilgrims describe a calm and secure city.

Towards the end of the 10th century a new era began in the annals of the city. The Holy Land, being far from the center of power in Baghdad, came under the independent rule of Egypt, which had rebelled against its Iraqi masters. In 878, the city came under the rule of Ibn-Tulun, ruler of Egypt under the aegis of the Abbasids, who had rebelled and made himself an independent ruler. During this period, the Muslim world was beset by conflicts on religious grounds, and the Byzantine Empire was also attempting to exploit this situation and reconquer regions it had lost centuries earlier. The situation also led to riots against the Christians in Jerusalem (966) and later also to the capture of the city by the Fatimids (969), who initially were favorably inclined towards the Jews and the Christians. However, the rise to power of the Fatimid caliph Al-Hakem B'Amar Allah brought severe damage to Jewish and Christian religious edifices, including the destruction of the Church of the Holy Sepulcher in 1009 – a destruction from which this church has never been fully rehabilitated. The period of this caliph's reign was marked by disquiet, from which Jerusalem suffered until his death in 1021. The Jews were trapped between the Fatimids, who were generally favorable to them, and Arabs of various movements which warred against the Fatimids.

On 7th December, 1033, the city experienced a violent earthquake, one of the most severe in its history. Parts of the walls of the Temple Mount collapsed, and the city wall was destroyed to such an extent that it was necessary to build new walls. Inscriptions attest both that the Dome of the Rock was repaired and that the Al-Aqsa mosque was rebuilt. The construction and restoration operations went

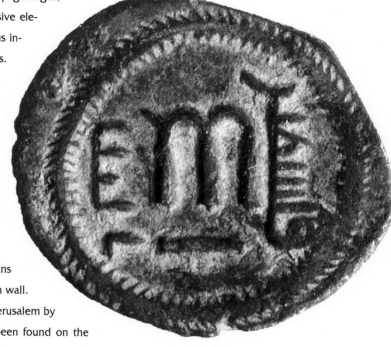

Umayyad bronze coin
*Flanking the letter M are the Arabic inscriptions Falastin (Palestine) and Ilya – i.e., Aelia, the Roman name of the town, still in use in this period; 660-680.
The Israel Museum, Jerusalem*

Plan of the Muslim Temple Mount
At top, the Al-Aqsa Mosque; below, the Dome of the Rock. From a Muslim manuscript, 15th century. Bibliothèque Nationale, Paris

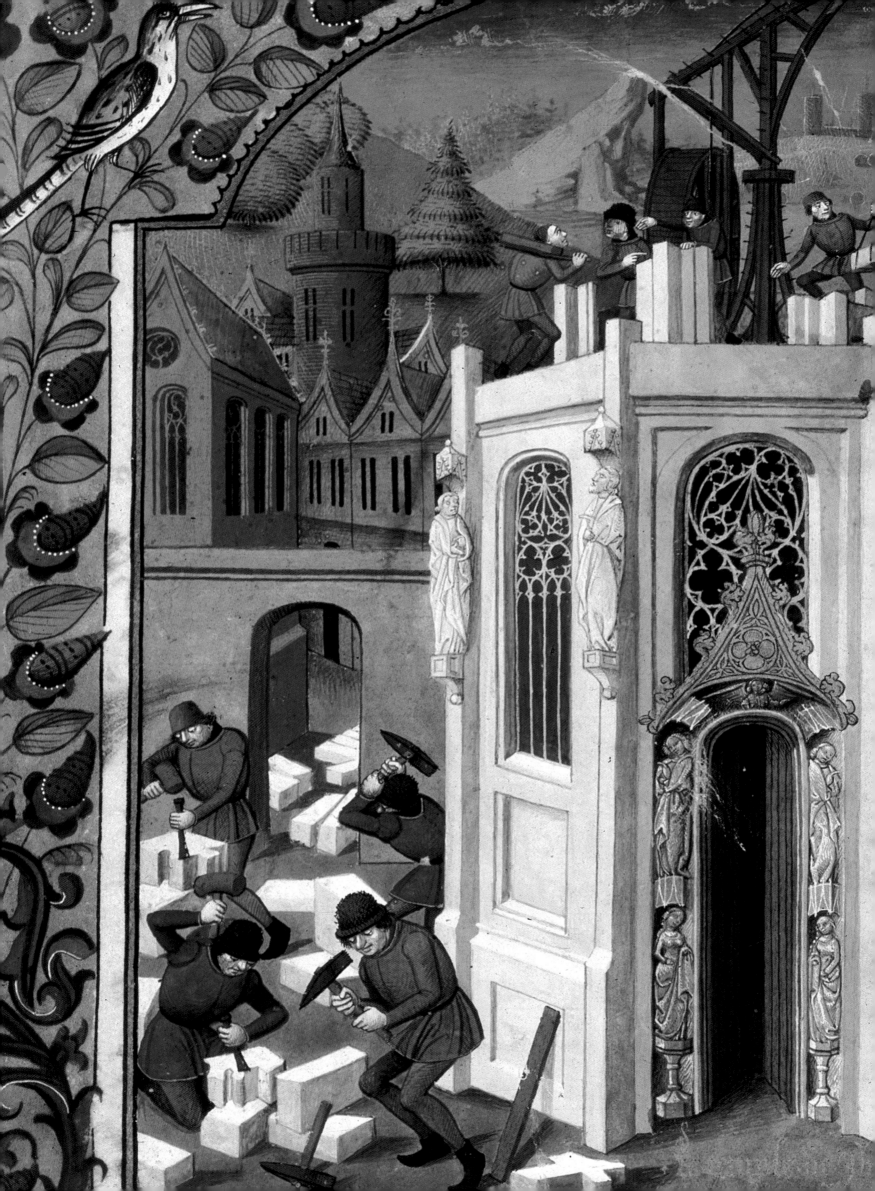

"Jerusalem Surrounded by Mountains"

Jerusalem, with the Temple pictured as the Dome of the Rock, in an Italian-Jewish marriage contract (Ketubbah) from Rivarolo, 1727.
Formerly in the Jewish Museum of Berlin, lost in the war

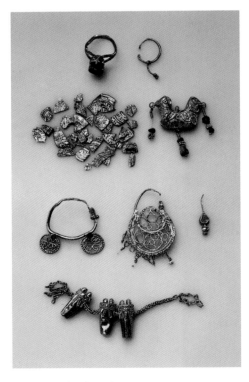

Gold Muslim Jewelry

Excavated at the area south of the Temple Mount, 11th century. Israel Antiquities Authority, The Israel Museum, Jerusalem

Previous pages:
"The Sultan Umar rebuilds the Temple of Jerusalem"

Miniature from a manuscript of Guillaume de Tyr, Histoire de la conquête de Jérusalem, France, ca. 1470. Bibliothèque Nationale, France

on for decades, and the rebuilding of the city walls took about thirty years.

In the mid-11th century, for the first time since the days of Charlemagne, some European merchants, from Amalfi in Italy, established an institution of their own in Jerusalem. South of the Church of the Holy Sepulcher they founded a hostelry for pilgrims named after St. John (of Alexandria). It was possibly this name which led the Knights of St. John (the Evangelist) to build their hospital, similarly named, in the same place. The activity of Christians in Jerusalem increased, thanks to the intervention of the Byzantine emperors, especially Constantine IX (Monomachus), who consented to assist in the restoration of the wall, in exchange for the consolidation of the Christian quarter in Jerusalem by providing protection for it through the erection of an inner wall (1063). We know of this wall from historical sources only, and not from archaeological discoveries.

In the meantime a new element had appeared in the Middle East, the Seljuk Turks, who won a decisive battle against the Byzantine empire at Malzagirt, in Eastern Anatolia, in 1071. They managed to defeat the Byzantine army and to take control of large sections of Anatolia. They also reached the Holy Land and captured Jerusalem, although scholars are divided about the date, 1071 or 1073, and about the outcomes of the conquest. Some scholars view the conquest and the Seljuk rule (1071-1098) as a period of decline for the city, while others believe that while the conquest itself caused hardships for the city, it was followed by a period of development. We still find it difficult to decide which of these views is correct.

The Seljuk kingdom began to fall into decline, and the Fatimids, strengthened under their new ruler, Badr-al-Gamali, took advantage of this weakness and, on August 26th, 1098, captured Jerusalem again. Their hold on the city lasted less than a year, however, and on July 15th, 1099, Jerusalem was taken by the Crusaders.

With regard to the city's appearance, the beginning of this period is characterized by continuity. The network of roads and fortifications from the Byzantine era was preserved throughout the Muslim period. So were most of the churches, and it seems that only in a few places were small mosques built for the use of the recently arrived Muslims.

The major change began with the rise to power of the Umayyad dynasty, for whom Jerusalem served as an important focus for religious and political activity, and this found immediate expression in construction.

In the area where David's Tower had stood since the time of the Second Temple, the Umayyads erected a real fort – an enclosure containing a large, round tower, in addition to David's Tower. This fort, although small in size, was extremely strong. Even the Crusaders could not overcome it and it was evacuated only by agreement, after the Crusaders had captured the city. No changes appear to

Romantic view of the Dome of the Rock
Paul-Wilhelm Keller-Reutlinger(?) (1854-1920),
hand-colored lithograph. The Israel Museum, Jerusalem

have been made to the city walls. At the Damascus Gate, two cisterns from this period have been found. These cisterns obstructed the side gates of this Gate, which until then had contained three gates: one large central gate and two side gates, which were now blocked. The Muslims should also be credited with the restoration of the walls of the Temple Mount, which on their eastern side also served as a wall for the city itself. It would appear that the walls of the Temple Mount had been destroyed when the Temple was destroyed, and there had been no historical or religious reason to rebuild the Temple Mount and its walls until the Muslim period.

The greatest change in the city walls is discernible in the southern wall. As we know, the Empress Eudokia, in about 460, had restored the "First Wall" which dated from the time of the Second Temple, thus including the hill of the City of David and Mount Zion within the city limits. In this area in the southern part of the city, life continued undisturbed. During the Muslim period, there was a Jewish Quarter here, and it is also possible that there was a Karaite quarter as well. The change in the wall line occurred with the earthquake of 1033. We have already mentioned the efforts made to rebuild the city wall, and it appears that at this time the size of the city in the south diminished, and the new southern wall was built, more or less following the line of the existing wall. Except for a short period in Jerusalem's history – during the time of Saladin when once more only Mount Zion was included within the city limits – the southern wall remained along the course familiar to us today.

Within the city itself the Roman city plan was preserved during the Muslim period as well. Thus, for example, the Roman Cardo, which had been lengthened during the Byzantine period, continued to serve as the city's principal street during this period too. Then the Cardo, with its rows of columns,

Muslim silver bracelets
Discovered at the Temple Mount, Jerusalem,
11th century. Israel Antiquities Authority,
The Israel Museum, Jerusalem

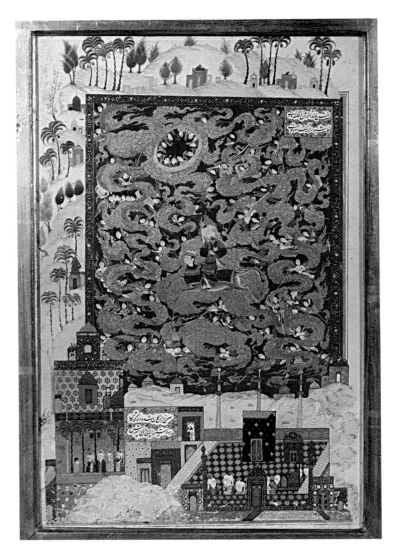

Muhammad's Ascension to Heaven following his Night Journey
The black Ka'bah stone is on the right, and the Rock of Foundation is at the lower left; from a Persian manuscript of Nizami's poems, 1504-5.
Private collection, Lucerne

The Temple and "School of Solomon"
From the Latin edition of a Hebrew work on the graves of the righteous, printed in Heidelberg, Germany, 1659

began to deteriorate and slowly continued its decline as buildings penetrated into the street. The broad avenue, with its rows of columns, began to disappear. Later, when the Crusaders arrived, there was no longer any point in preserving it, and they divided it into a number of parallel streets. According to descriptions by pilgrims and visitors to the city at that time, Jerusalem looked like a city that had a network of well paved streets, drained by gutters which channeled the rainwater into large public cisterns. Important streets from this period have also been discovered alongside the southern and the western walls of the Temple Mount. The great arch which passes over the western street also dates from this period. The justification for its existence was the road which led from the present-day Jaffa Gate to the Temple Mount, crossing over the great arch ("Wilson's Arch"), and the aqueduct which also passed above it to the Temple Mount.

During this period, due to the circumstances described above, the Christian Quarter, which exists to this day, came into being. The Jewish Quarter, which had been in the southern part of the city, moved to the northeast of the city after the earthquake. While in the southern quarter remains have been found that attest to the existence of the Jewish Quarter there, such as dyeing vats (the Jews were known as cloth dyers), candelabra drawn on lintels of houses, etc., we know about the northern quarter only by virtue of its name. During the latter part of the Crusader period, this quarter was called the "Juderia" or the "Juiverie" (the Jewish Quarter), even after the Jewish community in Jerusalem was wiped out by the Crusaders, and this quarter was settled by Christians brought in from Transjordania. As for the Karaite Quarter, although its precise location is not entirely clear, we know that during this period it might have been located on the eastern slope of Mount Zion, or the site of the present-day Siloam village.

The Christian Quarter was established at its present location during the 11th century, probably because the Church of the Holy Sepulcher stood at the center of this area. The church, as already noted, was destroyed in 1009 but was restored thanks to the efforts of the Byzantine emperor in the years 1042-1048. The changes instituted by the Emperor Constantine Monomachus served as a basis for the actual restoration of the church in Crusader times. The Muristan Quarter south of the church continued to serve as the city's central square during this period, even though we know that the European buildings constructed in Jerusalem by Charlemagne and the Amalfians, with their various appendages, were also built here. Indeed, during the Crusader period the area became filled with buildings, and there was active commerce which flowed in the direction of the main streets.

There is no doubt that the focus of Umayyad construction in Jerusalem was the Temple Mount. In 691 construction of the Dome of the Rock on the site of the Jewish Temple was completed, and a few years later, the Al-Aqsa mosque was built, together with other large administrative buildings. One of these may well have been the palace of the caliph himself.

The Christians continued using their churches in the city, and it is probable that only the New Church of the Mother of God was seriously damaged by the Arab conquest. Today we know of many churches which continued in use for many years until they were destroyed, some because of the ups and downs in relations between Muslims and Christians. From written descriptions and archaeological finds we know of many water installations, such as cisterns and pools in the city and its immediate environs, which served the inhabitants. We also know of cemeteries nearby which date from this period. The most famous of these were the one located in the present-day Mamilla area, and the one alongside the eastern wall of the Temple Mount. Both of these cemeteries had a long history, both Jewish and Christian, and also came to be accepted as burial places by Muslims.

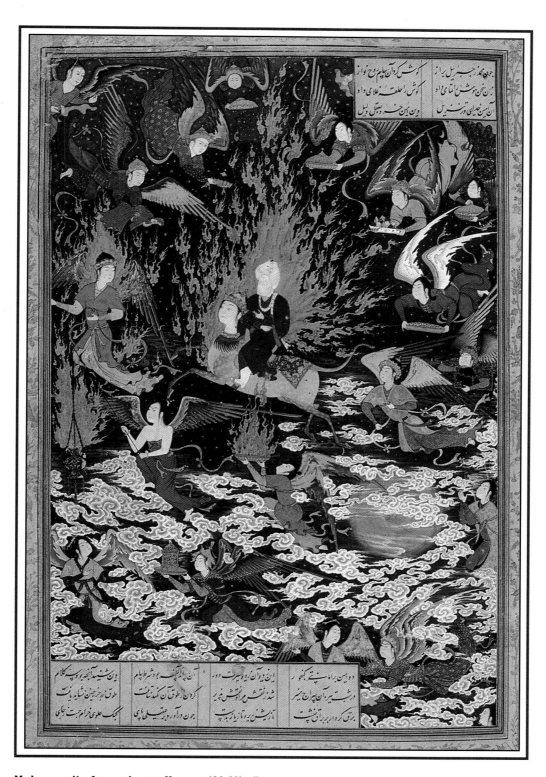

Muhammad's Ascension to Heaven (Al-Miraj)

From a Persian manuscript of Nizami's poems, 16th century. British Library, London

THE RETURN OF THE CROSS

1099-1187

A.D. A.D.

"Jerusalem is a large city, protected by strong walls.
It is built in the form of a square, with four equal sides."
(Father Daniel, 1105 A.D.)

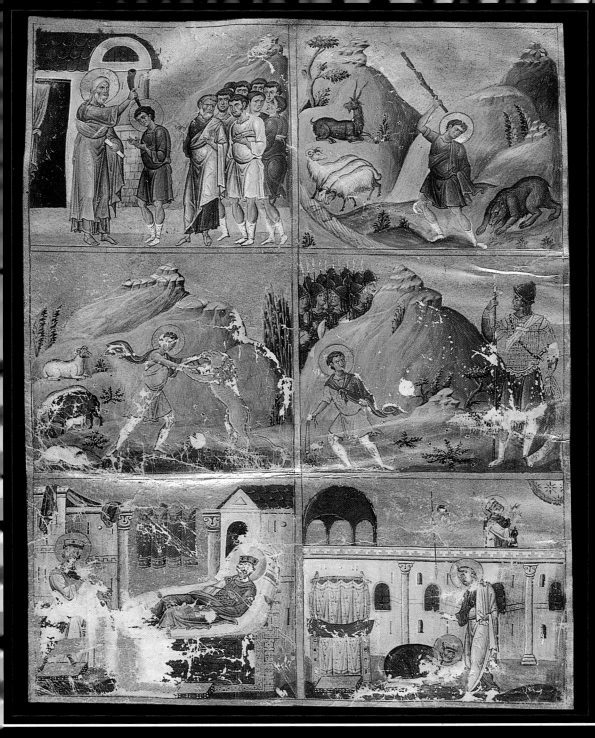

For almost a century, Jerusalem was the capital of a newly established state. Since it was a holy city, many churches were built there, and an estate was allotted for the Patriarch. The Temple Mount became an important center, the city's markets flourished, and many pilgrims came to visit. All this made it a dynamic city, and shaped the earthly image of Jerusalem from that time on.

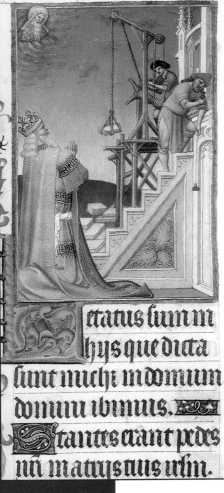

King Solomon overlooking the building of Jerusalem
The Limbourg Brothers, Très Riches Heures du Duc de Berry, 1413-16. Museé Condé, Chantilly, France (detail)

Right:
Imaginary map of Jerusalem based on the Scriptures
The map appears in a 14th century manuscript, Biblioteca Laurenziana, Florence

O n June 6th, 1099, the Crusaders reached the walls of Jerusalem and soon managed to capture the outermost of the two walls that encompassed the city from the north. When the Crusaders reached the main wall, the city's inhabitants, who had withdrawn to behind this wall, regrouped and prepared for a long siege. The siege actually lasted about six weeks, and on July 15th the Crusaders captured the city.

The walls which stood in the Crusaders' way were relatively new. In 1033 a severe earthquake had struck Jerusalem, and its fortifications had been badly damaged. All the city's inhabitants joined in to rebuild the ruins, and with much effort, the construction of the walls was completed in 1064, i.e., 35 years before the arrival of the Crusaders. On the vulnerable northern side of the city, two walls were built – one high and strong, and another, in front of the former, lower and apparently not as strong, as evinced by the speed with which the Crusaders breached it. The walls were protected by a moat, and we also hear of a moat in the city's south, where it

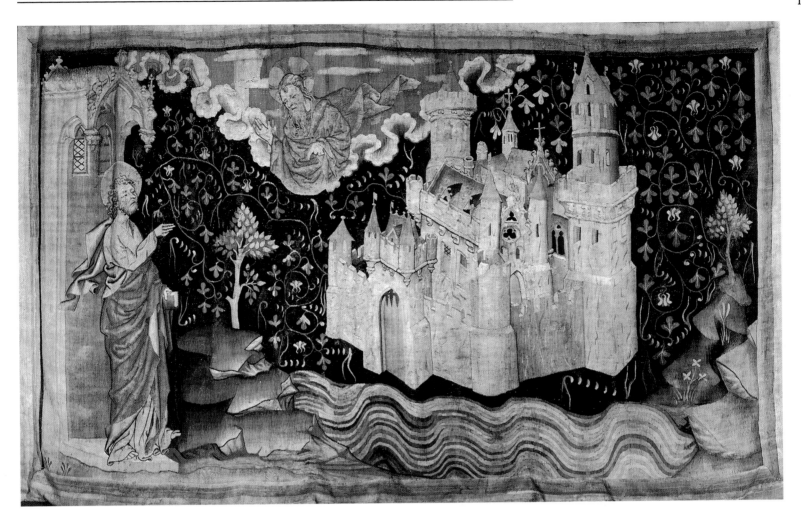

"The New Jerusalem"
Nicolas Bataille, 1373-87; a tapestry based on the Apocalypse. Musée des Tapisseries, Angers, France

separated the city from Mt. Zion. The archaeological excavations conducted there have not un-earthed any findings which can provide information on this southern moat.

The various Crusader armies sought out weak spots for their attack on the city. During the siege most of their forces, which were deployed along the northern wall, were concentrated at the north-eastern corner of the city, where they finally managed to breach the walls and enter the city.

Another Crusader force, which had besieged the city opposite the citadel, moved southward in the course of the siege and beset the city from the south. Only after the city had been invaded from the north did this southern force manage to enter the city, but they were unable to capture the citadel, which was so well fortified that it was not easy to capture it even from the direction of the city. It was only later, after negotiations, that the citadel surrendered, and the besieged Muslims left the city for the Muslim territories which remained along the southern coast of the country. Historians of the period describe a terrible massacre of the city's Muslim and Jewish inhabitants after the city was finally captured. The stories here are most horrendous. The city was virtually left empty of inhabitants. The Christian population had been expelled by the Mus-lims just prior to the Crusader siege, and the remaining Muslims and Jews were massacred or sold into slavery. The Crusaders apparently found it difficult to maintain city life in Jerusalem. A few days after their capture of the city, the heads of the armies met and decided to elect a king to rule over Jerusalem. The man they chose, Godfrey of Bouillon, did not actually receive the title "king", but according to one view he was called "Protector of the Holy Sepulcher", and according to another view, "Prince". After choosing a king, the Crusader leaders took another step towards normalization of city life, and also elected a Patriarch, who, by virtue of prior agreements, received the northwestern quarter of the city. This quarter, which became the prop-erty of the Patriarch – "The Patriarch's Quarter" – more or less parallels the present-day Christian Quarter. The choice fell on this particular quarter because it included the Church of the Holy Sepulcher, the ultimate goal of every pilgrim's journey.

"Paris Map" of Crusader Jerusalem
Jerusalem in a circular map, indicating its centrality, ca. 1260. Bibliothèque Nationale, Paris

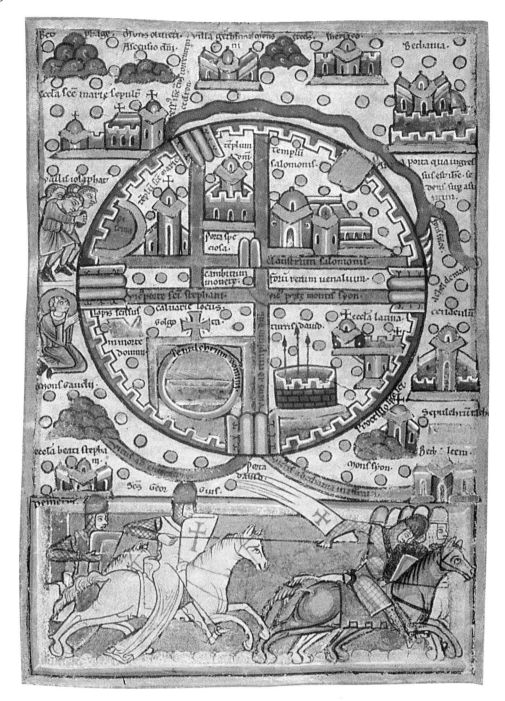

The Holy City surrounded by a circular wall
"The Hague Map" of Crusader Jerusalem, ca. 1170.
Royal Library, The Hague, Holland

The Last Supper
Detail of the carved marble lintel over the main
entrance to the Church of the Holy Sepulcher,
12th century, Jerusalem.
Rockefeller Museum, Jerusalem

In order to encourage the Crusaders to remain in the city, they were given a great privilege: ownership of the houses which they had seized. Their right to own and retain these properties was of course made conditional on their remaining in Jerusalem. Since many of the pilgrims aspired to return to their homes in Europe after their long voyage, this privilege was reserved for them for a period of an entire year. Thus many of the Muslim homes, which were relatively new (most, if not all of them, had most probably been built after the earthquake of 1033), remained in good condition throughout the entire Crusader period, and archaeologists have been unable to distinguish between them and Muslim houses which were built after the Crusader period. There are very few buildings in Jerusalem today which can be identified as Crusader houses.

Despite all the incentives offered by the heads of state, the city remained empty. Then King Baldwin I made another move. In his travels through southern Transjordania, he discovered Christians there who were living as Bedouins in the desert. After setting up a county there, the Transjordanian county, which became one of the most important of all the counties in the Crusader state, he brought the Christian Bedouin from there and settled them in Jerusalem to increase the number of Christians in the city. These residents were settled in what had formerly been the Jewish Quarter, and throughout the Crusader period it continued to be called "the Jewish Quarter". These Christian residents, who came from Palestine or Transjordania, were called "Syrians" during Crusader times, and their economic power in the city continued to increase throughout this period.

At this time the city plan was much as it had been in Roman-Byzantine times, although in some places, such as the Temple Mount and the Citadel, the stamp of the Muslims, who had introduced changes into the city, was clearly discernible. The main change in the functions of the various parts of the city occurred during the Crusader period. Until then, Jerusalem's central market had been located on the site of the Roman forum, south of the Church of the Holy Sepulcher. During Crusader times, this area served as the center for the Knights of the Order of St. John, and commerce shifted to the city's main streets. Thus, for example, anyone entering through the present-day Jaffa Gate (which was known as David's Gate in Crusader times), would pass through a street lined with shops, just as one does today. Likewise, the street descending from the Damascus Gate (which in Crusader times was called St. Stephen's Gate) towards Zion Gate was also lined with shops on both sides, just as it is today. Similarly, the many churches which were built at the time in Jerusalem have left their mark on the city to this day. We presently know of about 45 churches which had existed in Jerusalem. This is a very large number, especially if we estimate the number of inhabitants of the city at that time to have been about

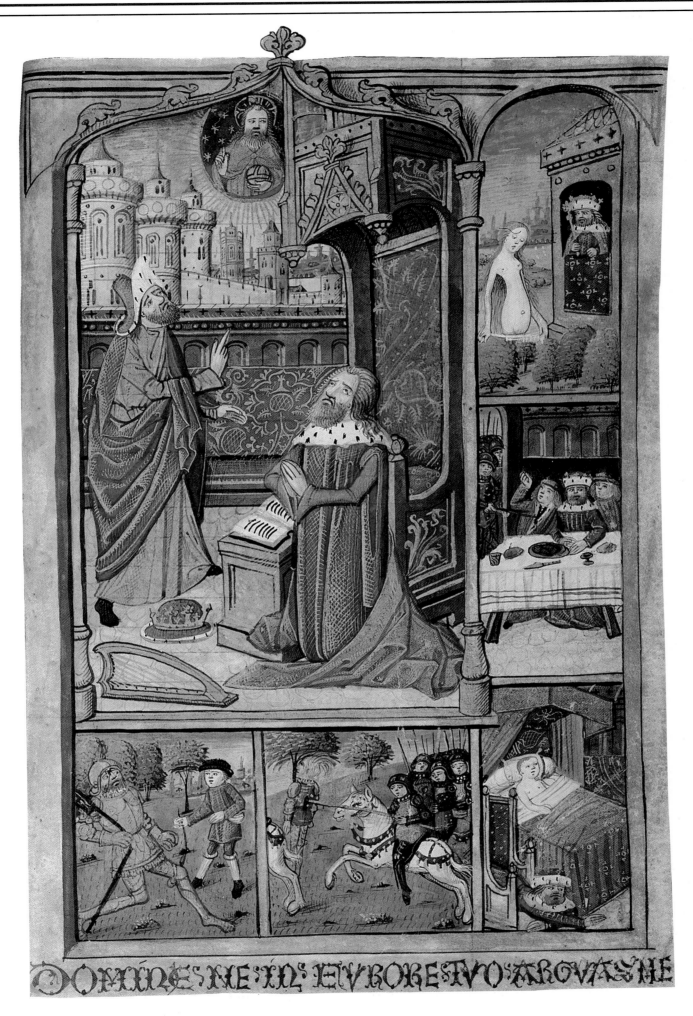

David in penitence, and other scenes in the life of the king

Miniature in the manuscript "The Playfair Book of Hours", from Rouen, France, late 15th century. Victoria and Albert Museum, London

"Cambrai Map" of Crusader Jerusalem
Ca. 1150. Bibliothèque de Cambrai, Cambrai, France

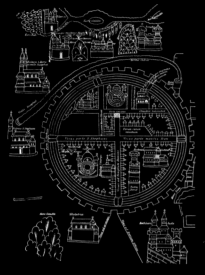

"Stuttgart Map" of Crusader Jerusalem
12th century. Württembergische Landesbibliothek,
Stuttgart, Germany

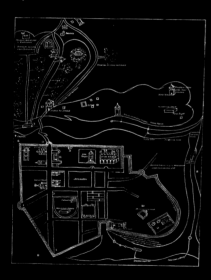

Map of Jerusalem
Based on the account of the Italian traveler Marino
Sanudo (ca.1260-1338) who visited the Holy Land
in the early 14th century. British Library, London

Right:
**Saint Stephen being led outside the walls
of Jerusalem**
Enamelled reliquary of St. Stephen, late 12th century.
Eglise Saint Priest, Gimel-les-Cascades, France

25,000 to 30,000. Dividing this number by the number of churches suggests that every 750 residents or so built a church for themselves, which makes for a very large number of churches. Another explanation for this is that the city contained churches whose sanctity derived directly from the acts of Jesus, his family and his disciples, and which had been built in an earlier period and had survived to the Crusader period. Such were the Church of the Holy Sepulcher, the Church of the Ascension, the Church of the Assumption, the Church of Mount Zion and so on. The other churches were local parish churches in areas populated by people with diverse religious identities – Greeks, Armenians, Georgians, Nestorians, Catholics, etc. Each such sect built a church for itself. Of these numerous churches quite a few have survived, some of which are still used as churches, while others have become mosques, and still others have been unearthed in archaeological excavations or surveys. The neighborhoods were concentrated around these churches, just as today the residential areas are concentrated around the mosques where the local residents pray.

From the many historical sources which have reached us, both documents dealing with real estate property, purchases, sales, and donations, etc., and from descriptions by pilgrims, it appears that there were a number of central holy places in the city which every pilgrim made sure to visit. The Church of the Holy Sepulcher was undoubtedly one such site. Built by Constantine the Great in the 4th century, it was destroyed in the year 1009 by the Fatimid caliph Al-Hakham B'amar Allah. Its restoration in 1048 was intended merely to preserve its function as a place for prayer, and nothing remained of its ancient beauty. The Crusaders who reached Jerusalem decided to rebuild it, and even created a sacred complex which included a monastery (for Augustinian canons), the House of the Patriarchate, additional chapels and also a new sacred site, created here for the first time – the pit in which, according to tradition, Queen Helena, Constantine's mother, had found relics of the Crucifixion: the cross, the nails, the crown of thorns, the rod and the sponge. The construction of the Crusader structure was prolonged, lasting 50 years, and it was consecrated in 1149 on the 50th anniversary of Christian rule in Jerusalem. This is the structure which still stands today. Its original form has changed over the years, for the various communities made diverse additions to the church, but in general it may be said that

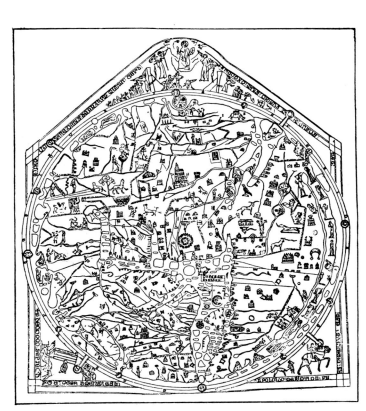

**Hereford map of the world
with Jerusalem in the center**
Ca. 1283. Hereford Cathedral, England

on the whole the church has been preserved as it was built. The monastery was totally destroyed, and is used today by the Ethiopian monks who serve in the chapels they maintain in the church – the House of the Patriarchate was taken from the Christians by Saladin, who turned it into a "Hanqa", i.e., a kind of monastery, which to this day is named after him, "Hanqat Salahia".

The Church of the Dormition on Mount Zion was also one of the most important churches in Jerusalem. Although it was preserved in a bad state, enough of it remains to allow reconstruction of its original form, and everyone today is familiar with the Hall of the Last Supper, which was a kind of wing of this church, whose columns can still be seen today near David's Tomb and next to the entrance to the Hall of the Last Supper.

The Church of the Tomb of the Virgin was totally destroyed, and only small sections of it were discovered in archaeological excavations conducted there in the 1930s. The crypt, which stems from the Byzantine period, has been preserved to this day, and during the years of Crusader rule, queens of the kingdom were buried there not far from the Tomb of the Virgin Mary. The Church of St. Anne, traditionally the place of the Virgin Mary's birth, has been preserved almost in its original form to this day, because Saladin converted it into a religious school (a "madrasa"), which saved it from ruin over the years. The Churches of St. Agnes, St. Ely, St. Peter in Chains, Thomas of the Germans, St. Thomas, St. Julian, St. Mark and others, have been preserved to this

day, and it is almost possible to use them today as they were used in the 12th century.

One of the central holy places was the Temple Mount. It towered above most of the houses that had been built along the length of Jerusalem's central valley. The pilgrims believed the Western Wall of the Temple Mount, the entire length of which was still exposed at that time, to be the city's eastern wall, which made the Temple Mount appear to be outside the city wall and east of it. When the Crusaders arrived, they found two mosques there, for which they could not find an appropriate liturgical expression. They therefore decided that the southernmost of the two (the Al-Aqsa Mosque) was Solomon's Temple, and that the Dome of the Rock was the Temple where Jesus had preached, "the Temple of the Lord". This latter Temple was of great importance, and it was even incorporated into the kingdom's schedule of official holidays. Thus, for example, the ceremonies of coronations of kings which were held in the Church of the Nativity culminated in a celebration that was held here. The entire Temple Mount was divided between two bodies. Its northern part belonged to the order of Augustinian canons who served in the "Temple of the Lord", and its southern part – where the main structure was the Al-Aqsa mosque – was used by the Knights Templar. At first, after the Crusader

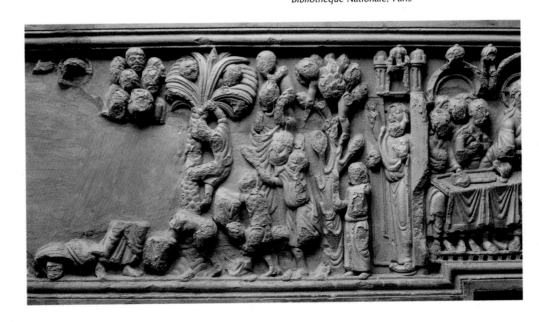

The Crusaders' siege of Jerusalem
French manuscript, 13th century.
Bibliothèque Nationale, Paris

Jesus' entry into Jerusalem
Detail of the carved marble lintel over the main entrance to the Church of the Holy Sepulcher, 12th century. Rockefeller Museum, Jerusalem

conquest, the Al-Aqsa mosque was used as a palace for their kings. They chose this particular structure for this purpose because it was a broad and spacious building and was relatively new, having been built after the earthquake of 1033. In 1118, Baldwin II gave the building to an order which had just been formed on the Temple Mount and was therefore called the Order of the Knights Templar. They settled at this site, and also built a magnificent palace there, the few meager vestiges of which are used today as part of the Islamic Museum and as part of the women's mosque.

The Crusaders also built a baptismal house on the Temple Mount, next to the Dome of the Rock. On the rock itself, they erected an altar with beautiful iron candelabra on either side which have been preserved to this day. The rock itself, which was sacred to Christians because of various traditions connected with it, was encircled with an iron screen to prevent pilgrims from breaking off pieces as souvenirs, as they were wont to do at Christ's Sepulcher, the Tomb of Mary and at other very holy sites.

From the various historical documents we learn of an increase in the number of different nationals in Jerusalem at this time. None of these nationals – English, French, Spanish, Portuguese, Italians and others – created a separate neighborhood for itself. On the contrary, the documents indicate that they sold houses and other property to one another without regard for country of origin, so there was no possibility for such "national quarters" to come about. Although there was a street in Jerusalem called

The Church of the Holy Sepulcher
Embossed on a Crusader seal of the 12th century

Coin of Baldwin III
Minted by the fourth king of the Latin Kingdom of Jerusalem, 1144-1163. The Israel Museum, Jerusalem (obverse; reverse at bottom of page)

"Spain Street", it is difficult to know why it was called by this name: not one of its known residents was of Spanish descent.

The city of Jerusalem subsisted mainly on government services; the king and his court, and the Patriarch and his court, were important economic focal points. The pilgrims who came to visit Jerusalem also provided a source of revenue. We have knowledge that there were Syrian and Latin moneychangers, souvenir shops near the Church of the Holy Sepulcher, and even a street where there were restaurants for pilgrims and which for this reason was called "The Street of Bad Cooking". All these served as sources of revenue for the city.

One document describes the importing of laborers from the present-day el-Bireh area to build a street in Jerusalem. This is almost the sole testimony to Jerusalem's ties with its economic hinterland. Because Jerusalem was located in the mountainous district of the country and

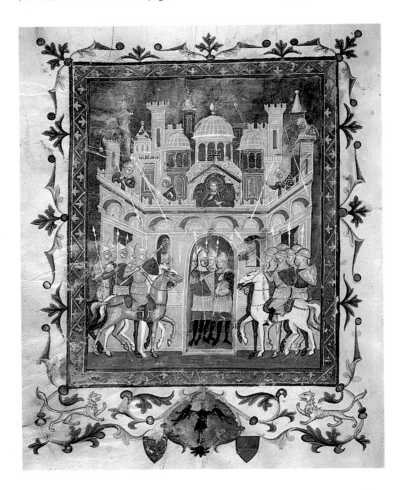

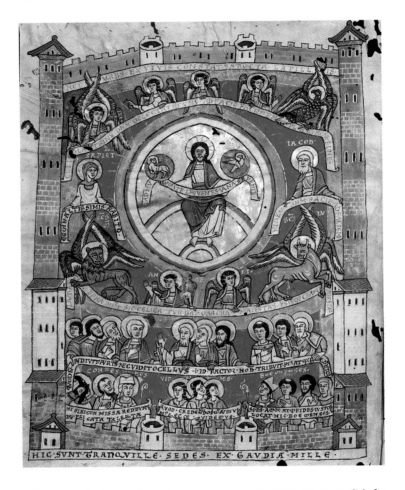

Left:
The Crusaders enter the gates of Jerusalem
From a manuscript of Descriptio Terrae Sanctae. Biblioteca Seminario, Padua, Italy

Right:
The Heavenly Jerusalem
Manuscript of St. Augustine's De Civitate Dei, 12th century (with contemporary figures in the miniature). Hradcany Castle, Prague

was at some distance from the coast, it did not have the same economic importance as did, for example, Acre, where commercial trade routes from the interior of the country to the coast were concentrated. For this reason the Italian cities that controlled commerce in the Mediterranean and assisted the Crusader state in its conquests waived their rights to the neighborhoods in Jerusalem which the state apportioned to them in exchange. In Acre, however, there were quarters that belonged to the Italian cities, and these were an important factor in that city's development. In Jerusalem, there were a few Italian merchants, who lived on David Street (as it was called during the Crusader period as well), not far from the present-day Jaffa Gate.

When Saladin began his attacks on the Crusader state in 1177, the heads of the kingdom decided to fortify it, and finances were prepared to inspect and repair the city walls. Although we do know the sums that were requisitioned for this purpose, we do not know whether the walls, which were then already about 120 years old and certainly in need of repair, were actually reinforced. In October 1187, Jerusalem fell to the armies of Saladin, who breached the city at exactly the same point where the Crusaders had entered it 88 years earlier. This was the end of the Crusader city. Not until 42 years later, in 1229, would the Christians return and rule over part of Jerusalem, their soul's desire.

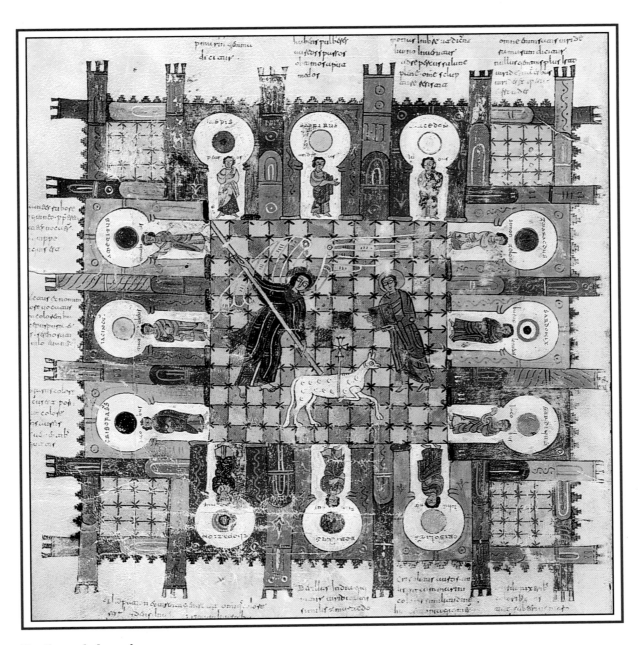

The Heavenly Jerusalem

Jerusalem as a square city with 12 gates in which stand the 12 Apostles, with the 12 precious stones in the Breastplate above their heads; from a manuscript of Beatus of Liébana, Commentary on the Apocalypse, Spain (province of León), mid-10th century.
Pierpont Morgan Library, New York

AN ORIENTAL CITY: THE MAMELUKES AND THE OTTOMANS

10

1250-1917

A.D. A.D.

"Throughout the entire kingdom there is no city in which the buildings are so strong, nor any city whose general appearance is so pleasant, as Jerusalem."
(Majir A-Din, 1495)

Sultan Suleiman the Magnificent as an old man, with two dignitaries
Ottoman miniature by Nigari, ca. 1560. Topkapi Palace Museum, Istanbul

Muhammad's Ascension to Heaven (Al-Miraj)
From a manuscript of Nizami's poems, 1494-95. British Library, London (detail)

Right:
Tomb of King David
Detail from Braun and Hogenberg map of Jerusalem

With the return of Jerusalem to the dominion of Islam, the Muslims were able to change the city's appearance and to imbue it with the Oriental character it has preserved to this day. The city flourished, and many sacred buildings were added to it. Its markets were filled with many goods. The great change in the city's appearance began in the mid-19th century. The empire was weakened, the city expanded considerably, and its foreign residents were granted extra privileges. Consulates were opened, the Jewish population grew and began to settle beyond the city walls, becoming the majority among the city's inhabitants. The process of moving out of the Old City continued to the end of the century, and with the outbreak of the First World War, a large proportion of the city's Jewish inhabitants already lived outside the walls.

I n the year 1250, after the battle at Mansourah between the Ayyubid rulers and "Saint" Louis, King of France, control of Jerusalem changed hands once more. The Mameluke soldiers, who were the property of the Ayyubid princes, managed to seize control of the state and to appoint their own sultan. Thus began the rule of the Mamelukes in Jerusalem, which continued until 1517, when the Ottoman sultans conquered the city. The Mamelukes were successful in exploiting the weakness of the various Ayyubid kings and princes, and took dominion over the entire Ayyubid kingdom and even beyond, so that the Mamelukian state extended from Southern Anatolia to the Sudan – a powerful state with its capital at Cairo.

Jerusalem did not play a significant role within this great state. Even at the beginning, when the Crusader state still existed next to Jerusalem, the Mamelukes did not bother to fortify the city, probably because of its location in the hilly area far from the main routes of the Mameluke state. Throughout the entire Mameluke period, Jerusalem had no city walls. These had been

destroyed during the Ayyubid period (1219), and were restored only by Suleiman the Magnificent (1538-1541). The Citadel alone, as the seat of the city's military rulers, was restored in 1310.

As already noted, Jerusalem did not occupy an important position in the kingdom. When the Mamelukes divided their kingdom and established administrative cities, Jerusalem was made subject to Damascus, whose rulers became responsible for it. Jerusalem's official status was raised slightly only in 1376, when a governor (Naib) was appointed for it, determined by Cairo (as distinct from a "Wilaya" appointment, determined by Damascus).

Jerusalem was considered a place of exile for dignitaries who had fallen out of favor or for high officials whom someone had decided to distance from the centers of power. Jerusalem, distant even from the mail routes – a most important concept in this extensive kingdom – was an isolated place well suited to the idea of creating a place of political exile.

The exiles who were sent to Jerusalem were called "batal", i.e., "the annulled". For some officials, exile to Jerusalem meant the end, since from here they were summoned to Cairo never to return. Others were eventually returned to power. The residence of these "annulled" people in Jerusalem brought a period of flourishing to building in the city, for they wanted to build religious edifices that would glorify their names and commemorate their deeds. The buildings they built were handed over to the authority of the Muslim Wakf. In a few instances, this was made conditional on the donor's heirs being allowed to manage these buildings as well as those properties purchased to maintain them (e.g., entire villages, bath-houses, shops, soap factories, etc.). In this way they ensured that the property would not be totally lost to members of their families, while Jerusalem itself benefited in terms of its outward appearance, even though it still lacked political significance.

The city was distant from the principal commercial trade routes, and hence was not involved in any extensive economic activity. The absence of a particularly fertile hinterland or of valuable industries made Jerusalem a quiet, provincial, and conservative city. Compared with other cities in the country such as Nablus, Safed or Gaza, Jerusalem was considered secondary, although it still had great religious significance. When the Mamelukes came to power, there was still a conspicuous Christian presence in the city. Many buildings from Crusader times were still standing and in good repair. This fact actually aroused a desire in the Mamelukes to reshape it as a Muslim city.

Various edifices on the Temple Mount were built or restored. For example, the mosaics inlaid on the Dome of the Rock and on the Al-Aqsa mosque were renewed. In general, it should be noted that the decisive majority of buildings presently on the Temple Mount stem from this period. The four towers which adorn the Temple Mount were built at this time, and so were the various water installations there.

A phenomenon typical of this period was the arrival in Jerusalem of religious sages, dervishes and learned scholars who came here to teach and study. This led to the construction of "madrasas" (colleges), buildings containing classrooms and hostelries for students. Here the principles of Islam were taught according to the various schools prevailing then in the Muslim world. These buildings, whose magnificent façades still constitute an artistic element of the first rank in the city's appearance, were built principally in the environs of the Temple Mount – actually, alongside the Western Wall, the northern wall, and in the streets leading to its gates. This network of "madrasas", which began to appear during the Ayyubid period (though some connect it to the time of the Seljuk rule, 1071-1098), employed many people in its administration, as well as preachers, teachers, teaching assistants, and the like.

Since many of the high officers and officials were of non-Muslim origin, by building these

Firman – an official Turkish decree
The decree forbids collection of additional taxes from Jews making pilgrimages to Jerusalem; issued during the reign of Sultan Mustafa III (1757-1774). The Israel Museum, Jerusalem

A sailing boat anchored in the port of Jaffa
From the travel book of Bernhard von Breitenbach, who visited the Holy Land in 1483

Jerusalem and the Valley of Jehoshaphat from the Hill of Evil Counsel
Thomas Seddon (1821-1856), 1854. Tate Gallery, London

Head of the Maronite Church in Jerusalem, in 1631
From the the travel book (printed 1646) of the Franciscan missionary Eugène Roger

"madrasas" they proved their allegiance to the religion which at times had been forced upon them but in the framework of which they had risen to greatness.

Generally speaking, the Mameluke city was a continuation of its predecessors, the Crusader and the Ayyubid cities. The major change in the city's appearance was discernible mainly on the Temple Mount and its immediate environs. Mameluke construction was distinguished, among other things, by the fact that it made extensive use of parts of dismantled Crusader buildings, e.g., Crusader capitals, cornices, window parts, etc. This process of dismantling Crusader structures continued during the Ottoman period as well, for some of the buildings erected by Suleiman the Magnificent are also inlaid with Crusader architectonic parts.

During the period under discussion, the process of turning the streets into commercial centers continued more vigorously. It will be recalled that it was the Crusaders who brought commerce and trade out of the Roman squares, where these had been concentrated, and onto the main streets. The Mamelukes continued and accelerated this process, and it was in their time that retail trade began to flourish on the side streets as well. We know of markets such as those of the silk merchants, the cotton merchants, the copper market, the souvenir market located near the Church of the Holy Sepulcher, and others. Stories told by contemporaries about these well-built markets describe the Crusader markets which still exist to this day.

Among the civil construction projects in Jerusalem, we should mention the aqueducts from Solomon's Pools, which were repaired a number of times during this period, and also the Citadel – the only fortification that continued to be used for the city's defense – which was also repaired several times. Tombs from the period were discovered mainly on the western side of the city – e.g., the Mamilla cemetery, the cluster of tombs on Strauss Street and others similar to them, especially the "Turbe" (burial structures) in the heart of the city.

Because of its sacredness, Jerusalem was a lodestone for peoples and sects from all over the Muslim world. Thus, for example, people from North Africa (the Maghreb) settled in the area south-west of the Temple Mount, and the southern gate of the Mount – the Mughrabi Gate – was named after them. They also built a mosque (the Mosque of the Mughrabis) on the Temple Mount, on the site of the western wing of the Templar palace from Crusader times. In the north of the city was an Eastern Quarter, inhabited by people from countries in Central Asia such as India and Afghanistan. In contrast to them, the Christians in Jerusalem suffered various restrictions – they were not permitted to renovate damaged churches, and they were expelled from sites sacred to them, such as the Church of the Cross, the Dormition, etc. Nonetheless, they – and especially the Eastern Christians – were not prevented from expanding their neighborhoods. This was because of the closer affinity of the Eastern Christians to the Arabs, which helped to make them more acceptable to the Muslims. Proof of this is found in the fact that Western pilgrims recorded the alienation and even animosity shown them by Eastern Christians.

The Jews too, who during the Mameluke period moved to the neighborhood which is known to this day as the Jewish Quarter, were also an important factor in the city. For the most part, they cooperated with the Muslims, because they had no pretensions to rule in Jerusalem or anywhere else.

We know, for example, of a case where damage to a synagogue in Jerusalem led to the Sultan's intervention on behalf of the Jews.

In 1517, after the battle of Marj-Dabik in northern Syria, when the Ottoman army defeated the Mameluke army, Jerusalem too was captured by the Ottomans. Selim the Cruel, conqueror of Jerusalem, paid only a short visit to the city and accepted its surrender while in Gaza. However, when the country was once again divided into provinces ("sanjaks"), Jerusalem became the capital of one "sanjak". The other "sanjaks" in the country were Safed, Nablus and Gaza. The "sanjak" of Jerusalem was divided into two districts, Jerusalem and Hebron.

Around the time when Jerusalem was captured, the Ottoman Empire was at its peak, especially during the time of Suleiman the Magnificent, also known as "The Law-Giver" (1520-1566). This had a considerable impact on Jerusalem, for the Ottoman rule spread a sense of security, and the flow of Christian and Jewish pilgrims increased. Likewise, economic growth began again, not only in Jerusalem but also in its environs, which were the sources of its supplies.

A small garrison comprising about 90 men was stationed at the Citadel in Jerusalem. The supervisor appointed by the central authorities made his seat the Jawaliyya building at the northwestern corner of the Temple Mount, which had been the seat of the Mameluke governor. Only later did he move to the heart of the city, to the Seraya, and in the 19th century to the Kishleh, adjacent to David's Tower.

Map of Jerusalem
From the Italian book by the Franciscan monk Bernardino Amico who served in Jerusalem in the years 1593-97

After Suleiman the Magnificent ascended the throne and established himself in power, various development projects were carried out in the city. By 1532, six fountains ("sabils") had already been installed to supply water to Jerusalem's neighborhoods. The best known of these is the "sabil" at The Sultan's Pool. It seems that the problem of water in the city was a severe one, for the first Ottoman construction project in Jerusalem was to install the "sabil" on the Temple Mount – the Kassim Pasha sabil (1527).

At the end of this decade, the construction of the city walls began. It will be recalled that the walls had been destroyed by the Ayyubids in 1219, and had not been rebuilt since. The Ottoman sultans greatly feared the Christians overseas might begin another crusade, especially since they had established massive fleets, such as the Spanish one. The period of Suleiman the Magnificent was also the time of Carlos I (Charles V of Austria), and Philip II, when Spain was at the height of its power, and was seeking influence in the Mediterranean. The Ottomans, fearing such an invasion, began building the walls of Jerusalem in 1537-38. Except for a few minor points where the Ottomans deviated from the ancient course, these walls may be seen as a reconstruction of the previous walls. This was the most important construction project ever undertaken by the Ottomans in Jerusalem. At the same time, some building work was also done on the Temple Mount. The Dome of the Rock was renovated, and it was at this time that the mosaics on the outside walls were replaced with the ceramic tiles familiar to us today. These tiles, with their inscriptions, are one of the Dome's distinguishing marks. They were installed in 1522 and have been restored several times since then.

The Church of the Holy Sepulcher in the 16th Century
From the travel book by the Flemish pilgrim Jean Zuallart, who visited the Holy Land in 1586

The Ottoman Empire opened the gates of commerce to the East, and the peripheries of this global trade reached Jerusalem. Jews who had won themselves a place of honor at the Sultan's court in Istanbul took care of their brothers in Jerusalem, and the city benefited from this. From the mid-16th century on, the Jews were already the second largest community in Jerusalem,

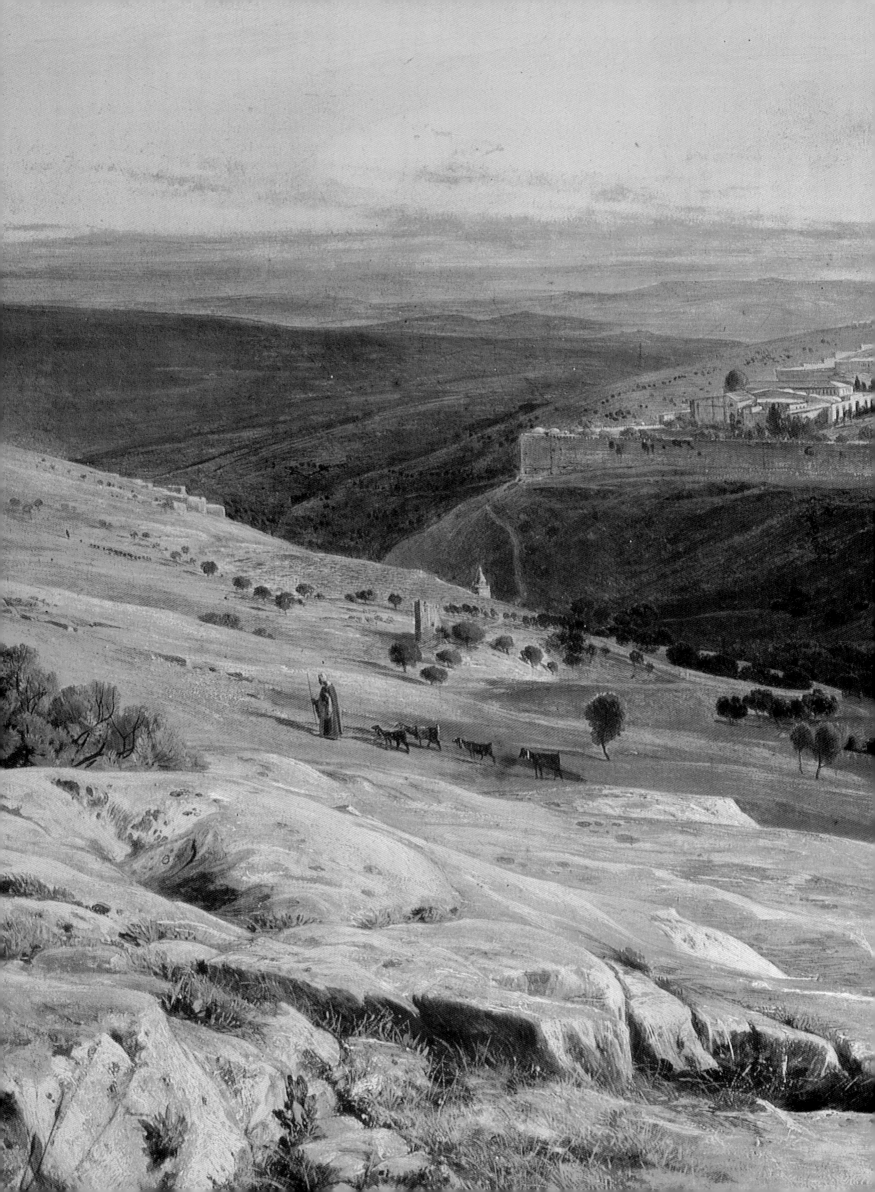

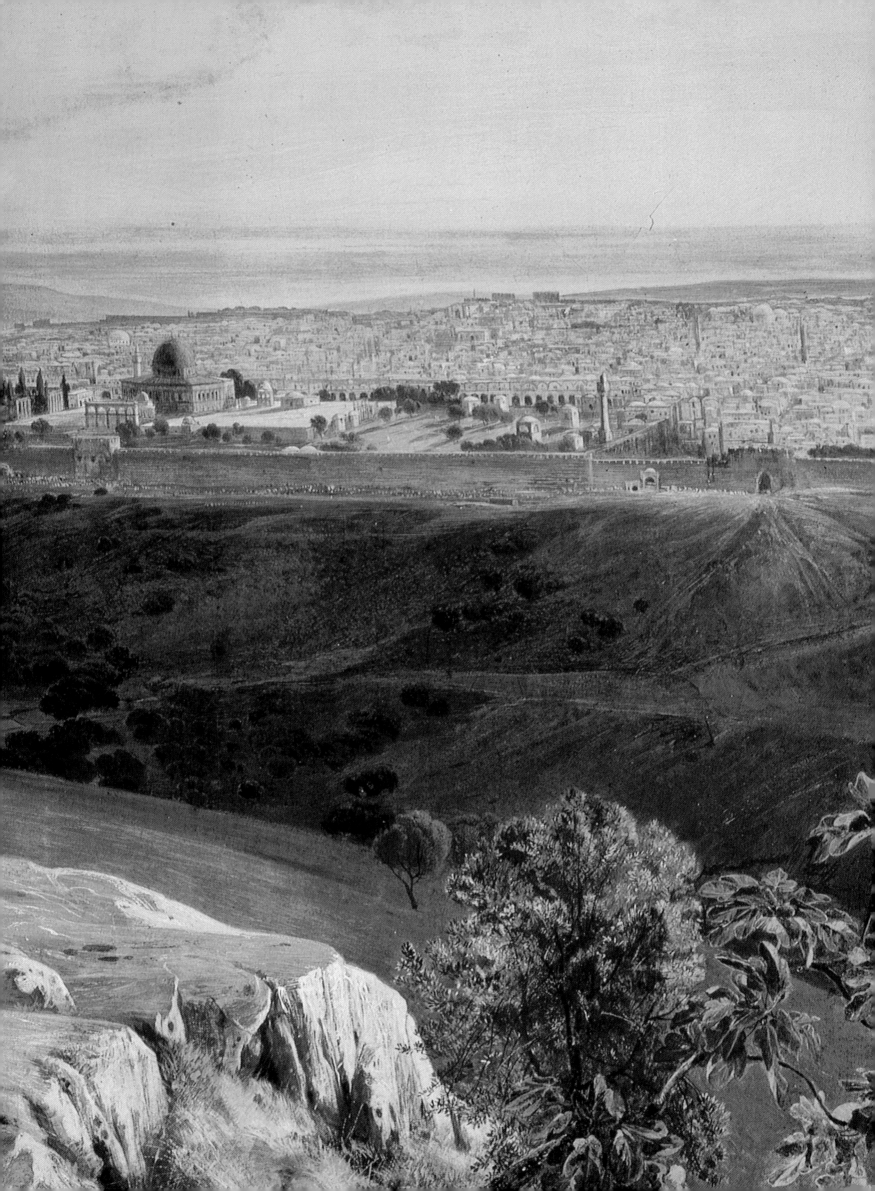

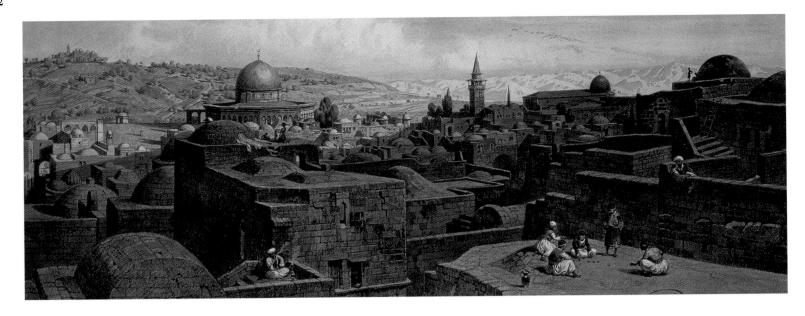

A view of Jerusalem with the Dome of the Rock from the terrace of the Austrian Hospital
Carl Friedrich Heinrich Werner (1808-1894), 1864.
Private collection

"Turkish Passport" to the Holy Land
Issued for a Christian pilgrim in the late 16th century; from the travel book (printed 1608) by the German theologian, Salomon Schweigger

Previous pages:
Jerusalem from the Mount of Olives
Edward Lear (1812-1888), 1859. Christie's Collection, London

after the Muslims. This prosperity, however, did not last long. When the Sultan Selim II came to power (1566), the entire empire began to decline. The authorities instituted the practice of allowing private persons to purchase the right to collect taxes, and these persons also attempted to recover some of their own expenses in this way. This was a harmful practice, because the tax farmers oppressed the population, who tried to evade the burden of payment and fled to outlying areas. In this way these people led to a decline in economic activity in the city. Expenditures for public needs gradually diminished, and the water and sewage systems were neglected. Public buildings suffered damage as well and very soon a sense of neglect was felt in the city. In the 17th century the Ottomans began to suffer defeats on the battlefields in Europe, and as a result became even less willing to invest in and to develop installations throughout their empire.

In the years 1603-1625, by dint of having purchased positions, Ibn Farukh ruled in Jerusalem. He extorted the city's inhabitants, and in effect brought about a total economic collapse. The Jews of Jerusalem appealed to the Jews at the court in Istanbul, and the latter succeeded in having him ousted. During his time the number of inhabitants in Jerusalem had dropped drastically. After his removal the population began to grow again, and in 1677 numbered about 15,000 inhabitants, still much fewer than the more than 20,000 people living there during the time of Suleiman the Magnificent, so that the city did not return to its 16th-century dimensions.

The decline in the Ottoman morale because of their defeats in Europe affected the attitude of the authorities in Jerusalem toward the Christians. The Franciscans, the most important faction among the Christians, had already been banished from their center at Mount Zion in 1552. They blamed the Jews for this, claiming the latter had persuaded the Ottomans to banish them. This accusation undermined the relations between the two communities to such an extent that Christian ships (mostly Venetian) sailing between Europe and the Holy Land refused to take Jewish pilgrims aboard. Later, the Franciscans inaugurated their new center, which exists to this day, in the Church of St. Savior (San Salvatore), in the northwestern part of the Old City. Changes in the ownership of churches became increasingly common as various sects grew impoverished and were forced to sell their properties. Thus, for example, the Greeks took control of the Monastery of the Cross, which had formerly been Georgian property, and there are other examples of this nature.

In place of the weak government, a number of Jerusalem families – such as the Nashashibis, Husseinis, Al'amis, Khalidis and others – began to appear in the city's socio-economic life. These families took permanent hold of the various government posts, and established a position of power for themselves.

From the beginning of the 17th century on, the city appeared totally neglected and on the verge of collapse.

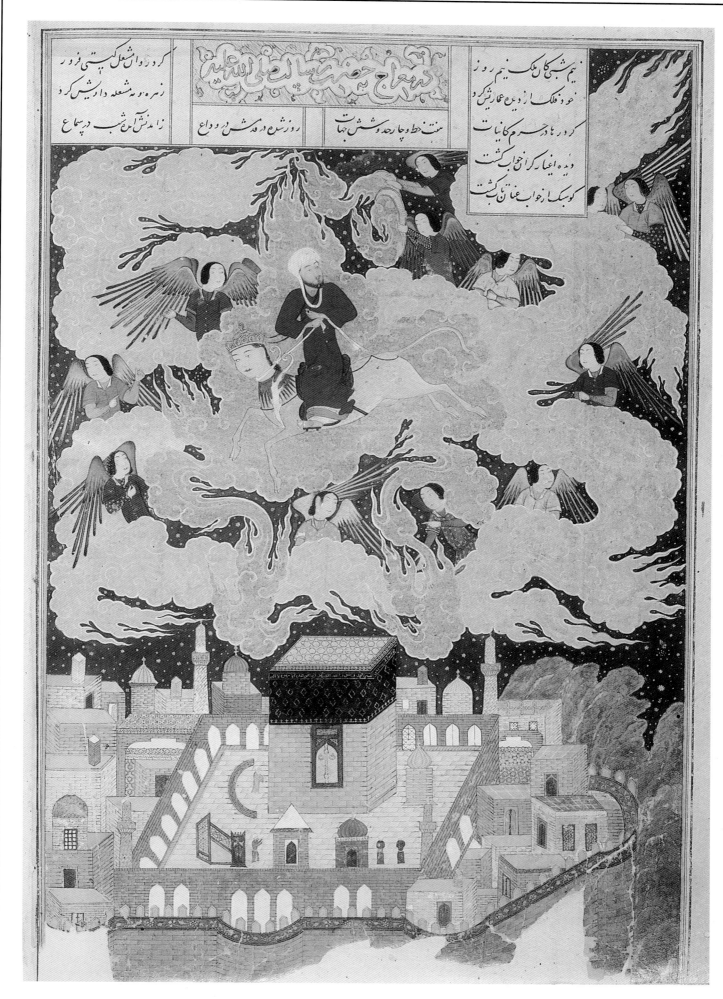

Muhammad's Ascension to Heaven (Al-Miraj)

From a manuscript of Nizami's poems, Persia, 1494-95. British Library, London

View of Jerusalem
*From Salomon Schweigger's pilgrimage book,
printed in 1608*

**Arab sheikhs in Jerusalem in the early
17th century**
*From the book by the Italian pilgrim Bianco Nóe,
printed in 1640*

Governor of Jerusalem in 1565
*From the travel book of the German pilgrim Johann
Helfrich, published in 1577*

The European powers played an important role in Jerusalem. The French were the first to exploit the weakness of the Ottoman Empire, and sought to establish a consulate in Jerusalem (between the years 1525-1636 and 1699-1716) to promote the interests of the French religious. However, objections by other Christians (the Franciscans, for example) who were supported by Venice which was still a very powerful state, prevented the French presence from making itself felt on a permanent basis. Moreover, the position of the Greek Orthodox among the Christians was especially strong, since they lived within the Empire and were not considered foreigners.

In 1629, a conflict erupted over the holy places in the Church of the Holy Sepulcher. The Sultans wavered between the Greeks, who were citizens of the Empire, and the foreigners, who enjoyed the backing of European powers. Towards the end of the 17th century, the Greeks had already appealed to the Russians to support them against the French and Venetians. These power struggles went on into the 18th century as well, and reached their peak in the Crimean War, after which the arrangement known as "the status quo" was reached, according to which the interests of the holy places in Jerusalem are managed to this day.

The 19th century wrought changes in the annals of the city. The crumbling Ottoman Empire did not manage to preserve its unity, and in 1831 the Holy Land was conquered by the Egyptians. Mohammed Ali and his son, Ibrahim Pasha, had succeeded in establishing a dynasty of rulers who on the face of it ruled on behalf of the Ottomans but in fact were completely independent and even fought against the Ottomans. Thus Ibrahim Pasha conquered Palestine in 1831, and introduced innovations and reforms in the spirit of the European states of that time. The non-Muslims benefited from these reforms, for Ibrahim Pasha's laws prohibited discrimination against them. The Egyptians thus gained the support of the European powers, by acting in the interests of their citizens.

The first expression of the new spirit was the renovation of the four Sephardi synagogues in the Jewish Quarter. Likewise, Jews were permitted to pray undisturbed at the Western Wall.

In 1840, Ottoman rule returned to the city. This, however, was a different Ottoman Empire. It had already assimilated the changes and reforms (the Tanzimat) legislated after the Crimean War in 1856, after which the European powers had won many concessions within the Empire. Among these were recognition of the rights of foreigners, both in matters of religion and with regard to purchase of real estate, construction of churches, etc. Especially important was the regulation that foreign citizens were subject to their consuls and not to Ottoman rule. This applied to Jews as well, for most of the Jews in the world then lived within the boundaries of the powers which were parties to the agreements, such as Russia, Germany, Austro-Hungary, etc. Because of its unique position in these matters, in 1873 Jerusalem became an independent unit within the Empire, and was subject directly to Istanbul.

Events in the Middle East in general affected Jerusalem. The opening of the Suez Canal (1869) and the visits by royal sovereigns to Jerusalem on their way to the inauguration of the canal drew attention to the city. The transportation system leading to the city was greatly improved, and this in turn increased the traffic of tourists and pilgrims coming there. This made it necessary to build hotels and hostelries, and a period of construction began in the city itself, which quickly spread to beyond the walls of the Old City and opened new horizons for the development of Jerusalem outside the walls. Thus a new period in the city's annals began.

Suleiman the Magnificent (1494-1566)
The Turkish Sultan who erected the wall of Jerusalem (1535-1541), which is still standing today. Kunsthistorisches Museum, Vienna

11

RETURN AND RENEWAL: THE CAPITAL OF ISRAEL

19th-20th

CENTURY CENTURY

"Jerusalem too can flourish once again
and become a most magnificent city in our own period."
(Theodore Herzl)

Hanukkah lamp
Brass, Bezalel School of Arts and Crafts, Jerusalem, ca. 1930. The Jewish Museum, New York

The Jewish national movement – which drew nourishment from the sources of the past, and developed as a social movement in the late 19th-century sense – aspired to realize its aims in the Holy Land. Herzl already envisaged Jerusalem as a modern city. Following the British conquest of the country, major institutions were established in the city, such as the Hebrew University, the national institutions, as well as modern neighborhoods. Thanks to these developments, Jerusalem gradually returned to the center of the Jewish people's striving for renewal, and subsequently became the capital of its state – the State of Israel.

Moses the Lawgiver
Detail from a Mizrach tablet, color lithograph, Germany (Breslau?), late 19th century. The Jewish Museum, New York

Right:
Kiddush (Sabbath benediction) cup engraved with the Wailing Wall
Gilded silver, Poland, late 19th – early 20th centuries. Wolfson Museum, Hechal Shlomo, Jerusalem

As a consequence of the relief felt by the foreign residents in Jerusalem at the beginning of the conciliatory regime established after the Crimean War, massive construction began in the city. The Christians built many churches, including the Church of the Sisters of Zion (1868), the Church of St. Anne (1860), the Catholic Austrian Hostel (1856), the Russian Orthodox Church of Alexander Nevsky (1887), and the Protestant Church of the Messiah and the Church of the Bishop Gobat (1855). The Jews, too, built extensively – e.g., the Hurvat Yehuda HeHasid (1864), Nissan Beck (1872), etc. While the Christians established missionary medical institutions, the Jews developed hospitals of their own: in 1845, the Rothschild Hospital was built, and in 1857 the Bikur Holim Hospital. The Jews also established charitable institutions, such as the Batei Mahase in 1860.

The Jewish city continued developing, especially in the Old City. Hagai Street (Hebron Street) was one route of development, and the Armenian Quarter too was a target for Jewish expansion. The Jewish Quarter, the smallest of the city's quarters, (about one sixth of the area of

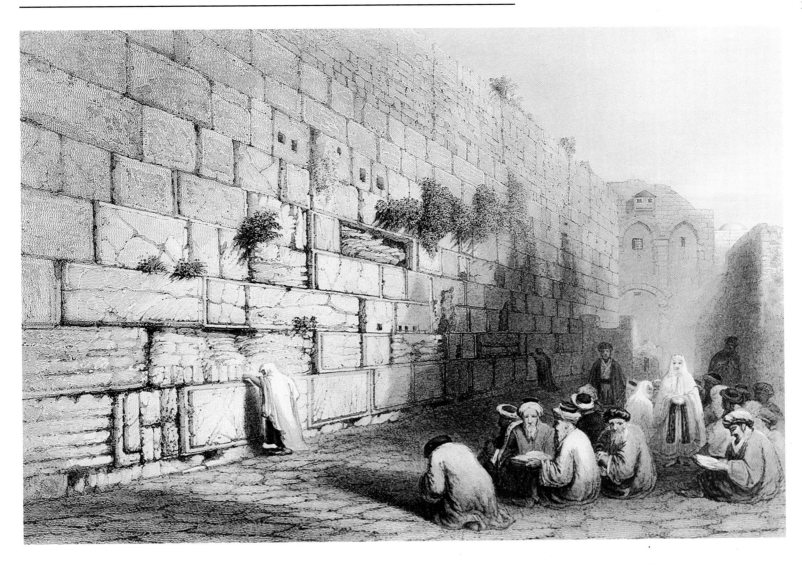

Jews' Place of Wailing, Jerusalem
Stipple engraving by William Henry Bartlett (1809-1854), 1842. The Israel Museum, Jerusalem

the Old City), was unable to contain the number of Jews in the city, who now made up more than sixty per cent of the city's population.

Since the Muslim rulers now also allowed non-Muslim residents to purchase lands, Jews began purchasing areas of land outside the city too. The British consul, James Finn, had built a house outside the city, and immediately after this, in 1856, Bishop Gobat built a Protestant school on Mount Zion. In 1860, the Russians established a complex north of the city, containing hostelries for pilgrims, hospitals, a consulate, and other facilities. Jews saw these building projects as opening up possibilities for themselves as well, but to many of them moving outside the walled city seemed to be difficult and unsafe. Sir Moses Montefiore, while visiting Jerusalem in 1854, purchased a tract of land west of the city. Here, in 1860, with the assistance of Yehuda Toura, he established the Mishkenot Sha'ananim neighborhood. In 1867, Jews from Morocco established a neighborhood of their own, Mahane Yisrael, near the Mamilla Pool. Over the years, the road to this neighborhood became one of the most important commercial centers in Jerusalem until 1948.

Jewish Sephardi family in Jerusalem
From a book by the French scholar P. Lortet, published in Paris, 1884

Due to the unique topography of the city's environs, urban development took place principally to its north and its west. German Templars built a large neighborhood southwest of the city (1872), and in 1869 Jews purchased a tract of land near the road leading to Jaffa. Here they founded the Nahalat Shiv'ah neighborhood, which became the nucleus of the new city. In 1874, Jews built the Me'ah She'arim neighborhood, which became a

"Next Year in Jerusalem"

View of the wall of the Holy City in an early 18th-century Passover Haggadah from Moravia. Private collection

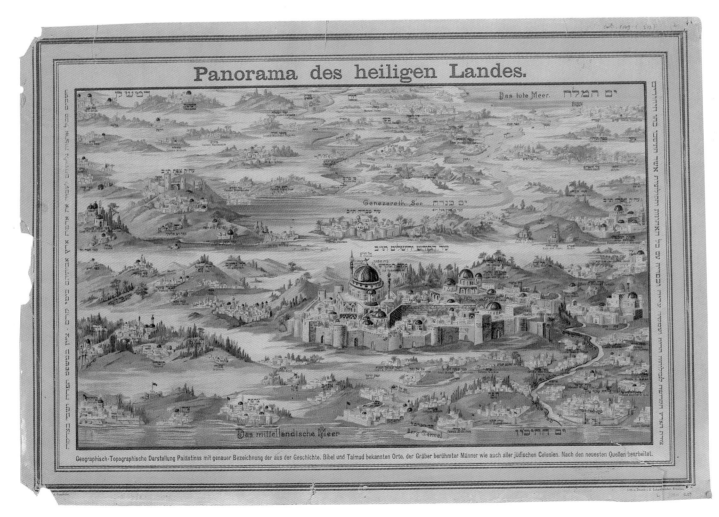

Panorama des heiligen Landes.

Geographisch-Topographische Darstellung Palästinas mit genauer Bezeichnung der aus der Geschichte, Bibel und Talmud bekannten Orte, der Gräber berühmter Männer wie auch aller jüdischen Colonien. Nach den neuesten Quellen bearbeitet.

Panoramic view of the Holy Land with Jerusalem in the center

Color lithograph by S. Schottländer, Breslau, early 20th century. Jewish and National University Library, Jerusalem

model for other neighborhoods as well, for its residents managed to organize themselves in advance to finance the purchase of land and the construction. After settlement had begun, a committee was set up to take care of enlargement of houses, to establish regulations, and so on. An important factor in the planning was the allocation of space for synagogues, ritual baths, public baths, water cisterns, etc.

The construction of new neighborhoods continued in this way until the First World War. Due to the war, donations from abroad ceased, and Jewish construction came to a halt.

Muslims too began construction outside the city walls, mainly on a continuum from north of the walls (the area known today as East Jerusalem), and also residential neighborhoods for the well-to-do in the Bak'ah and Katamon areas.

The Wailing Wall (or "Solomon's Wall")
Vasily Vasileyvich Vereschgain (1842-1904), 1874.
The Israel Museum, Jerusalem

The turn of the century was marked by a growth in the number of the city's inhabitants. The Christian population had quadrupled since the mid-nineteenth century, and now numbered some 13,000 people. A similar growth had occurred among the Muslims, whose number now reached 12,000. As for the Jews – who already in the mid-19th century formed the majority of Jerusalem's population – on the eve of the First World War they numbered about 45,000.

A turning point in the city's development was the voyage of European rulers to the opening ceremonies of the Suez Canal. For this occasion, an excellent road was paved from Jaffa to Jerusalem (1862), yet the journey still took about ten hours. In 1892, the railway between Jaffa and Jerusalem was inaugurated, and this cut the time of travel to only four hours. The railway constituted competition for the coaches, and this also led to shortenings of distance and traveling time.

The possibility of transporting iron girders and other construction materials to Jerusalem accelerated the rate of construction in the city. At this time electric light poles were erected, and after some time several public buildings were lit up from the outside. Mail services improved considerably, and this had much influence on Jews establishing themselves in the city, for they were largely dependent on their brothers in Europe. By the mid-19th century all the great powers had established post offices, and in 1865 the telegraph line between Jerusalem

Sir Moses Montefiore's carriage
Used by the famous Anglo-Jewish philanthropist (1784-1885) to travel to Jerusalem during his last visit (1875) to the Holy Land

and Beirut was inaugurated. All these innovations promoted the growth of the population, since the feeling that the Holy Land was no longer so remote attracted many pilgrims to it. The transportation of raw materials to the city had become easier, enabling many workshops to be set up, for weaving, metal casting, cloth dyeing, etc. In addition, hotels were built, and these also provided employment for many of the city's inhabitants. At the same time, many of them continued to work at their traditional occupations, as silversmiths, tinsmiths, carpenters, and the like.

An important feature of this period was the beginnings of the Hebrew press, with the founding of the *Havazelet* newspaper and its print-shop, which also trained Hebrew print-workers. Another occupation developed in the city with the establishment of banks, which helped in the city's development. Worthy of note among the major banks was The Anglo-Palestine Bank, which was established in Jerusalem in 1902, and later became the national bank of the country.

These development activities ceased with the outbreak of the First World War. These were four very difficult years and the inhabitants of Jerusalem suffered from hunger. In addition, the Turks attempted to recruit them into the Turkish Army, and this led many of them to flee. The city was declining rapidly when the British Army entered it on December 9th, 1917. Two days later, General Allenby arrived in Jerusalem and declared his intention to continue to preserve the status quo during the new British regime as well. The British occupation was revolutionary in one respect: for the first time, after

Seal of the Ashkenazi Community in the Four "Holy Cities" of the Holy Land
In the center: the Wailing Wall with the symbolic "Cedars of Lebanon," early 20th century

Rachel's Tomb and the Wailing Wall
Carved in a wood Mezuzah case from Jerusalem, early 20th century. The Jewish Museum, New York

Right:
The Binding of Isaac
Color lithograph by Moses, son of Isaac Mizrachi, Jerusalem, 1888. The Jewish Museum, New York

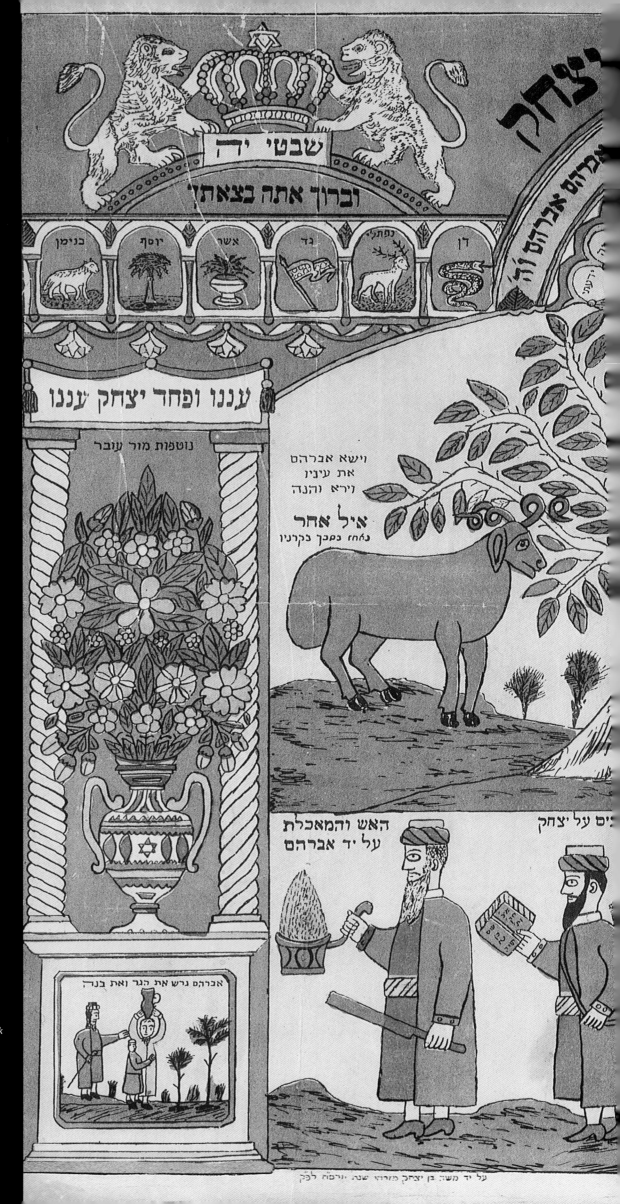

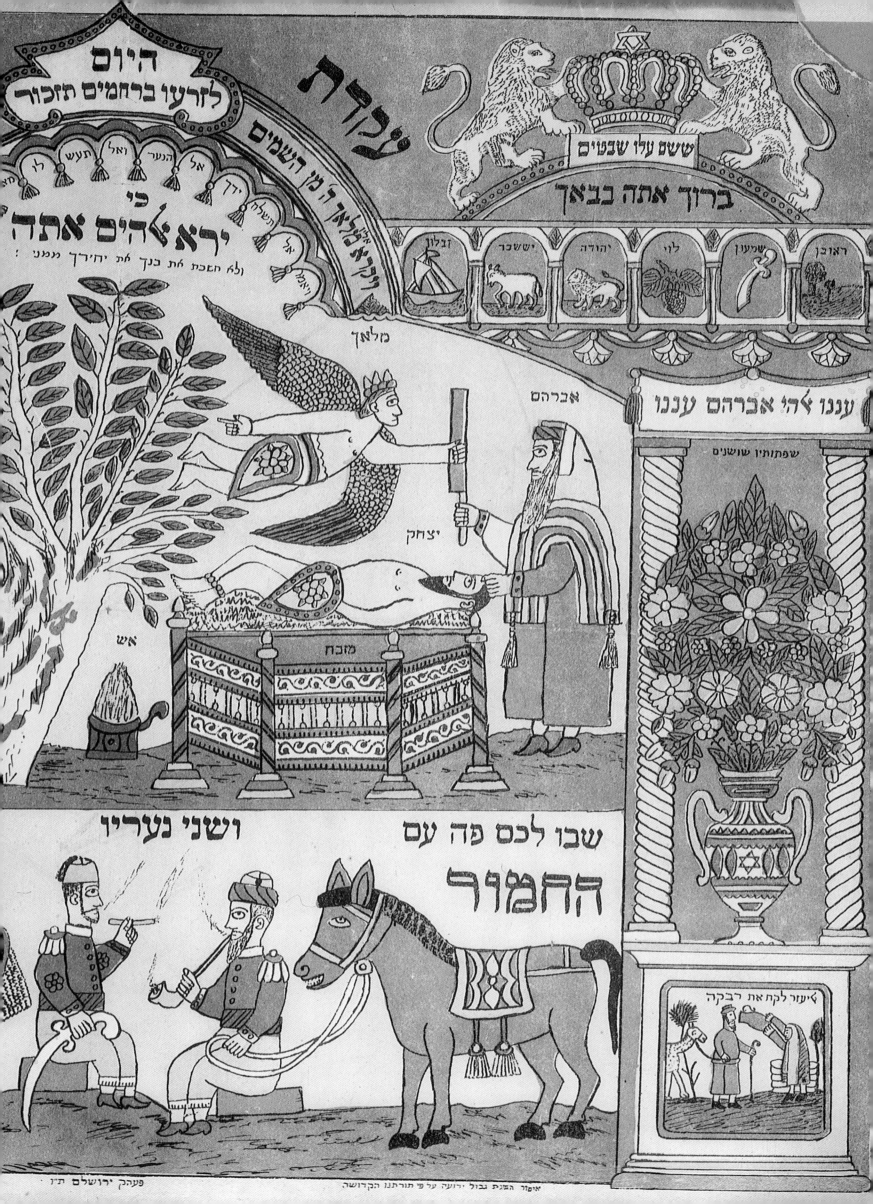

hundreds of years, Jerusalem once more became the capital city of the country. Having made this decision, the British began work on improving the city's outer appearance. They conserved its character by means of the fine architecture used in the public buildings they erected, such as the High Commissioner's Palace (Armon Hanatziv), the Rockefeller Museum, the Central Post Office and others. All these buildings were built in a style which blended Oriental and European elements. In

Itinerarium of Jewish holy sites and the "Holy Towns" in the Land of Israel
Folk painting (watercolor), Eretz-Israel, first half of the 19th century. The Israel Museum, Jerusalem

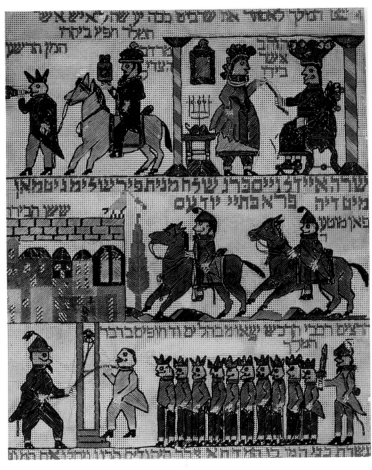

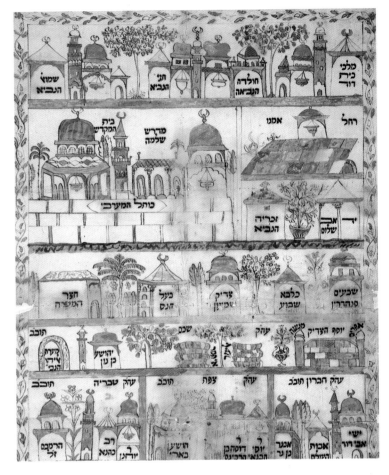

Purim wall decoration
The story of the Book of Esther depicted on perforated paper embroidered with wool and silk threads by Sarah Weissberg, Jerusalem, late 19th century. The Jewish Museum, New York

contrast to the Ottoman period, the British did not construct buildings solely according to the European tradition. They even legislated a law to the effect that all new construction in Jerusalem be only of stone, and this has continued to affect the special character of the city to this day.

The British were aware of Jerusalem's importance to members of the three religions. Accordingly they set up a municipal council, comprising two representatives of each religion, headed by a Muslim mayor with two deputies, one Christian and one Jewish. The British rule upset the balance which had existed among the communities under Ottoman rule, and a short time after the inception of the British civic administration (1st July 1920), Muslim riots against the Jews broke out. All the British attempts to calm the situation proved futile, and during all the years of the British Mandate (1917-1948) it was almost impossible to activate the municipal council in an orderly manner because of the struggles among the various communities represented on it.

Nonetheless, the British Mandate brought improvement to Jerusalem; its population tripled in comparison to its number at the beginning of the Mandate. The built-up area increased proportionately and even more, because of the many new public buildings and gardens in the city. The city center finally moved out of the Old City and into the bounds of the new city, principally to the triangular area bordered by Jaffa Road, King George Street and Ben Yehuda Street, which still serves as a city center to this day.

Because of the rioting and disturbances among the communities, new neighborhoods were established by Jews who had left the Old City, and the Jewish Quarter gradually contracted to its size during the first half of the 19th century. The Jewish population left the Old City and moved to new neighborhoods established at that time, such as Rehavia, Beit Hakerem and Talpiot, which became

An Ashkenazi Jew in early 20th-century Jerusalem
Drawing by the noted Swedish traveler Sven Hedin, from his book "Jerusalem", published in 1918

centers of the Jewish garden neighborhoods.

The city developed mainly as a city of services, and aside from some light industry and home manufacture there was almost no heavy industry there at all. The Jewish population, which now comprised about seventy per cent of the city's total population, was occupied with developing the Eretz-Israeli culture. Literature, education, museums, concerts and so on, played an important role in the city's cultural life. 1925 saw the laying of the cornerstone for the Hebrew University, which added a special color to the city's Jewish population. The archaeological exploration of the country, which was centered in Jerusalem, led to the establishment of important institutes by the great powers – America, England, France, Germany and others. The Hebrew University too was involved to a great extent in research on Jewish Palestine. Likewise, an important English-language newspaper, *The Palestine Post*, began being published in Jerusalem, where it continues to appear to this day, as *The Jerusalem Post*. The Bezalel School of Arts and other institutes soon turned Jerusalem into a most important cultural center in this country.

The city's growth necessitated an increase in its water supply, and consequently the British began to bring water to Jerusalem from the springs of Wadi Kelt. Later (in 1935) they installed the water pipeline from Rosh Ha'ayin to Jerusalem. Central sewage systems in the city (and in the Old City as well) improved the general state of sanitation, and thus the lives of the inhabitants as well.

As already mentioned, from the outset of the British Mandate, riots and disturbances on religious and ethnic grounds raged in Jerusalem, and they continued to be focussed on Jerusalem even while they spread to other parts of the country.

The Zionist movement's attitude to Jerusalem was not unequivocal. It was marked by ups and downs, despite the fact that the very name of this movement was derived from Jerusalem's other name, "Zion". Part of this attitude was negative, due to the fact that the active Zionist Movement was for the most part socialistic, while most of the Jewish population of Jerusalem was not. Likewise, many of the city's Jewish inhabitants were religiously observant, while the Zionist movement was principally secular and had little interest in the religious values of Judaism. The developmental momentum led by the Zionist movement found no outlet in Jerusalem or the other towns in the hilly regions, because the topography there did not allow for the accelerated development possible in the coastal cities. However, the fact remains that the national institutions and the Hebrew University were established in Jerusalem and not in Tel Aviv.

Debates concerning the centrality of Jerusalem began at the very outset of Jewish settlement in this country. Thus, for example, already in 1882, when a place was being sought for the settlement of

Leather binding for a prayer book, with David's Citadel
The picture is embossed on a thin layer of copper, "Bezalel" work, Jerusalem, early 20th century. Private collection, Herzliya

A Persian Jew of early 20th-century Jerusalem
Drawing by Sven Hedin, from his book "Jerusalem", 1918

Opening ceremony of the Hebrew University of Jerusalem on Mt. Scopus
Leopold Pilichowski (1869-1933), 1925.
Art Collection of the Hebrew University of Jerusalem

The Churvah ("Ruin") Synagogue in the Old City of Jerusalem
Erected in 1864 and destroyed by the Jordanians in 1948. Popular print appearing in numerous books and broadsheets printed in Jerusalem in the late 19th and early 20th century

the "Committee of Pioneers of Yesod Hama'alah", the pioneers rejected the idea of establishing themselves in Jerusalem because the city was outside the domain of Zionist activities, i.e., far from the ports where pioneers arrived and from the centers of Zionist settlement, which was concentrated principally in villages distant from Jerusalem. Another factor in this negative attitude was the social structure inside Jerusalem: disputes among various factions in the city, religious fanaticism among the old settlers, and the fear felt by many Jewish inhabitants of Jerusalem that the "Halukah" funds (donations by Jews abroad) would be transferred to the Zionist settlements. Furthermore, the Jerusalem population attacked the secular way of life of the "Zionists". Ultimately, the "Pioneer Committee" center was set up in Jaffa.

Later, there was the story of the "Hovevei Zion" (Lovers of Zion) association, which sought a center for their representatives in Israel. Again, the issue of geography and of Jerusalem's distance from the new settlements arose. "We have no need of the walls of Jerusalem, nor of the Temple, nor of Jerusalem itself ... the city which is not central ... We need the Land of Israel, and we need a real center ... We need boldness of spirit and action" (Moshe Lilienblum, 1882).

The activities of Baron Rothschild were also moved out of Jerusalem, but for a different reason: fear of alarming the Ottomans by excessive Jewish activity in the city, which was holy to them as well.

In general, the First Aliyah was not "anti-Jerusalem". For these immigrants Jerusalem symbolized the past, the days of the First and Second Temples, but not the future of national renewal. Jerusalem was the center of the old settlement, and it was a city, while the Zionist Movement sought to create a "new Jew", who dwelt on the land, and this was not something that Jerusalem could provide.

The extremists among the Zionists, who were socialists, saw the situation in Jerusalem as representing an attitude opposed to the Jewish national revolution, and even declared: "To the Jerusalem of above people pray, but in other places in the Land of Israel of below – we live".

Despite all this, it was clear to all that Jerusalem would be the heart of the Jewish settlement in the land. The growth of both secular and religious Jewish settlement during the time of the British Mandate attests to this.

Messianic view of the Mount of Olives

The tombs in the Kedron Valley appear at the mountain's foot, and the wall represents the city's eastern wall with the closed Gates of Mercy; popular miniature picture found in numerous Hebrew books and decorative pages printed in Jerusalem in the late 19th and early 20th century

"Mizrach" tablet with the Wailing Wall

The Mizrach used to indicate (chiefly for European Jews) the direction of prayer to Jerusalem; color lithograph, Germany (Breslau?), late 19th century. The Jewish Museum, New York

The Ramban Synagogue in the Old City of Jerusalem

From a Hebrew manuscript describing and illustrating the Holy Sites, Casale Monferrato (Italy), 1598. Cecil Roth Collection, Leeds

Acknowledgments

The authors and the publisher wish to thank the libraries, museums, and private collectors listed below for permitting the reproduction of works of art in their collections and for supplying the necessary photographs.

Photographic credits

Art Collection of the Hebrew University of Jerusalem: 146.

Art Resource: 21, 23, 29, 36-37, 38, 52, 61, 62, 63, 68, 69, 72-73, 74, 78, 82-83, 85, 87, 89, 117, 118-119, 124, 125, 128, 135, 137, 138, 142-143, 144, 147.

Art Resource / Alinari: 67.

Art Resource / Bridgeman: 32, 121, 130-131, 132.

Art Resource / Lauros Giraudon: 24, 69, 106-107, 110, 114, 115.

Art Resource / Scala: 43, 45, 48-49, 51, 66, 70-71, 79, 81, 84, 91, 92, 94-95, 122.

Bible Lands Museum, Jerusalem: 31.

Biblioteca Laurenziana, Florence: 25, 26-27, 28.

Biblioteca Marciana, Venice: 86, 113.

Biblioteca Nazionale, Naples: 60.

Biblioteca Seminario, Padua, Italy: 122.

Bibliothèque Nationale, Paris: 15, 21, 28, 35, 41, 50, 53, 57, 59, 75, 105, 106-107, 121.

Bibliothèque de l'Arsenal, Paris: 43, 55.

Biblioteca Estense, Modena, Italy: 34.

Brera Gallery, Milan: 79.

British Library, London: 32, 38, 104, 111, 126, 133.

Christie's Collection, London: 130-131.

Countess of Sponeck Collection, Frankfurt: 33.

Eglise Saint Priest, Gimel-les-Cascades, France: 118-119.

Gross Family Collection, Tel Aviv: 80.

Hereford Cathedral, England: 120.

Kaplan Collection: 2-3, 46-47.

Kunsthistorisches Museum, Gemäldegalerie Vienna: 73, 135.

Laor Collection, Jewish National and University Library, Jerusalem: cover, 13, 17, 140.

Musée Condé, Chantilly, France: 24, 68, 114.

Museum Voor Schoone Kunsten, Ghent, Belgium: 48-49.

Photographers' credits

David Harris: 18, 28, 58, 93, 96-97, 127.

Erich Lessing: 7, 18, 19, 21, 23, 36-37, 38, 52, 61, 62, 63, 69, 72-73, 74, 79, 87, 89, 118-119, 122, 124, 135.

Massimo Velo: 25, 60.

Abraham Hay: 141.

Yoram Lehmann: 139.

JERUSALEM
STONE AND SPIRIT

IERVSALEM

ratta con parte del suo circuito secondo che hoggidi si uede dalla parte d'Oriente

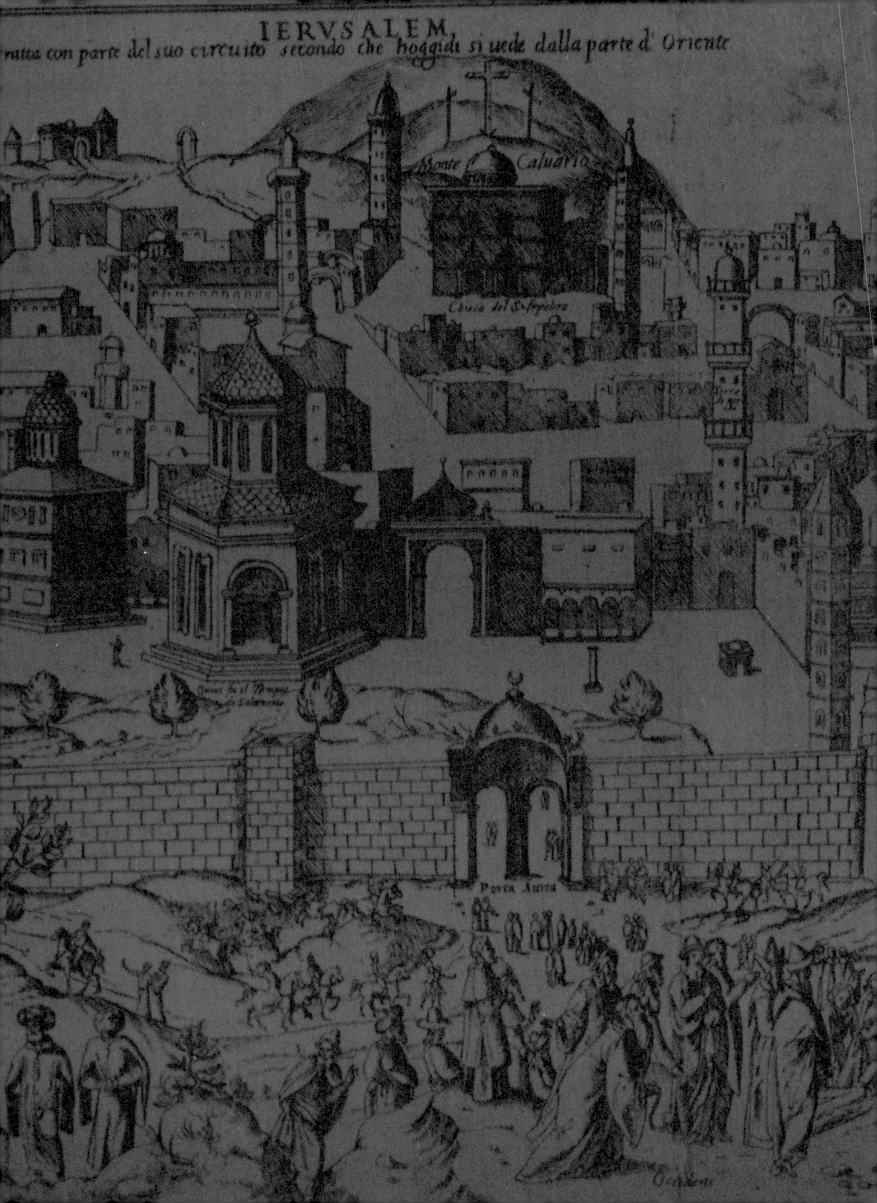

Monte Caluario

Chiesa del Salsepolcro

Porta Aurea